ENDURANCE

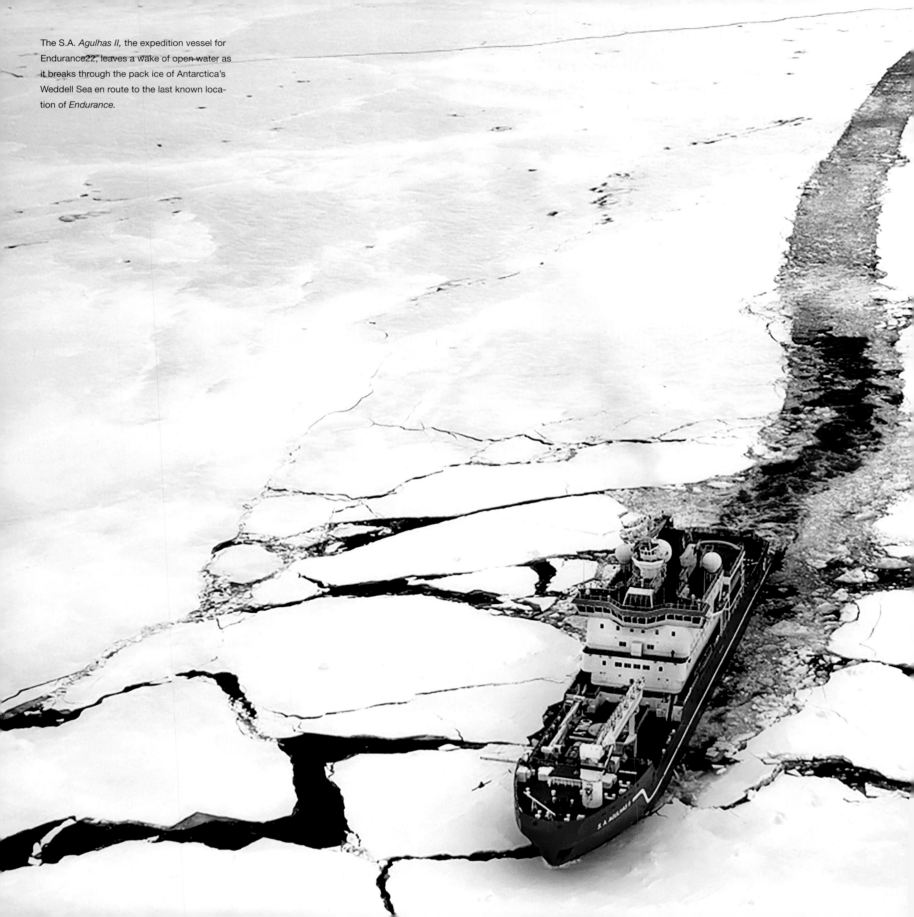

The S.A. *Agulhas II,* the expedition vessel for Endurance22, leaves a wake of open water as it breaks through the pack ice of Antarctica's Weddell Sea en route to the last known location of *Endurance.*

ENDURANCE

The Discovery of Shackleton's Legendary Ship

JOHN SHEARS AND NICO VINCENT

NATIONAL GEOGRAPHIC

Washington, D.C.

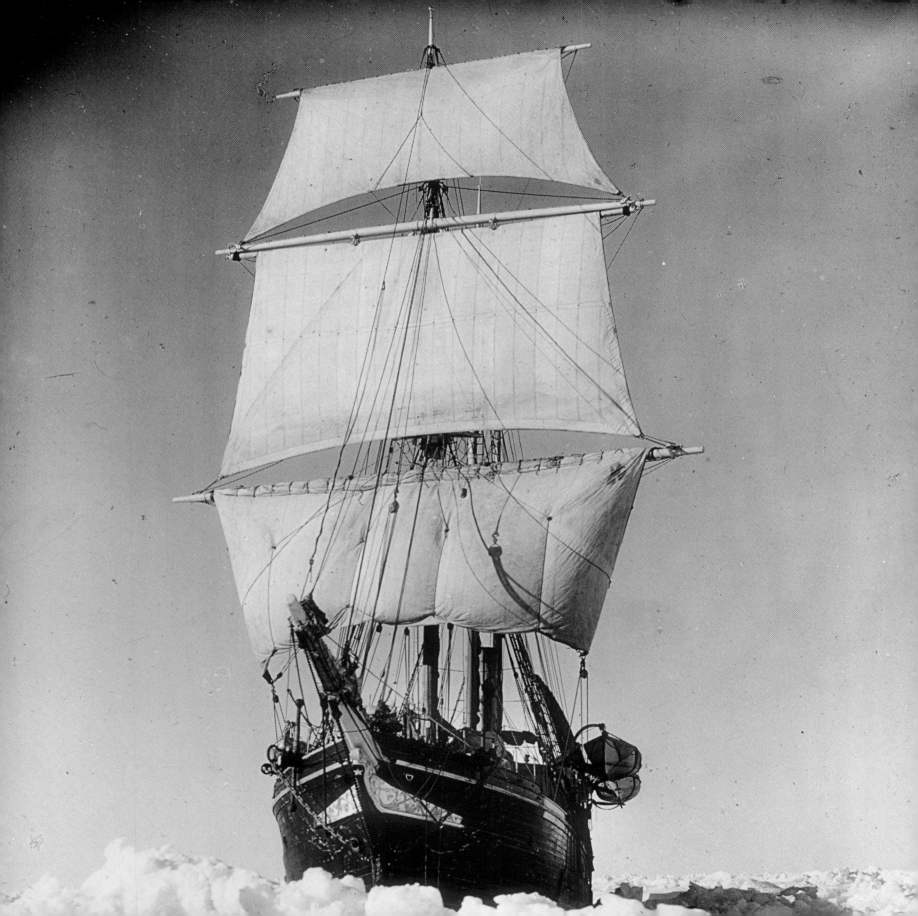

Contents

Endurance under full steam and sail rams through the Weddell Sea pack ice on the Imperial Trans-Antarctic Expedition (1914–16).

BUCKINGHAM PALACE

On March 5, 2022, exactly one hundred years to the day after the British explorer Sir Ernest Shackleton was buried on the island of South Georgia, his legendary ship *Endurance* was discovered under the ice in the remote Weddell Sea in Antarctica by the Endurance22 expedition team. News and images of the historic discovery transfixed people all over the globe.

This account by Expedition Leader Dr John Shears and Deputy Leader and Subsea Project Manager Nico Vincent, of the discovery of *Endurance* was the culmination of a mission that took years to design, develop and deliver. Their task and the ambitious plan to achieve it, developed under the authority of the Falklands Maritime Heritage Trust, was described as 'The Impossible Search for the Greatest Shipwreck'. Only after weeks of intensive subsea survey, and just a few days before the brutal Antarctic winter weather closed in, was the wreck located, in breath-taking condition and less than five nautical miles from its last recorded location.

Endurance has lain hidden and protected by the pack ice and deep waters of the Weddell Sea for over one hundred years. This first-hand account of the search for Endurance describes the impressive teamwork of the expedition members as they confronted and overcame the immense challenges of the Weddell Sea. The text is illustrated by outstanding colour photographs of the expedition in action and the magnificent underwater images of the wreck.

It is of the utmost importance that we safeguard this priceless treasure of our past, and other surviving heritage of the *Endurance* story. This includes the Stromness Manager's Villa, that the South Georgia Heritage Trust, the charity of which I am Patron, its USA partner Friends of South Georgia Island and the Government of South Georgia & the South Sandwich Islands plan to save from collapse and protect and conserve for the future.

I commend this tale of Endurance past and present to you, and encourage you to immerse yourself in a story of leadership and teamwork that will inspire many generations to come.

Anne

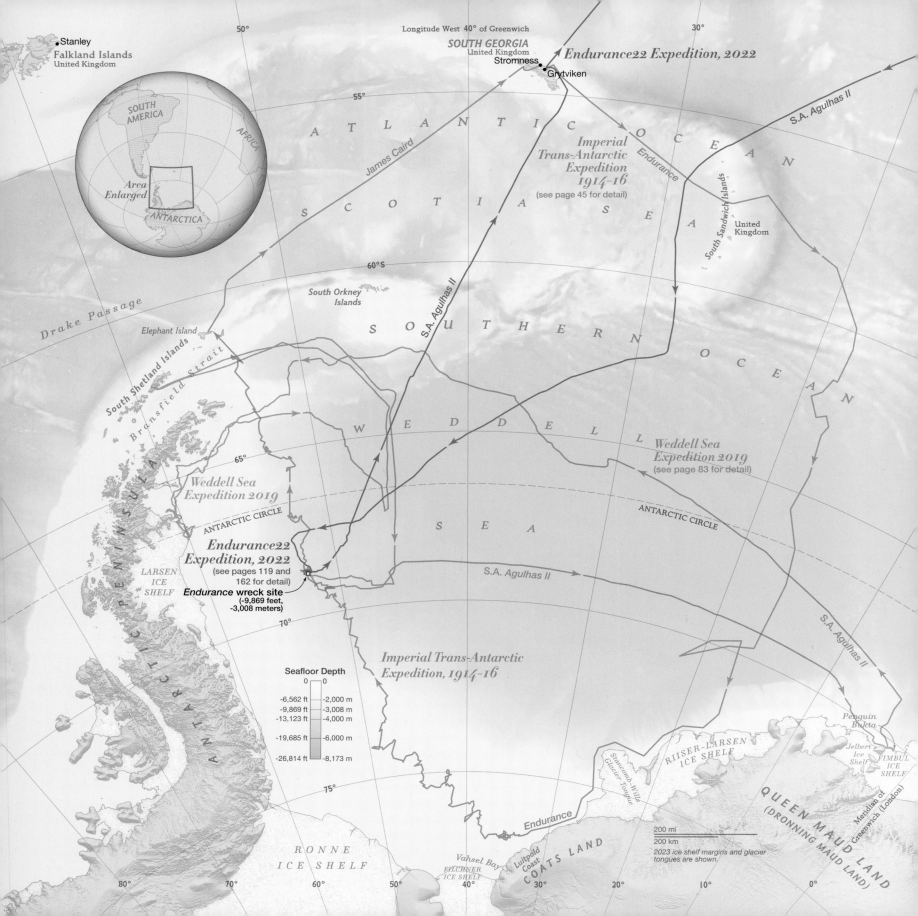

Stanley
Falkland Islands
United Kingdom

SOUTH GEORGIA
United Kingdom
Stromness
Grytviken

Endurance22 Expedition, 2022

Longitude West 40° of Greenwich

S.A. Agulhas II

A T L A N T I C O C E A N

*Imperial
Trans-Antarctic
Expedition
1914-16*
(see page 45 for detail)

James Caird

S C O T I A S E A

Endurance

South Sandwich Islands
United Kingdom

Drake Passage

South Orkney
Islands

S.A. Agulhas II

S O U T H E R N O C E A N

Elephant Island

South Shetland Islands

Bransfield Strait

W E D D E L L S E A

*Weddell Sea
Expedition 2019*
(see page 83 for detail)

ANTARCTIC CIRCLE

ANTARCTIC CIRCLE

*Weddell Sea
Expedition 2019*

*Endurance22
Expedition, 2022*
(see pages 119 and
162 for detail)

Endurance wreck site
(-9,869 feet,
-3,008 meters)

S.A. Agulhas II

A N T A R C T I C P E N I N S U L A

LARSEN
ICE
SHELF

Seafloor Depth

0	0
-6,562 ft	-2,000 m
-9,869 ft	-3,008 m
-13,123 ft	-4,000 m
-19,685 ft	-6,000 m
-26,814 ft	-8,173 m

*Imperial Trans-Antarctic
Expedition, 1914-16*

S.A. Agulhas II

Penguin
Bukta

Jelbert
Ice
Shelf

FIMBUL
ICE
SHELF

RIISER-LARSEN
ICE SHELF

Stancomb-Wills
Glacier Tongue

Q U E E N M A U D L A N D
(DRONNING MAUD LAND)

Meridian of
Greenwich (London)

RONNE
ICE SHELF

Vahsel Bay
FILCHNER
ICE SHELF

Luitpold
Coast

COATS LAND

Endurance

200 mi
200 km

*2023 ice shelf margins and glacier
tongues are shown.*

Area
Enlarged

SOUTH
AMERICA

AFRICA

ANTARCTICA

Introduction

DONALD LAMONT

Chairman, Falklands Maritime Heritage Trust

In July 2014, Dr. John Shears and I were among a group of interested people whom National Geographic invited to Washington to discuss forming an expedition to find Shackleton's *Endurance,* the famous ship hidden under the ice of the Weddell Sea in Antarctica since November 21, 1915. While that particular initiative did not bear fruit, others began to make plans to search the Weddell Sea using new technology. Leading the field was the subsea technology firm Ocean Infinity, which came to play the central role for the expeditions to find *Endurance* in 2019 and 2022. In 2022, the right combination of technology, people, funding, and luck came together to locate, film, and survey the wreck of Shackleton's lost ship. In this book, Dr. Shears (leader of the expedition) and Nico Vincent (deputy leader and subsea manager) put the expedition in context, give an authoritative account of its planning and execution, and present the implications of their discovery.

In 2019 the Weddell Sea Expedition (WSE2019) made a credible effort to find *Endurance.* But the remotely operated underwater vehicle (ROV) failed, the autonomous underwater vehicle (AUV) went wandering and could not be retrieved, and the expedition's mother ship, the S.A. *Agulhas II,* had to retreat from the encroaching ice for fear of being trapped like Shackleton's ship a century before.

The failure of WSE2019 can, however, be deemed essential to the success of Endurance22. The Falklands Maritime Heritage Trust was not involved in the 2019 project. We had been responsible for a search that led to the finding of the S.M.S. *Scharnhorst,* one of the German warships sunk in the Battle of the Falklands in 1914, and we were

The route of the Imperial Trans-Antarctic Expedition is shown here alongside the voyages of the S.A. *Agulhas II* during the Weddell Sea Expedition (2019) and Endurance22 (2022).

proud of the documentary that had been made of that expedition. Few expected that this success would give the trustees—Bill Featherstone, Saul Pitaluga, Mensun Bound, and me—access to the funding needed to organize the much more challenging and complex expedition to find Sir Ernest Shackleton's iconic ship. But so it proved.

Some early decisions were easy. We adopted many of the components of WSE2019 for Endurance22. Dr. John Shears was the obvious choice as expedition leader. Mensun Bound would be the trust's representative and director of exploration. Ocean Infinity again supplied the AUVs, but this time they were new Saab Sabertooths. And because the S.A. *Agulhas II,* her master (Captain Knowledge Bengu), ice pilot (Captain Freddie Ligthelm), and crew had performed so outstandingly in 2019, we spent no time considering alternatives for 2022. And we were keen to involve Reach the World, a U.S.-based nonprofit dedicated to bringing explorers into classrooms in the United States and elsewhere. Likewise, the U.K.-based Royal Geographical Society would work with us to further develop teaching materials it had created on Antarctica, Shackleton, and the 2019 expedition.

But Endurance22 would by no means be just a repeat of WSE2019. As planning for the new expedition got under way, the trust met regularly and frequently with John and Nico to review their plans. John and Nico devoted much effort to working out how to deal with the challenging Antarctic ice, which might prevent the mother ship from reaching the wreck site to launch the Saab Sabertooth subsea vehicles from the stern. The developing plans had significant cost implications and required very detailed consideration of the logistics. As we, the trustees, scrutinized our computer screens, we were enormously impressed by John and Nico's intense focus on all the things that could go wrong and how the team would avoid them or respond effectively no matter what.

Any expedition to Antarctica requires rigorous planning. Conducting a subsea search in the hostile environment of the Weddell Sea imposes so many more challenges. And on top of all that, the global COVID pandemic further threatened the movement of personnel and equipment. It was a triumph of leadership and planning by John and Nico—and all who cooperated in confronting the serious logistical challenges—that the S.A. *Agulhas II* was able to

depart on schedule from Cape Town, South Africa, on February 5, 2022, ready to resume the search.

Nico handpicked the subsea team he would lead and made plans for the search based on the lessons learned from WSE2019. The 2019 effort taught the team that this search could not be conducted based on normal subsea search practices, just with ice added. Instead of trying to defeat the ice, the team had to work with it, maneuvering the ship to where the Sabertooth could be best deployed. These decisions depended on the closest collaboration between Nico; Captain Freddie Ligthelm; Dr. Lasse Rabenstein, our chief scientist; and Dr. Marc de Vos, our meteorologist from the South African Weather Service, working together with Captain Knowledge Bengu and John. Success and professional reputations were at stake. The authors describe how success came just as Mensun Bound had publicly affirmed: with the wreck of *Endurance* upright and largely intact on the seafloor.

From the early stages of planning, the trust aimed to ensure that the story of Shackleton and this expedition to find his lost ship would be broadcast widely throughout the world. We intended from early on that there would be a major film documentary. We also wanted to use social media to generate among younger audiences an interest in Antarctica, in exploration, and specifically in our expedition. Working with Dan Snow—the British television presenter and historian—as the face of the expedition, Natalie Hewit, the U.K. documentary filmmaker, headed a media team she selected for their skills and willingness to work in partnership with other members of the team. Esther Horvath, our official photographer, and Tim Jacob, for the first time broadcasting an Antarctic expedition live into classrooms for Reach the World, contributed to our efforts to share the story as well.

So too does this book. I hope it will engage you in the dramatic narrative of our expedition and of Shackleton, his men, and others who push the limits of human capability, resilience, and endurance. I hope you will be inspired by reading what teamwork and leadership can achieve. And I hope you will be stimulated to learn more about the environment in which these stories unfolded: Antarctica, the continent about which we know little, but which is so important to our very existence.

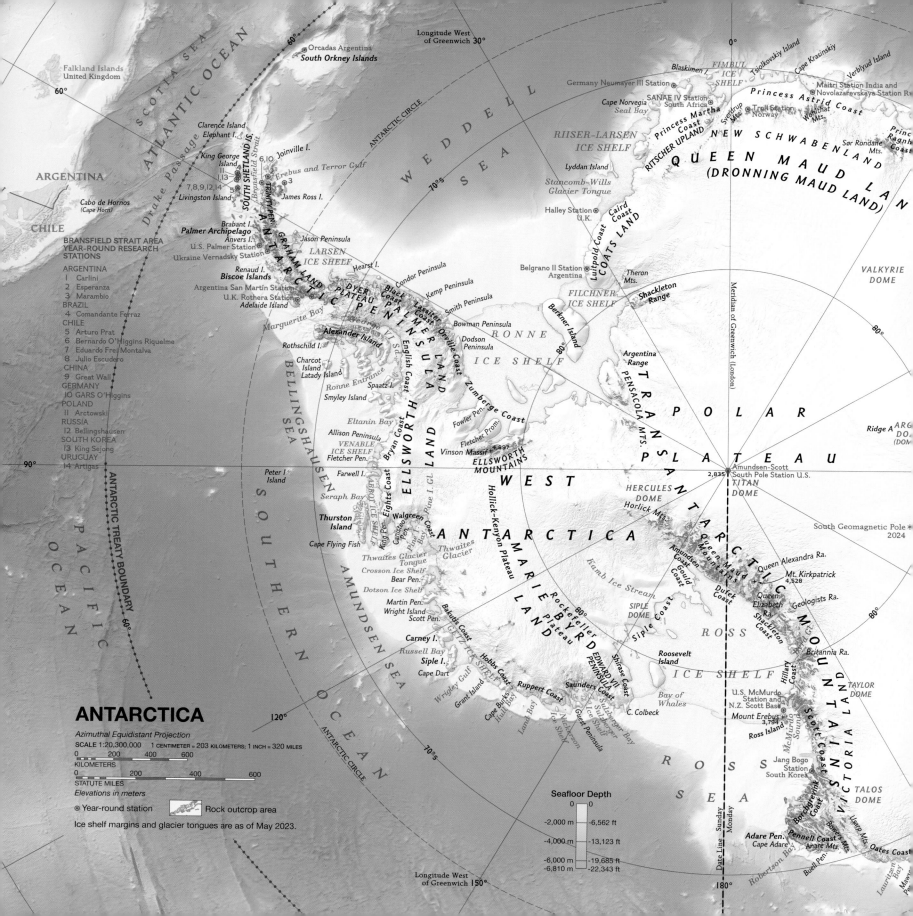

ANTARCTICA

Azimuthal Equidistant Projection

SCALE 1:20,300,000 1 CENTIMETER = 203 KILOMETERS; 1 INCH = 320 MILES

KILOMETERS
0 200 400 600

STATUTE MILES
0 200 400 600

Elevations in meters

◉ Year-round station Rock outcrop area

Ice shelf margins and glacier tongues are as of May 2023.

BRANSFIELD STRAIT AREA YEAR-ROUND RESEARCH STATIONS

ARGENTINA
1 Carlini
2 Esperanza
3 Marambio
BRAZIL
4 Comandante Ferraz
CHILE
5 Arturo Prat
6 Bernardo O'Higgins Riquelme
7 Eduardo Frei Montalva
8 Julio Escudero
CHINA
9 Great Wall
GERMANY
10 GARS O'Higgins
POLAND
11 Arctowski
RUSSIA
12 Bellingshausen
SOUTH KOREA
13 King Sejong
URUGUAY
14 Artigas

Seafloor Depth

0	0
-2,000 m	-6,562 ft
-4,000 m	-13,123 ft
-6,000 m	-19,685 ft
-6,810 m	-22,343 ft

Longitude West of Greenwich 30°

Longitude West of Greenwich 150°

ANTARCTIC TREATY BOUNDARY

ANTARCTIC CIRCLE

Map labels

ATLANTIC OCEAN
SCOTIA SEA
Falkland Islands United Kingdom
ARGENTINA
CHILE
Cabo de Hornos (Cape Horn)
Orcadas Argentina
South Orkney Islands
Clarence Island
Elephant I.
King George Island
Joinville I.
Erebus and Terror Gulf
James Ross I.
SOUTH SHETLAND IS.
Bransfield Strait
Livingston Island
Drake Passage
Brabant I.
Palmer Archipelago
Anvers I.
U.S. Palmer Station
Ukraine Vernadsky Station
Biscoe Islands
Renaud I.
Argentina San Martín Station
U.K. Rothera Station
Adelaide Island
Marguerite Bay
Rothschild I.
Alexander Island
Charcot Island
Latady Island
Ronne Entrance
Spaatz I.
Smyley Island
Eltanin Bay
Allison Peninsula
VENABLE ICE SHELF
Fletcher Pen.
Farwell I.
Seraph Bay
Peter I Island
Thurston Island
Cape Flying Fish
PACIFIC OCEAN
SOUTHERN OCEAN
BELLINGSHAUSEN SEA
AMUNDSEN SEA
GRAHAM LAND
ANTARCTIC PENINSULA
TRINITY PEN.
DYER PLATEAU
Black Coast
Lassiter Coast
Jason Peninsula
LARSEN ICE SHELF
Hearst I.
Condor Peninsula
Kemp Peninsula
Smith Peninsula
Bowman Peninsula
Dodson Peninsula
George VI Sd.
English Coast
Orville Coast
Zumberge Coast
Fowler Pen.
Fletcher Prom.
Vinson Massif 4,897
ELLSWORTH MOUNTAINS
ELLSWORTH LAND
PALMER LAND
Bryan Coast
Eights Coast
King Pen.
Canisteo Pen.
Walgreen Coast
Pine I. Gl.
Pine Island Bay
ABBOT ICE SHELF
Thwaites Glacier Tongue
Thwaites Glacier
Crosson Ice Shelf
Bear Pen.
Dotson Ice Shelf
Martin Pen.
Wright Island
Scott Pen.
Carney I.
Russell Bay
Siple I.
Cape Dart
Bakutis Coast
GETZ ICE SHELF
Hobbs Coast
Wrigley Gulf
Grant Island
Cape Burks
Hull Bay
Ruppert Coast
Land Bay
MARIE BYRD LAND
WEST ANTARCTICA
Hollick-Kenyon Plateau
Rockefeller Plateau
EDWARD VII PENINSULA
Shirase Coast
Sulzberger Bay
Saunders Coast
Guest Peninsula
Nickerson Ice Shelf
Sulzberger Ice Shelf
Cape Colbeck
Roosevelt Island
Bay of Whales
ROSS ICE SHELF
ROSS SEA
Kamb Ice Stream
SIPLE DOME
Siple Coast
Gould Coast
Du-rek Coast
HERCULES DOME
Horlick Mts.
TRANSANTARCTIC MOUNTAINS
Amundsen Mountains
Queen Maud Mountains
Queen Alexandra Ra.
Mt. Kirkpatrick 4,528
Queen Elizabeth Ra.
Geologists Ra.
Shackleton Coast
Britannia Ra.
Hillary Coast
U.S. McMurdo Station and N.Z. Scott Base
Mount Erebus 3,794
Ross Island
McMurdo Sound
Jang Bogo Station South Korea
Scott Coast
VICTORIA LAND
TAYLOR DOME
TALOS DOME
Borchgrevink Coast
Pennell Coast
Adare Pen.
Cape Adare
Anare Mts.
Oates Coast
Buell Pen.
Usarp Mts.
Bowers Mts.
Robertson Bay
TITAN DOME
POLAR PLATEAU
Amundsen-Scott South Pole Station U.S. 2,835
South Geomagnetic Pole 2024
Ridge A
ARGUS DOME
VALKYRIE DOME
Meridian of Greenwich (London)
WEDDELL SEA
RIISER-LARSEN ICE SHELF
FIMBUL ICE SHELF
Blaskimen I.
Tsiolkovskiy Island
Cape Krasinskiy
Verblyud Island
Germany Neumayer III Station
SANAE IV Station South Africa
Maitri Station India and Novolazarevskaya Station R.
Cape Norvegia
Seal Bay
Troll Station Norway
Sør Rondane Mts.
Svobodnyy Mts.
Wohlthat Mts.
Princess Astrid Coast
Princess Martha Coast
RITSCHER UPLAND
NEW SCHWABENLAND
QUEEN MAUD LAND (DRONNING MAUD LAND)
Princess Ragnhild Coast
Lyddan Island
Stancomb-Wills Glacier Tongue
Halley Station U.K.
Caird Coast
COATS LAND
Luitpold Coast
Belgrano II Station Argentina
Theron Mts.
Shackleton Range
FILCHNER ICE SHELF
Berkner Island
RONNE ICE SHELF
Argentina Range
PENSACOLA MTS.
TRANSANTARCTIC PLATEAU

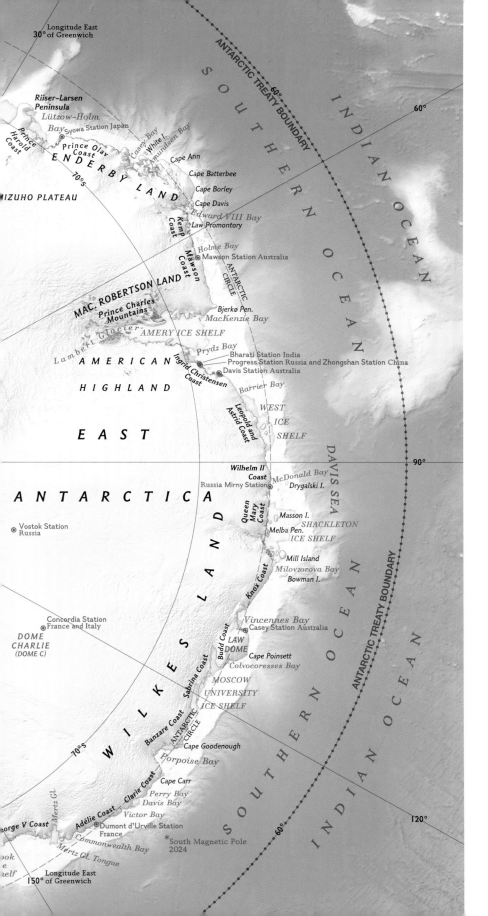

Riiser-Larsen
Peninsula

Lützow-Holm
Bay

Prince
Harold
Coast

Syowa Station Japan

Prince Olav
Coast

ENDERBY LAND

MIZUHO PLATEAU

Casey Bay
White I.
Amundsen Bay

Cape Ann

Cape Batterbee

Cape Borley

Cape Davis

Edward VIII Bay
Law Promontory

Kemp
Coast

Holme Bay
Mawson Station Australia

Mawson
Coast

ANTARCTIC
CIRCLE

MAC. ROBERTSON LAND

Prince Charles
Mountains

Bjerkø Pen.
MacKenzie Bay

Lambert Glacier

AMERY ICE SHELF

AMERICAN

Prydz Bay

Bharati Station India
Progress Station Russia and Zhongshan Station China
Davis Station Australia

Ingrid Christensen
Coast

HIGHLAND

Barrier Bay

EAST

Leopold and
Astrid Coast

WEST

ICE

SHELF

ANTARCTICA

Wilhelm II
Coast

McDonald Bay

Russia Mirny Station

Drygalski I.

Vostok Station
Russia

Queen
Mary
Coast

Masson I.

SHACKLETON

Melba Pen.

ICE SHELF

Mill Island

Milovzorova Bay

Bowman I.

Concordia Station
France and Italy

Knox Coast

DOME
CHARLIE
(DOME C)

Vincennes Bay
Casey Station Australia

Budd Coast

LAW
DOME

Cape Poinsett

Colvocoresses Bay

Sabrina Coast

MOSCOW

UNIVERSITY

ICE SHELF

Banzare Coast

ANTARCTIC
CIRCLE

WILKESLAND

Cape Goodenough

Porpoise Bay

Clarie Coast

Cape Carr

Mertz Gl.

Perry Bay
Davis Bay

Adélie Coast

Victor Bay

George V Coast

Dumont d'Urville Station
France

Commonwealth Bay

Mertz Gl. Tongue

*South Magnetic Pole
2024

SOUTHERN OCEAN

INDIAN OCEAN

INDIAN OCEAN

ANTARCTIC TREATY BOUNDARY

DAVIS SEA

60°

60°

90°

120°

70°S

70°S

60°

Antarctica is dotted with research stations where scientists and support staff live and work. Activities on the continent are governed by the international Antarctic Treaty, in force since 1961, which designates Antarctica as a natural reserve devoted to peace and science.

The Lost Ship

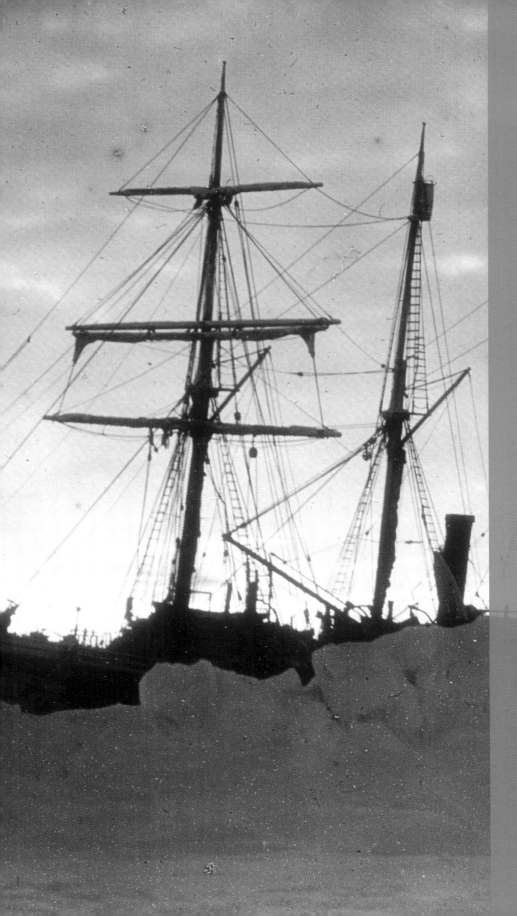

"AT 5PM
SHE WENT DOWN
BY THE HEAD.
THE STERN
THE CAUSE OF
ALL THE TROUBLE
WAS THE LAST
TO GO UNDER
WATER. I CANNOT
WRITE ABOUT IT."

—Sir Ernest Shackleton's diary,
November 21, 1915

Endurance photographer Frank Hurley often hiked for miles across the sea ice to capture distant views of the ship.

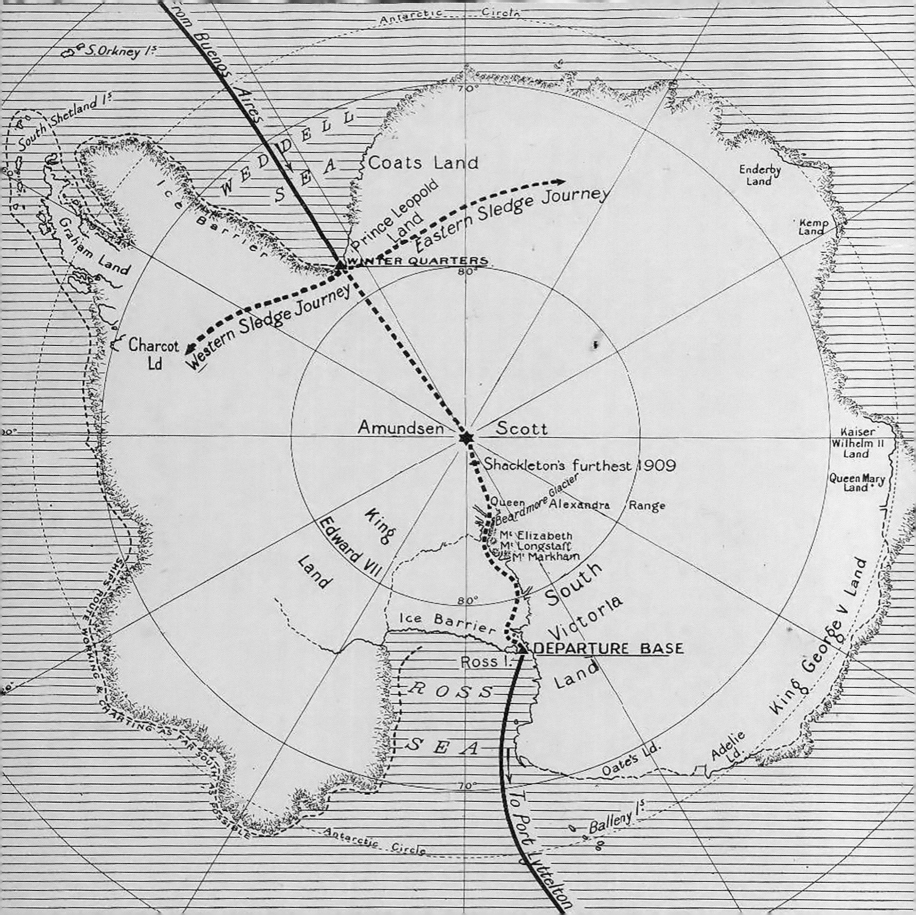

The Lost Ship

JOHN SHEARS

On November 21, 1915, one of the most famous ships in history, Sir Ernest Shackleton's *Endurance*, disappeared below the treacherous pack ice in Antarctica. Shackleton and a crew of 27 men had sailed her from England on a daring expedition to be the first to cross the frozen continent. *Endurance* never returned home from this, her maiden voyage. She was crushed and holed, and then sank beneath the ice of the Weddell Sea, east of the Antarctic Peninsula, forcing Shackleton and his crew to embark on an epic fight for survival.

For over a century, *Endurance* was thought lost forever, impossible to find because of her remote, frozen resting place. Any search for her would be an immense challenge. Her last recorded position in the western Weddell Sea was over 350 miles (560 km) from the nearest land, and she was wrecked in one of the most hostile seas on Earth, where the bitterly cold temperatures cause the sea to freeze solid. In places, the ice is over 16 feet (5 m) thick. Even if explorers were able to reach the wreck site, any underwater search would be across an uncharted seafloor more than 10,000 feet (3,050 m) below the surface. It would take a herculean effort from an international team of the world's foremost engineers, technicians, scientists, and mariners to find *Endurance,* and the historic Endurance22 expedition assembled just such a crew. After years of preparation and a crushing failed first attempt in 2019, we embarked on a dramatic, high-stakes adventure back to the Weddell Sea in 2022 to find the wreck.

I, Dr. John Shears, served as the expedition leader of the Endurance22 mission, and my co-author, Nico Vincent, served as deputy leader and subsea project manager. I'm a polar geographer with more than 30 years' experience working in both the Antarctic and the Arctic. Nico is one of the world's best and most experienced subsea engineers. Together, we have written this book to give a firsthand account of our search for *Endurance,* and the triumphs and trials we faced along the way. We hope this record illuminates that our successes were the stunning result of a united effort by an incredible international team, and not any one individual. We also hope our unique insights will bring the epic story of Shackleton and *Endurance* to a new, modern audience.

This 1914 map of the Antarctic continent shows Shackleton's proposed crossing route for the Imperial Trans-Antarctic Expedition. He used this map in the expedition prospectus sent to possible funders of the mission.

SHACKLETON, ALONG WITH CREW MEMBERS CAPTAIN FRANK WORSLEY AND TOM CREAN, MARCHED FOR 36 HOURS NONSTOP TO STROMNESS WHALING STATION. WHEN THEY ARRIVED ON MAY 20, 1916, THEY RAISED THE ALARM TO SAVE THE REST OF THEIR CREW.

THE GREATEST OF FAILURES

On August 1, 1914, Ernest Shackleton and his crew set sail on *Endurance* from Millwall Docks in London, England, bound for Antarctica on the Imperial Trans-Antarctic Expedition. The expedition sought to be the first to cross the Antarctic continent, "the last great polar journey that can be made," as Shackleton wrote in the expedition prospectus.

But Shackleton and his men never reached shore to begin their pioneering polar journey. On January 18, 1915, *Endurance* became trapped in the thick pack ice of the Weddell Sea within 80 miles (130 km) of her intended destination, Vahsel Bay—where Shackleton had planned to begin the crossing. For 10 months, the ship drifted northward, locked into the ice's grip, until it was crushed and sunk on November 21, 1915. The 28 crew members had abandoned ship a few weeks before on October 27, along with their 49 sledge dogs and a cat, and then endured five months sheltering in tents camped out on the ice in the freezing cold. They survived on meager rations salvaged from the sinking ship, and they hunted for seals and penguins but were slowly starving.

Their camp drifted north in the pack ice until the ice floes began to melt. Then the men launched their three lifeboats to escape to Elephant Island on the northern end of the Antarctic Peninsula. But there was no hope of rescue from the remote and inhospitable island, so Shackleton took a crew of five men and sailed north to the island of South

Georgia in an attempt to find help. A perilous 800-mile (1,300 km) voyage in the *James Caird,* a 22-foot (7 m) wooden lifeboat, lay between the men and possible salvation.

Despite hurricane storms, huge waves, and excruciating cold, Shackleton and his crew sailed the *James Caird* for 17 days to reach South Georgia. Historians regard the voyage as one of the greatest small boat journeys ever made. Unfortunately, the lifeboat landed on the uninhabited west coast of South Georgia, so Shackleton was forced to trek across the mountains to civilization. Three of the men were too exhausted to continue, but Shackleton, along with crew members Captain Frank Worsley and Tom Crean, marched for 36 hours nonstop to Stromness whaling station. When they arrived on May 20, 1916, they raised the alarm to save the rest of their crew.

On August 30, on his fourth rescue attempt, Shackleton finally succeeded in bringing the *Yelcho,* a tug loaned by the Chilean Navy, through the ice back to Elephant Island. Incredibly, he found all 22 of the remaining men still alive. Although the Imperial Trans-Antarctic Expedition was an epic failure, the incredible heroism and survival following the loss of *Endurance* made Shackleton and his men legends of exploration and adventure.

IN THE WAKE OF A LEGEND

On July 5, 2021, the Falklands Maritime Heritage Trust announced that the Endurance22 expedition would search for Shackleton's *Endurance.* The trust organized and funded the expedition. It was to be the largest, and most complex, nongovernmental expedition ever organized to Antarctica. The expedition would require a modern icebreaker ship, two helicopters, two ice camps, tracked vehicles and Ski-Doos, fuel, and supplies, and it would use the latest satellite communications and data. It would also need highly specialized equipment to search for, survey, and film the wreck, including two purpose-built remotely operated vehicles to explore the seafloor. We planned for not just finding *Endurance,* but also revealing her to the world in stunning detail and showcasing new possibilities in underwater exploration.

The expedition had three objectives: to locate and survey the wreck of *Endurance,* to bring the story of Shackleton to a new generation, and to investigate and study the remote western Weddell Sea ecosystem. To fulfill these ambitious aims, the expedition brought together 65 world-leading experts alongside 45 officers and crew on board the South African icebreaker S.A. *Agulhas II.*

Assembling such a complex expedition required years of careful planning. But on February 5, 2022, the expedition departed from Cape Town, South Africa, for Antarctica. Ahead of us would be an unprecedented 45-day mission to the Weddell Sea, battling heavy sea ice, freezing temperatures, and harsh weather in a quest to be the first to find *Endurance.* It would prove to be the adventure of a lifetime.

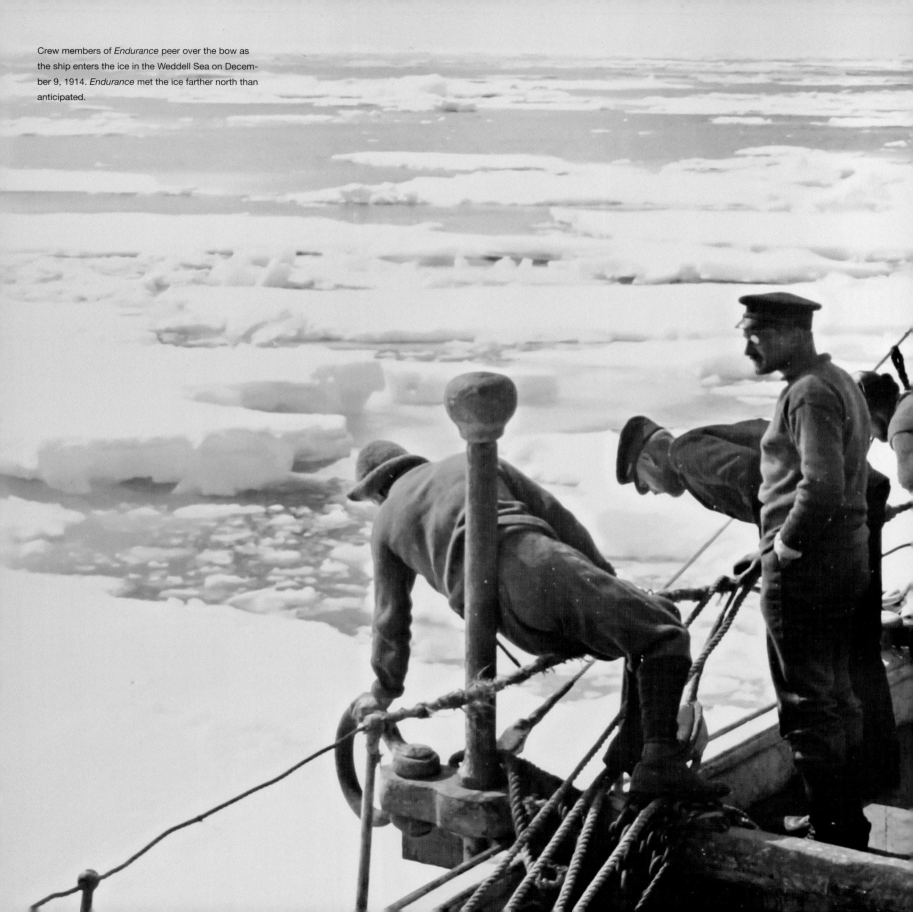

Crew members of *Endurance* peer over the bow as the ship enters the ice in the Weddell Sea on December 9, 1914. *Endurance* met the ice farther north than anticipated.

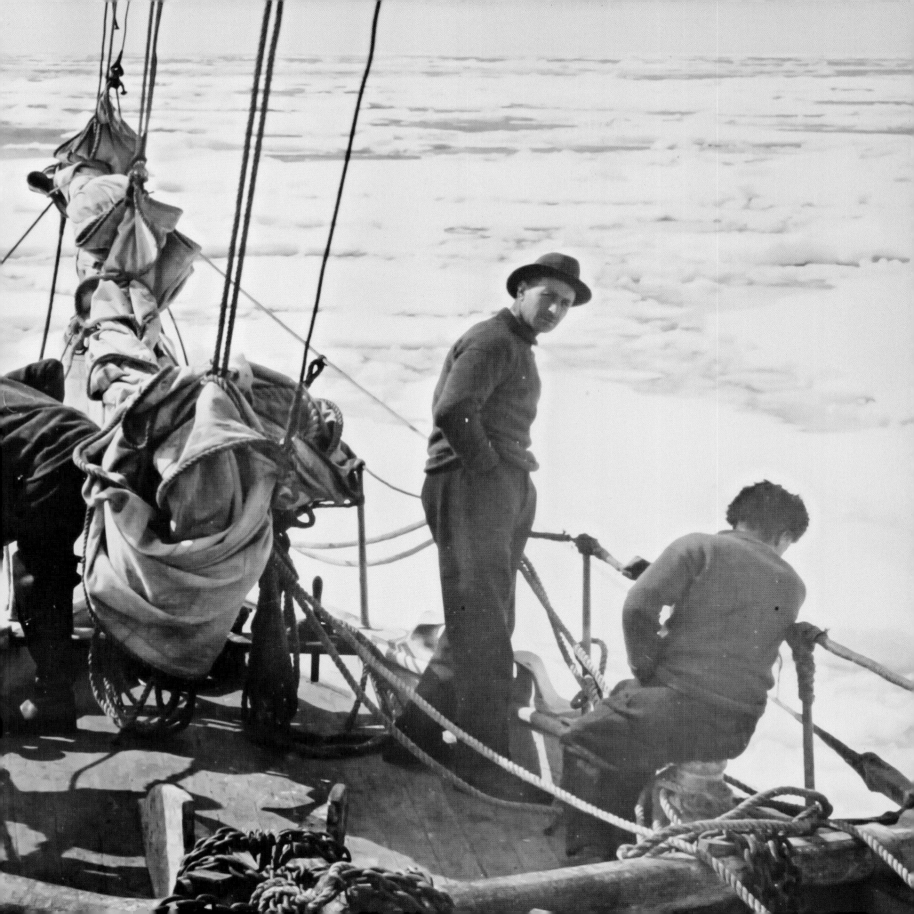

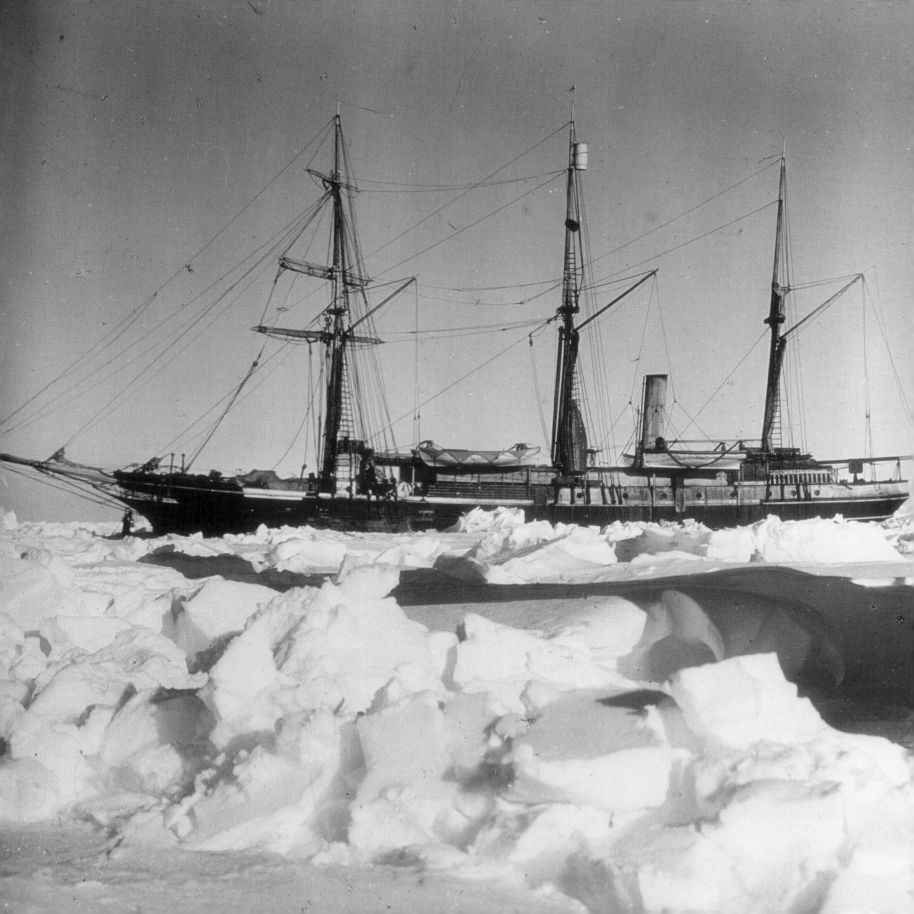

The Vessels

Modern technology has transformed polar expedition ships over the past century. *Endurance* was built to withstand the ice, but its specifications pale beside those of the S.A. *Agulhas II,* used for the Endurance22 expedition. *Endurance* was a three-masted wooden sailing vessel, called a barquentine, launched in 1912. She had a length of 144 feet (44 m), a width of 25 feet (8 m), and a weight of 350 tons (317 t). The S.A. *Agulhas II,* made of steel, has a length of 440 feet (134 m), a width of 71 feet (22 m), and a massive weight of 12,897 tons (11,700 t).

A 350-horsepower steam engine powered *Endurance,* while four diesel-electric generators provided 4,000 horsepower each to the S.A. *Agulhas II.* Perhaps the cost of each vessel is the most eye-catching comparison: Shackleton bought *Endurance* fully fitted out in 1914 for £13,000 (about $2.3 million today), while the S.A. *Agulhas II* cost $127 million to build in 2012.

LEFT: *Endurance* sits frozen in the pack ice, January 1915. Atop the main mast, the white wooden barrel is the crow's nest, the view from which, Shackleton reported in his diary, "gave no promise of improved conditions ahead."

BELOW: Locked into the Weddell Sea pack ice, the S.A. *Agulhas II* deploys its crane to lower the rope basket with a group of scientists onto the ice.

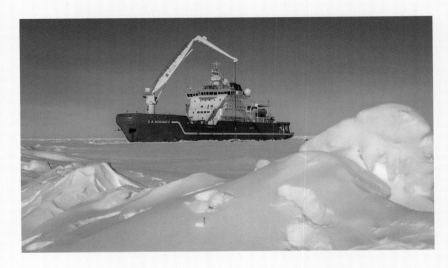

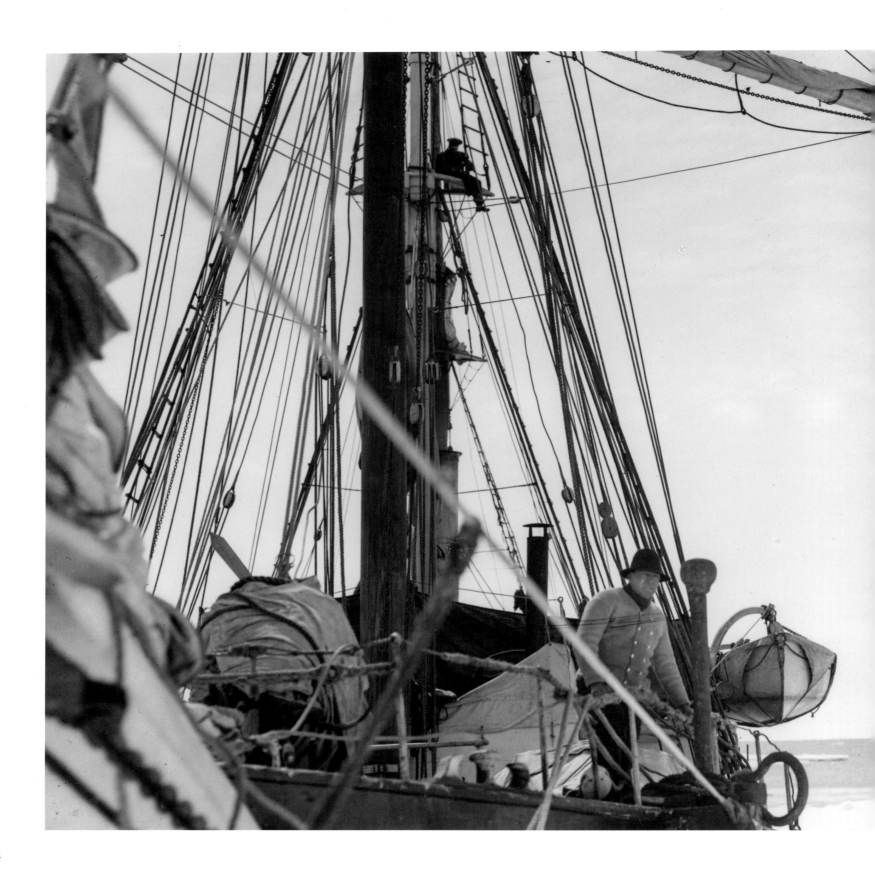

As *Endurance* pushes through loose pack ice, Shackleton examines the way ahead while Hurley films the scene from aloft.

Every night when *Endurance* was trapped in the ice, one crew member would serve as night watchman while the rest slept, patrolling the ship, staying alert for fire on board, and noting changes in the weather and sea ice conditions.

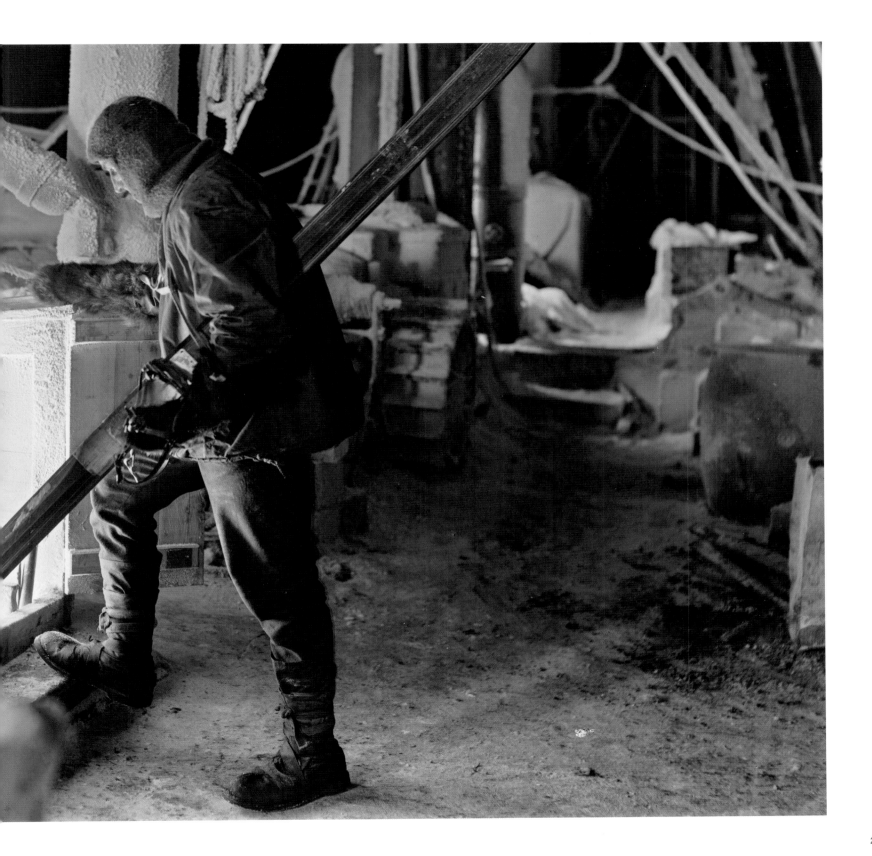

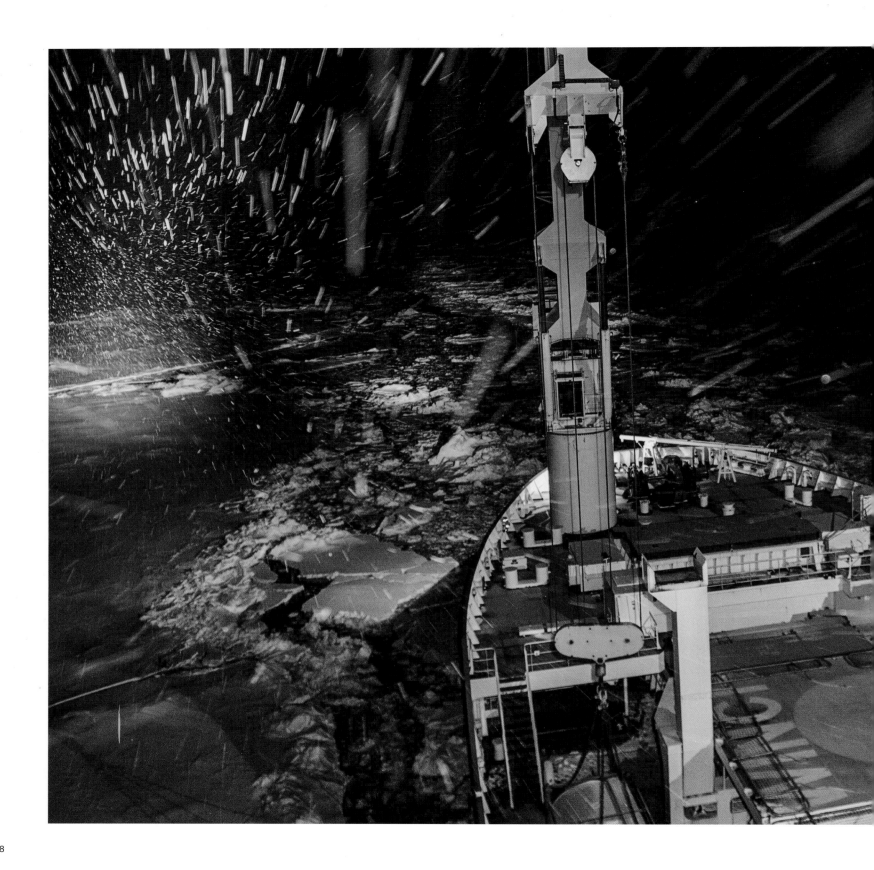

Late at night, amid a ferocious blizzard, the S.A. *Agulhas II*
breaks her way through the pack ice in the Weddell Sea during
the Endurance22 expedition. The ship's crew and the expedition
team worked in shifts 24 hours a day, seven days a week, in their
search for *Endurance*.

A Planet Labs optical satellite captures an image of the S.A. *Agulhas II* locked into an ice floe on February 20, 2022. While the *Endurance* crew used sextants and chronometers to chart their course through these waters, the Endurance22 team navigated with the help of state-of-the-art technology, such as satellite remote sensing and airborne drones.

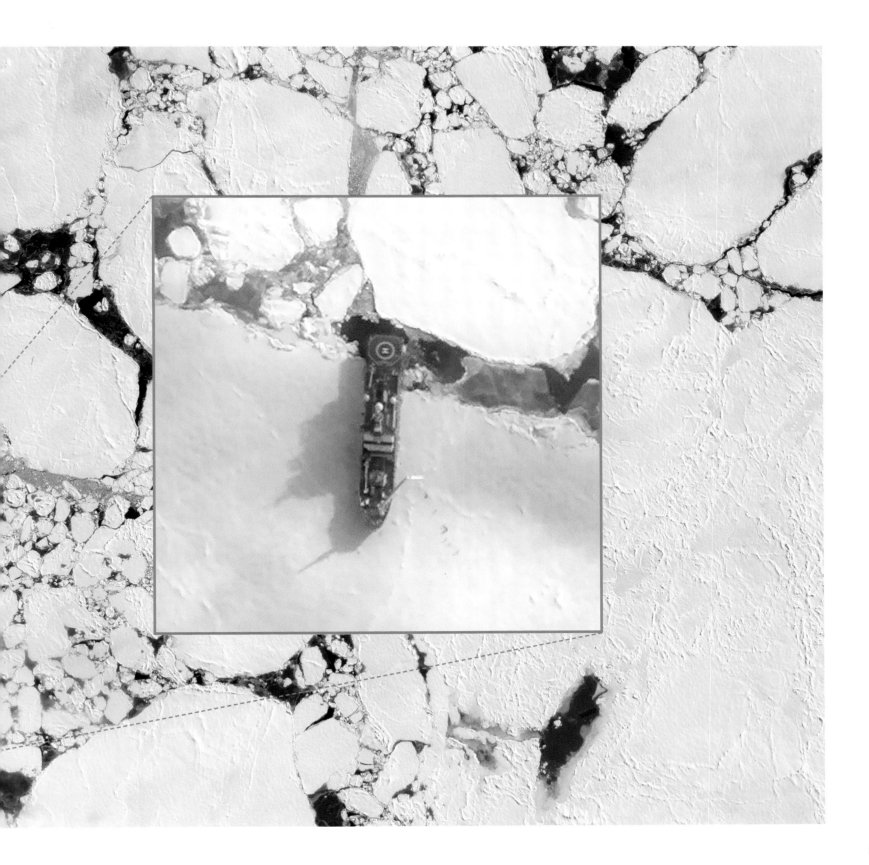

Stewarding Shackleton's Legend

TIM JACOB, EDUCATION AND OUTREACH COORDINATOR, ENDURANCE22

If a ship sank in one of the most remote corners of Earth over 100 years ago, does it still matter? The verdict among historians and researchers has been a resounding "Yes!" But what about the general public, and particularly students? Throughout the Endurance22 expedition, education and outreach partners Reach the World put this question—and the legacy of Sir Ernest Shackleton and *Endurance*—to the test. Over the course of a year-long virtual exchange program, including written articles for students and livestream events featuring expedition team members, Reach the World sought to bring Shackleton's story to life by inviting young people to join Endurance22 from their classrooms around the world. But would this tale of leadership, resilience, and teamwork resonate with a new generation of young people, most of whom had never heard his name?

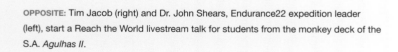

Shackleton's story is riddled with hardship, foiled plans, and failure. He was proof that people do not need to be perfect to accomplish big things. Reach the World aspired to show students that the tenets of Shackleton's enduring legacy—curiosity, resourcefulness, and sheer grit—are not exclusive to him or other explorers of his era, but are abundantly present in today's explorers, including the students themselves. By immersing themselves in Shackleton's story, the students found they had more in common with the great explorer adrift upon the Weddell Sea in 1915 than it may first have seemed. Students had to navigate the unknown, and the unexpected, as they learned about Shackleton doing the same.

If students needed inspiration to learn, Shackleton was the perfect man to give it to them. He largely built his own legend, not only by relentlessly pursuing his dreams, but also by cleverly using photography and film to make dramatic events and remote places real for others. Similarly, Endurance22 brought students aboard with satellite communications, so they could witness the expedition's fortitude, ingenuity, and international cooperation in real time. They explored the Weddell Sea and asked expedition team members their questions, all as the search for *Endurance* unfolded. They entered Shackleton's story just in time for the final chapter and, along the way, found themselves becoming a key part of the narrative.

More than 33,000 students participated in the Endurance22 expedition's virtual exchange. On March 9, 2022—the morning the world learned *Endurance* had been found—hundreds of students joined a historic livestream event, anticipating an important update on the search. When they heard that *Endurance* had been found, each tiny window on the laptop screen erupted with cheers and flailing arms. The internet connection was as choppy as the South Atlantic, but the children's voices came through loud and clear. They were not saying, "You did it!" They were shouting: "*We* did it!"

OPPOSITE: Tim Jacob (right) and Dr. John Shears, Endurance22 expedition leader (left), start a Reach the World livestream talk for students from the monkey deck of the S.A. *Agulhas II*.

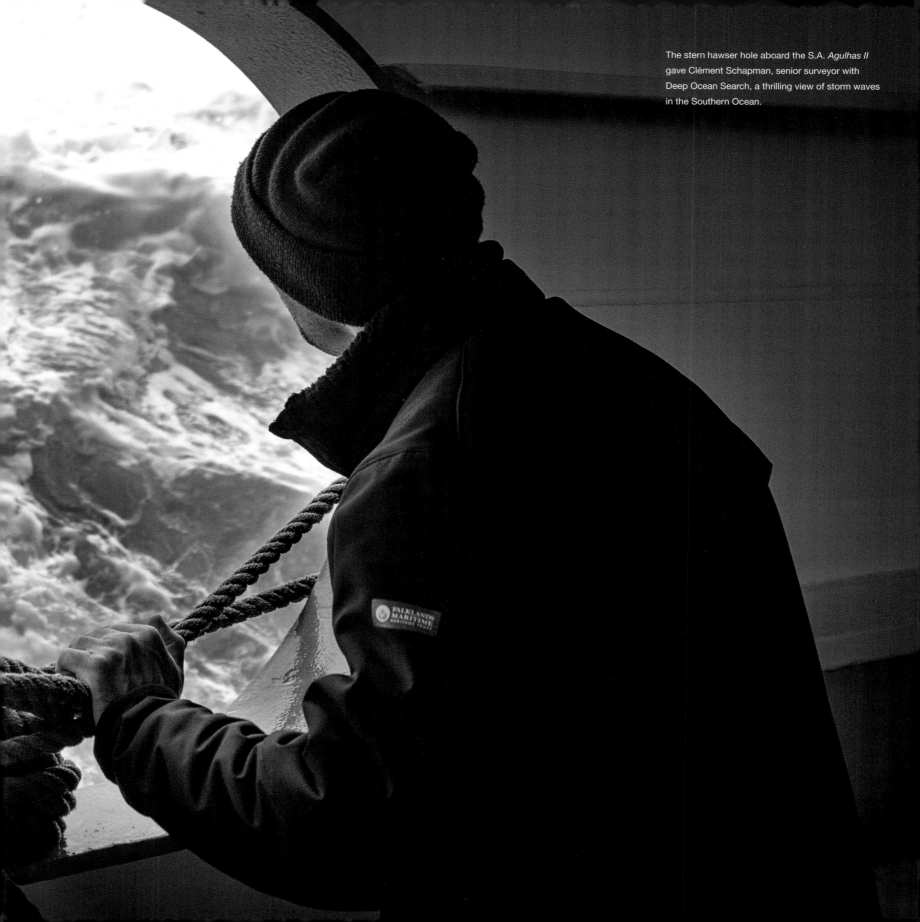

The stern hawser hole aboard the S.A. *Agulhas II* gave Clément Schapman, senior surveyor with Deep Ocean Search, a thrilling view of storm waves in the Southern Ocean.

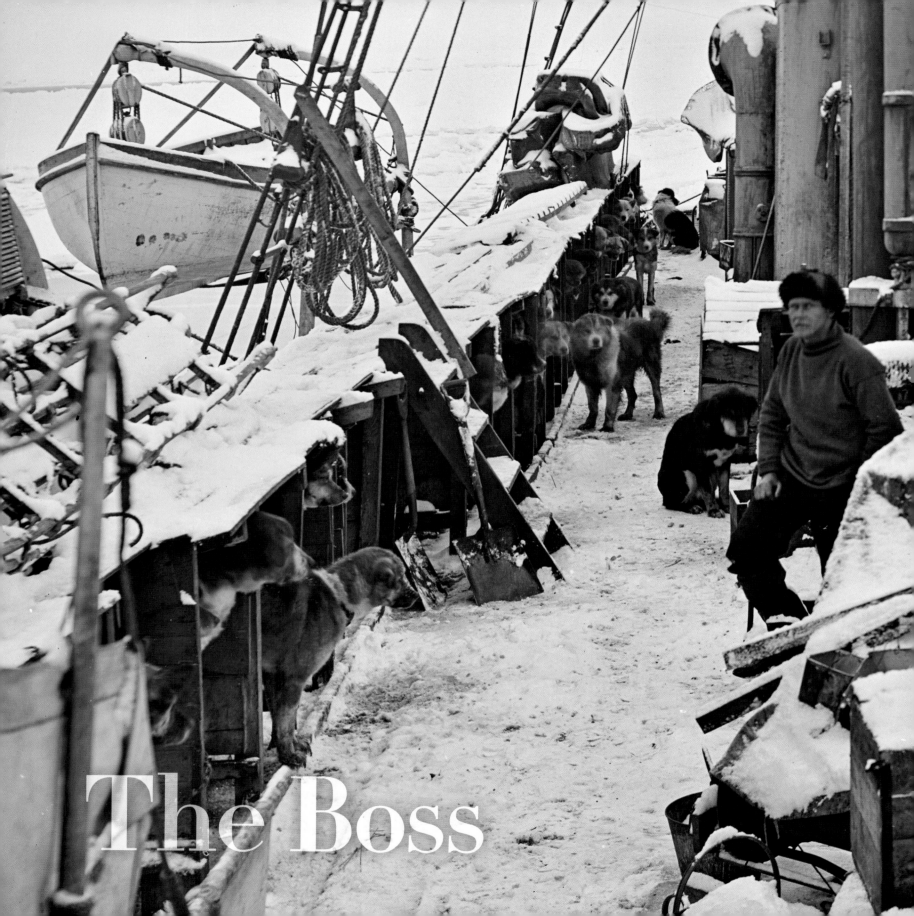

The Boss

"MEN ARE
NOT MADE
FROM
EASY
VICTORIES
BUT
BASED ON
GREAT
DEFEATS."

—Sir Ernest Shackleton

A light snowfall blankets
the deck of *Endurance*.

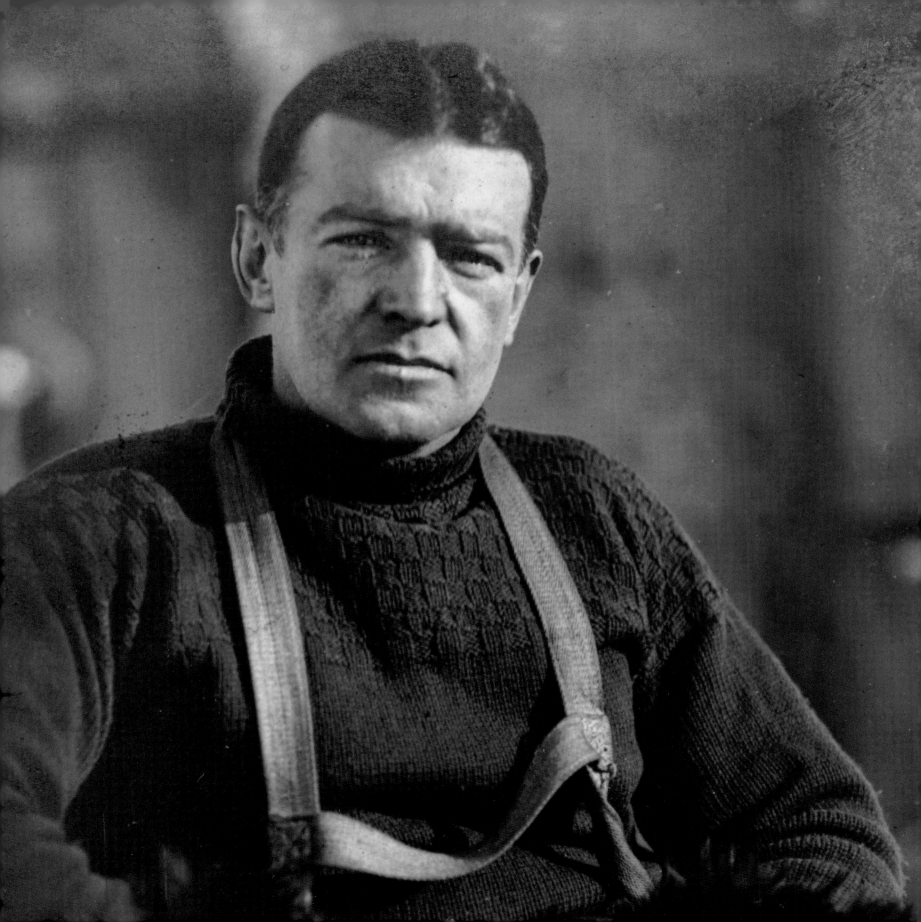

The Boss

JOHN SHEARS

Shackleton was already a famous polar explorer and global celebrity by the time he started preparations for the first crossing of Antarctica, in 1913. He wrote best-selling books about his adventures, and he gave illustrated lectures to audiences of thousands around the world.

Shackleton entered the British Merchant Navy in 1890 at the age of 16. His career as a polar explorer began in 1901, when he was selected by Captain Robert Falcon Scott to go as an officer on the ship R.R.S. *Discovery* as part of the British National Antarctic Expedition, which would carry out research and exploration in the Ross Sea region of Antarctica. As third officer, Shackleton was in charge of the stores, supplies, and seawater chemical analysis, and Scott chose him along with another team member to make an attempt to be the first to reach the South Pole. The three men came within 460 miles (740 km) of the pole, but sickness, scurvy, and starvation forced them back. Shackleton became seriously ill on the return march and had to be carried on a

sledge. Although he survived and recovered, he was invalided home by Scott before the end of the expedition. The two men became rivals to reach the pole first.

In 1907, Shackleton returned to the Antarctic as the leader of his own expedition, the British Antarctic Expedition on the ship *Nimrod*. During the expedition, Shackleton and three of his crew sledged within 97 miles (156 km) of the pole—the farthest south ever reached—before exhaustion, hunger, and a shortage of supplies forced Shackleton to turn back and save his men. Nevertheless, the expedition discovered and surveyed new land in the Ross Sea, and made the first ascent and survey of Mount Erebus on Ross Island. Shackleton returned to Britain a national hero, and he was knighted by King Edward VII in 1909. But he continued to hold ambitions for being first to the South Pole.

Shackleton's hopes were dashed, however, on December 14, 1911, when the Norwegian explorer Roald Amundsen and a team of four others reached the South Pole, closely followed by Captain Scott and another party of four on January 17, 1912. While Amundsen and his team survived the return journey, Scott, along with all his companions, died. With the pole conquered, Shackleton spurred himself on to greater ideas. He developed a "last great journey" to

This portrait of Shackleton was taken by Frank Hurley during the Imperial Trans-Antarctic Expedition. Shackleton was then 40 years old. He sat for the portrait wearing a wool sweater, his mitten harness, and a pair of his fur sledging mitts.

cross Antarctica. He announced the expedition in a letter to the *Times* on December 29, 1913, saying his Imperial Trans-Antarctic Expedition would start in 1914 with "the object of crossing the Antarctic continent from sea to sea."

The journey across Antarctica would stretch roughly 1,800 miles (2,900 km) from coast to coast, starting at Vahsel Bay on the eastern coast of the Weddell Sea, then heading south to the pole before continuing across the continent to finish at McMurdo Sound on Ross Island. Shackleton planned to lead a party of five men on the crossing using 100 dogs with sledges, including two motor sledges with aerial propellers. Meanwhile, six men under the leadership of Lieutenant Aeneas Mackintosh would trek inland from the Ross Sea to lay down supply depots for the transcontinental party. (They would succeed in putting in the depots, but three of the men, the Reverend Arnold Spencer-Smith, Victor Haywood, and Mackintosh himself, died on the ice in the Ross Sea in 1916.)

THE FATED VESSEL

A vital step in Shackleton's preparations was finding a ship capable of taking the Imperial Trans-Antarctic Expedition to Vahsel Bay. He found that ship in Norway. She was called *Polaris*—the North Star.

Shackleton purchased *Polaris* for £13,000 from Lars Christensen, a Norwegian shipowner, on March 25, 1914. She was a brand-new 350-ton (318 t) wooden sailing ship,

originally designed by Christensen and Adrien de Gerlache, the Belgian polar explorer, as a luxury yacht to carry small groups of wealthy tourists to the Arctic for polar bear and walrus hunts. *Polaris* was exceptionally well constructed, strong and rugged, specifically designed for operating in ice-covered seas, and had fittings for scientific instruments. With some modifications, Shackleton reasoned she would make an excellent Antarctic expedition ship.

Polaris was 144 feet long and 25 feet wide (44 m x 7.6 m). She was a barquentine sailing vessel with three masts. Her foremast was square rigged and her mainmast and mizzenmast were fore and aft rigged. Powered by her 10 sails and a 350-horsepower coal-fired steam engine, she could make a top speed of about 10 knots (11.5 mph/18.5 kph). Her bottom, or keel, consisted of four layers of solid oak measuring a total thickness of 7 feet 1 inch (216 cm). Her sides made from oak and Norwegian fir tapered from 30 inches to 18 (76 to 46 cm). She had special protection for breaking through the ice. Her hull was sheathed in greenheart, a tropical hardwood and one of the densest woods in the world, and her frames were double the number and double the thickness of a conventional wooden vessel. Her bow was over four feet (1.2 m) thick and was constructed from oak timbers, each hewn from an individual tree that naturally followed the curve of the ship's design.

Simply put, at the time of her launch, *Polaris* was one of the strongest wooden ships ever built. But Shackleton

bought her for a bargain. The final sale price was less than the cost of building her.

After the sale, Shackleton renamed the ship *Endurance,* in honor of his family motto, *"Fortitudine Vincimus*—By Endurance We Conquer." The ship was delivered from Sandefjord to London, where she moored in the West India Dock on the River Thames, on June 10, 1914. Here she was refitted, prepared, and made ready for her maiden voyage to Antarctica.

PREPARATIONS

More than 5,000 people applied to join Shackleton's expedition. One letter of application came from "three sporty girls" who argued "we do not see why men should have all the glory, and women none, especially when there are women just as brave and capable as there are men." Shackleton's reply was short and terse: "No vacancies for the opposite sex on the expedition."

Shackleton's top priority was to find an experienced captain for *Endurance.* Although Shackleton would have the overall leadership of the expedition and lead the crossing party, he needed a captain to command the ship when he left it in Antarctica. His original choice was John King Davis, who had commanded *Nimrod* on the British Antarctic Expedition. However, Davis thought the expedition was doomed to failure and declined. Shackleton chose instead the New Zealander Lieutenant Frank Worsley, an experi-

enced merchant navy officer with exceptional navigational skills. Worsley's expertise would play a vital role in the survival of Shackleton and his men. It was Worsley's highly accurate position of *Endurance*'s sinking location on November 21, 1915, that became the starting point for our search for the wreck.

Shackleton chose several of the crew because of their experience with him on the *Nimrod* and *Discovery* expeditions. He appointed Frank Wild as his deputy and Tom Crean as the second officer. Others he appointed after short interviews, sometimes lasting only a few minutes. Shackleton was a shrewd judge of character. He selected an excellent team of 27, ranging from tough British sailors to bright young scientists from the University of Cambridge.

With the crew assembled, *Endurance* left London on August 1, 1914, just before the outbreak of the First World War. Shackleton had offered the ship's services to the Royal Navy, but Britain's First Sea Lord at the time, Winston Churchill, replied with a one-word telegram saying PROCEED. Within weeks of Shackleton's departure, thousands of men would be dead in the trenches on the western front in Europe.

Endurance sailed under Worsley's command from England bound for Buenos Aires, Argentina. On October 9, Shackleton, Frank Wild, and Frank Hurley, the expedition's Australian photographer, met the ship at harbor. The last members of the expedition to arrive on board were the

FOR EIGHT LONG MONTHS THROUGH THE DARK, FREEZING ANTARCTIC WINTER, THE SHIP DRIFTED NORTH IN THE PACK, WHERE IT WAS BATTERED, SQUEEZED, AND CRUSHED BY THE IMMENSE PRESSURE OF MILLIONS OF TONS OF PACK ICE.

Canadian sledge dogs—the *Endurance* crew had built them kennels on the main deck.

On October 26, 1914, *Endurance* left Buenos Aires, freshly painted and flags flying as it sailed down the River Plate. She carried Shackleton and 27 men, as well as 69 dogs and a cat named Mrs. Chippy. Next stop was South Georgia, a remote island in the South Atlantic.

TRAPPED

Endurance arrived at Grytviken, the largest whaling station on South Georgia, on November 5 to refresh supplies and learn about the state of the floating sea ice—the pack ice— in the Weddell Sea. The news wasn't good. The whalers told Shackleton that the ice conditions were severe enough to trap *Endurance* before it even reached the Weddell Sea. They advised him to wait and allow the ice to melt back before continuing south. *Endurance* spent a month at South Georgia, taking on extra stores, winter clothing, and coal, before departing on December 5. Shackleton could not wait any longer to sail into the Weddell Sea before the onset of the Antarctic winter. The ship carried such a load that the coal was piled high on the decks. The crew hung whale meat in the rigging—food stores for the dogs.

The whalers' warnings proved correct, and *Endurance* encountered the ice just three days later. Her progress slowed, and she was often stopped, but she gradually worked her way toward the expedition landing site at

Vahsel Bay. Often, Frank Worsley would climb into the ship's crow's nest and use his binoculars to check the ice conditions. He would be on the lookout for "iceblink," a white glare on the underside of the clouds caused by the reflection of light from the ice. It told Worsley there was concentrated pack ice ahead.

However, despite Worsley's careful navigation, the ice closed around *Endurance* on January 18, 1915, with Vahsel Bay just over 80 miles (128 km) away. She became beset, frozen into the pack ice and drifting out of sight of the Antarctic mainland.

After several failed attempts to break *Endurance* free by digging, sawing, pickaxing, and ramming the ice, Shackleton finally admitted they were trapped. On February 24, he formally turned the ship into a "wintering station," with the crew ending their ship routine and the dogs moving off the ship into "dogloos" made from large blocks of ice and snow.

For eight long months through the dark, freezing Antarctic winter, the ship drifted north in the pack, where it was battered, squeezed, and crushed by the immense pressure of millions of tons of pack ice.

The end began on October 24, when a huge pressure wave of ice hit the ship and pinned her against three massive floes. The hull twisted and bent like a tree in a hurricane. The ice smashed across her stern and almost tore the sternpost, the upright support for the rudder, clean from the hull. Water began to pour in. Shackleton ordered Henry McNish, the ship's carpenter, to build a cofferdam to try to stop the leak while the crew worked the pumps day and night in the engine room, but it was a hopeless task. The ship could not be saved.

On October 27, Shackleton gave the order to abandon ship. He wrote in his diary: "At 5 pm I ordered all hands on to the ice. The twisting, grinding floes were working their will at last on the ship. It was a sickening sensation to feel the decks breaking up under one's feet, the great beams bending and then snapping with a noise like heavy gun-fire." Shackleton was the last to leave the ship. He hoisted the ship's British flag, a blue ensign, so she would "go down with colours flying," and the men gave three cheers in farewell.

THE END OF *ENDURANCE*

At first, Shackleton decided that he and his crew would trek 346 miles (557 km) across the ice to Paulet Island, on the east of the Antarctic Peninsula, where he knew there was a hut and supply of stores. Preparations were grim. The crew had to kill the weakest of their animals (including Mrs. Chippy, the cat), and the men were only allowed to take two pounds (0.9 kg) of personal belongings with them. They chose precious possessions like spoons, knives, and toothbrushes. Shackleton allowed Leonard Hussey, the meteorologist, to keep his banjo because it would give the crew "vital mental tonic." They began marching on October 30.

But on November 1, Shackleton abandoned their efforts. The crew was exhausted and demoralized, and the immense difficulty of dragging the sledges and lifeboats across the ice made progress slow. They set up a new camp, Ocean Camp, on a large ice floe, fewer than two miles (3.2 km) from the wreck of *Endurance*.

Over the coming days, the men made frequent trips back to the abandoned ship—caught, crushed, and splintered in the ice, but still just afloat—to salvage anything that might help them to survive. Shackleton ordered her masts to be taken down so they didn't fall and injure the salvage parties, and the men used an improvised steel chisel to drill three holes in the deck and rescue vital stores and rations. A salvage party led by Wild removed the ship's wheelhouse to use as a kitchen galley and store at Ocean Camp. A wonderful find came on November 2, when Hurley saved his photographic glass plates and cinematograph film from the ship. The plates were by then under four feet (1.2 m) of water, but Hurley had the foresight to store them in soldered waterproof tins. He dived through the wreckage to haul them out. Hurley returned to Ocean Camp with 400 plates, though ultimately Shackleton only allowed him to keep 150 to save weight on the journey home. Hurley smashed the plates he left behind. Amazingly, the plates he kept survived, and most are now archived at the Royal Geographical Society in London and the Scott Polar Research Institute in Cambridge.

The last time anyone saw *Endurance* afloat was November 21, 1915, when Hurley led a last salvage party back to the ship. She was a sorry and desperate sight. Her masts lay down across the deck, rigging was strewn about, and her bow was under several feet of ice. Only her funnel was still upright. At five o'clock in the evening at Ocean Camp, Shackleton saw *Endurance* begin to sink, her funnel falling behind an ice ridge and her stern rising into the air. The crew dashed onto the camp's lookout platform to watch the ship disappear. After it slipped below, they watched in silence as the pool of water in the ice closed up until there was nothing but a featureless expanse of white. Using a sextant and chronometer, Worsley calculated the position where the ship had vanished and wrote the coordinates in his diary and the ship's logbook: 68° 39' 30" S, 52° 26' 30" W. This was the only record of *Endurance*'s lonely resting place.

Over the next 10 months, Shackleton and his 27 men underwent an astonishing feat of survival. They all lived through the ordeal, despite starvation, serious injury, hypothermia, and frostbite. Though Shackleton lost *Endurance,* he persevered. His incredible grit, determination, and inspirational leadership saved his men.

Now over 100 years later, we sought *Endurance* to write the final chapter to one of the most famous shipwreck stories in human history. It would be the ultimate shipwreck search, requiring a united effort and the overcoming of immense challenges. Together, we hoped to show that the spirit of Shackleton endures.

The routes of *Endurance* on the Imperial Trans-Antarctic Expedition and Shackleton's rescue attempts to save his 22 crew members stranded at Elephant Island crisscrossed the Southern Ocean. Shackleton rescued his men on August 30, 1916—his fourth attempt.

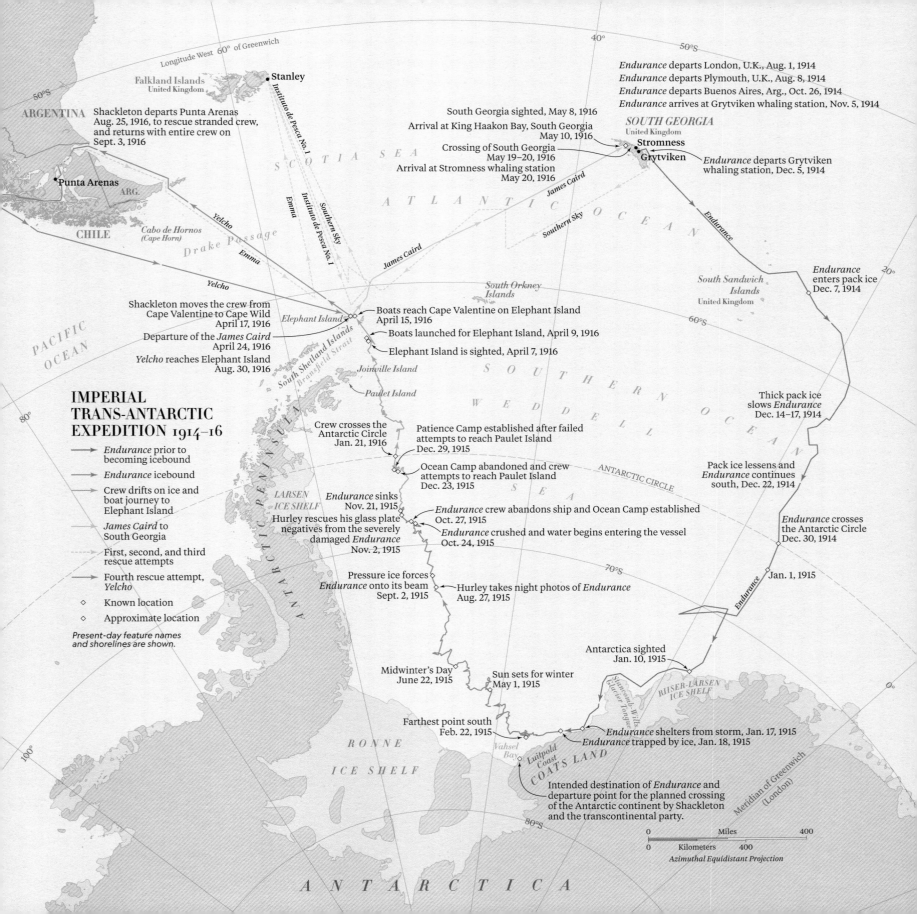

IMPERIAL
TRANS-ANTARCTIC
EXPEDITION 1914–16

→ *Endurance* prior to becoming icebound

→ *Endurance* icebound

→ Crew drifts on ice and boat journey to Elephant Island

→ *James Caird* to South Georgia

--- First, second, and third rescue attempts

→ Fourth rescue attempt, *Yelcho*

◇ Known location

◇ Approximate location

Present-day feature names and shorelines are shown.

ARGENTINA

Falkland Islands
United Kingdom

● Stanley

Longitude West 60° of Greenwich

Punta Arenas

CHILE
ARG.

Cabo de Hornos (Cape Horn)

Drake Passage

Yelcho

Emma

Yelcho

Instituto de Pesca No. 1

Emma

Southern Sky

Instituto de Pesca No. 1

James Caird

SCOTIA SEA

ATLANTIC OCEAN

Southern Sky

James Caird

Shackleton departs Punta Arenas Aug. 25, 1916, to rescue stranded crew, and returns with entire crew on Sept. 3, 1916

South Georgia sighted, May 8, 1916

Arrival at King Haakon Bay, South Georgia May 10, 1916

Crossing of South Georgia May 19–20, 1916

Arrival at Stromness whaling station May 20, 1916

Endurance departs London, U.K., Aug. 1, 1914
Endurance departs Plymouth, U.K., Aug. 8, 1914
Endurance departs Buenos Aires, Arg., Oct. 26, 1914
Endurance arrives at Grytviken whaling station, Nov. 5, 1914

SOUTH GEORGIA
United Kingdom

◇ **Stromness**
● **Grytviken**

Endurance departs Grytviken whaling station, Dec. 5, 1914

South Sandwich Islands
United Kingdom

Endurance

Endurance enters pack ice Dec. 7, 1914

Shackleton moves the crew from Cape Valentine to Cape Wild April 17, 1916

Departure of the *James Caird* April 24, 1916

Yelcho reaches Elephant Island Aug. 30, 1916

Elephant Island

South Orkney Islands

Boats reach Cape Valentine on Elephant Island April 15, 1916

Boats launched for Elephant Island, April 9, 1916

Elephant Island is sighted, April 7, 1916

South Shetland Islands

Bransfield Strait

Joinville Island

Paulet Island

SOUTHERN WEDDELL

Thick pack ice slows *Endurance* Dec. 14–17, 1914

PACIFIC OCEAN

Crew crosses the Antarctic Circle Jan. 21, 1916

Patience Camp established after failed attempts to reach Paulet Island Dec. 29, 1915

Ocean Camp abandoned and crew attempts to reach Paulet Island Dec. 23, 1915

ANTARCTIC CIRCLE

Pack ice lessens and *Endurance* continues south, Dec. 22, 1914

LARSEN ICE SHELF

Endurance sinks Nov. 21, 1915

Hurley rescues his glass plate negatives from the severely damaged *Endurance* Nov. 2, 1915

Endurance crew abandons ship and Ocean Camp established Oct. 27, 1915

Endurance crushed and water begins entering the vessel Oct. 24, 1915

SEA

Endurance crosses the Antarctic Circle Dec. 30, 1914

Endurance

Jan. 1, 1915

ANTARCTIC PENINSULA

Pressure ice forces *Endurance* onto its beam Sept. 2, 1915

Hurley takes night photos of *Endurance* Aug. 27, 1915

70°S

Antarctica sighted Jan. 10, 1915

Midwinter's Day June 22, 1915

Sun sets for winter May 1, 1915

RIISER-LARSEN ICE SHELF

Stancomb Wills Glacier Tongue

Farthest point south Feb. 22, 1915

Vahsel Bay

Luitpold Coast

COATS LAND

Endurance shelters from storm, Jan. 17, 1915

Endurance trapped by ice, Jan. 18, 1915

RONNE

ICE SHELF

Intended destination of *Endurance* and departure point for the planned crossing of the Antarctic continent by Shackleton and the transcontinental party.

Meridian of Greenwich (London)

0	Miles	400
0	Kilometers	400

Azimuthal Equidistant Projection

A N T A R C T I C A

Shackleton, age 27, at the wheel of the R.R.S. *Discovery* in 1901. *Discovery* was the expedition ship of the British National Antarctic Expedition (1901–04), led by Captain Robert Falcon Scott—and Shackleton's first mission to Antarctica.

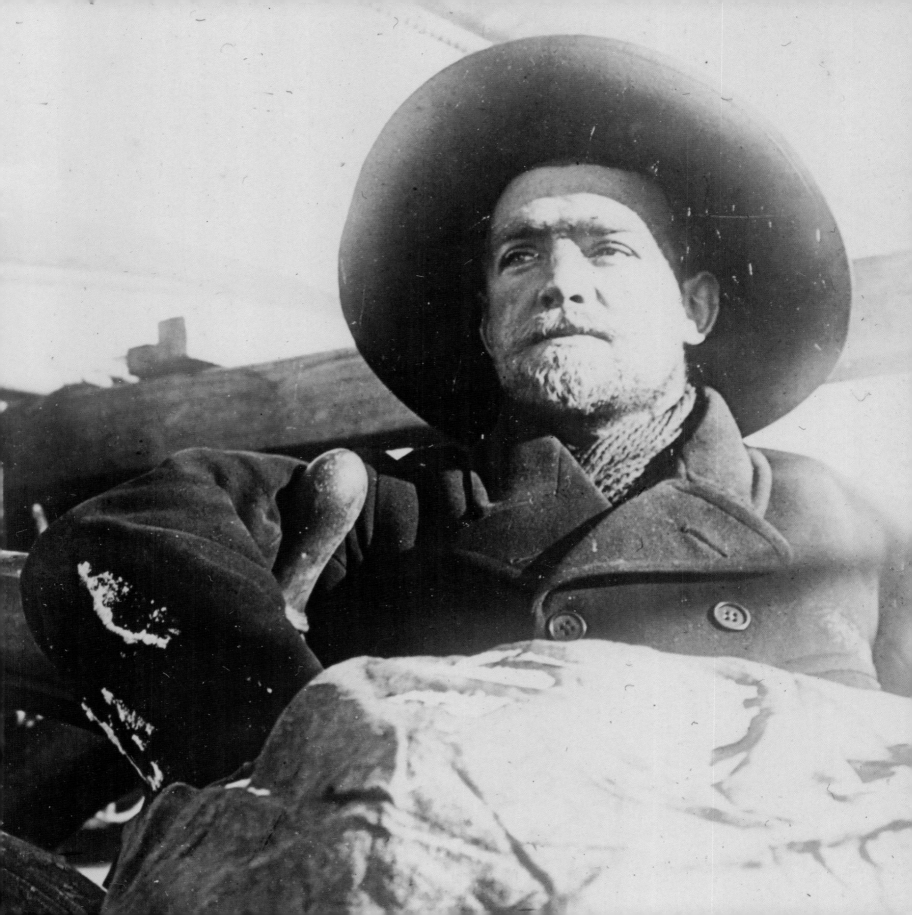

On the British Antarctic Expedition (1907–09) aboard the ship *Nimrod,* Shackleton made an unsuccessful attempt with three others to reach the South Pole. When Shackleton took this photograph on Christmas Day, 1908, they were still 287 miles (461 km) from the pole. The four men celebrated the day with crème de menthe and cigars in their tent.

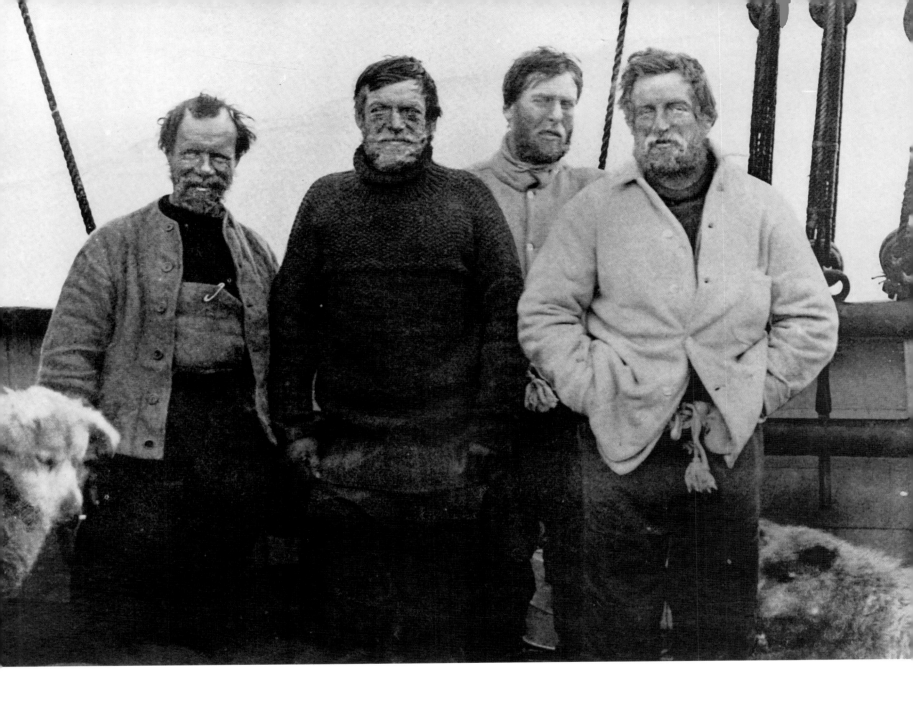

The four members of the British Antarctic Expedition's southern party, on board *Nimrod* after their failed attempt to reach the South Pole. From left to right: Frank Wild, Ernest Shackleton, Eric Marshall, and Jameson Adams.

Endurance arrives in London in May 1914, following her delivery voyage from Sandefjord, Norway.

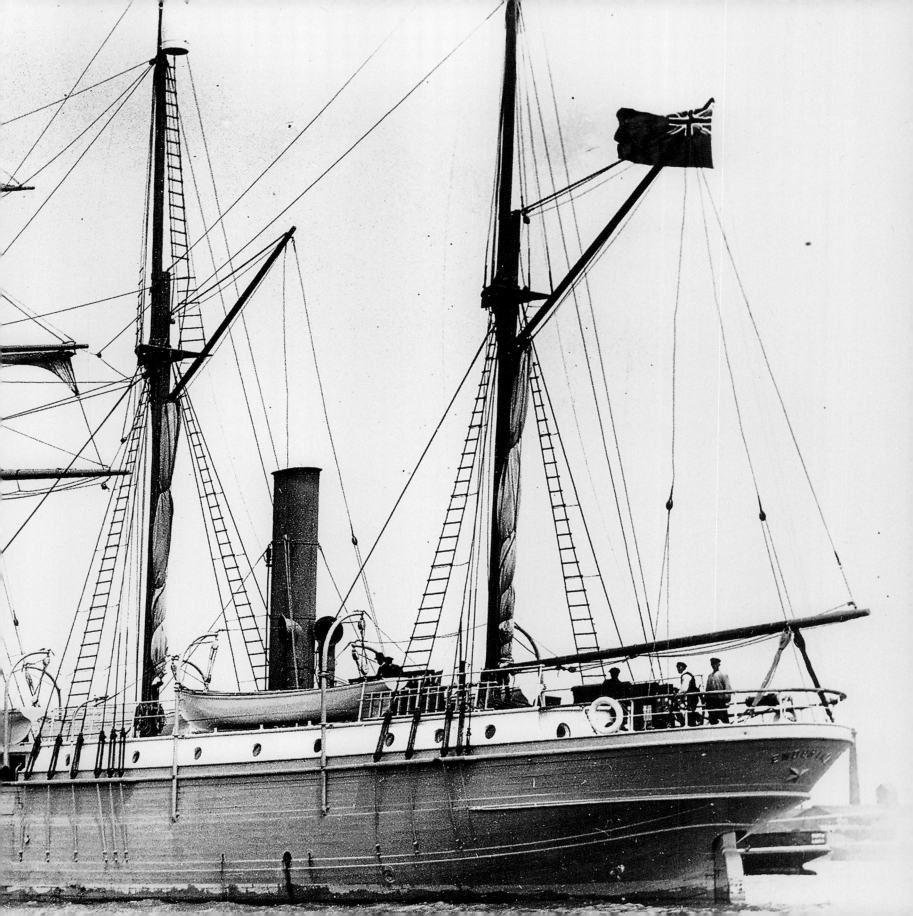

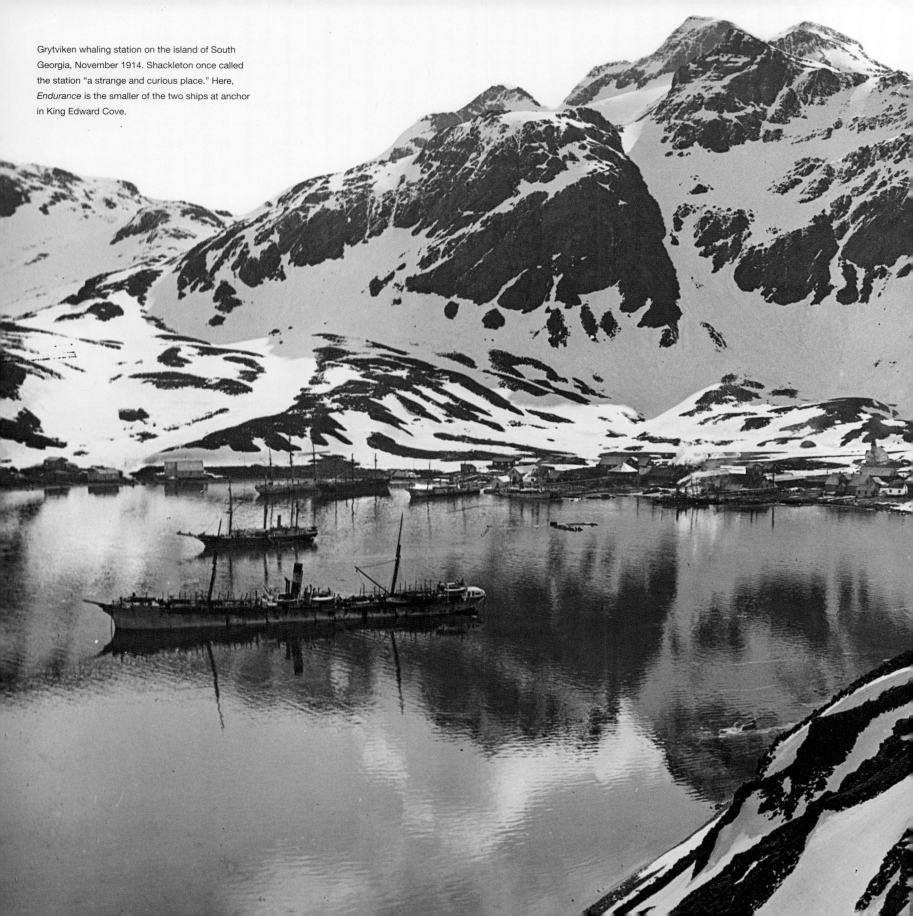

Grytviken whaling station on the island of South Georgia, November 1914. Shackleton once called the station "a strange and curious place." Here, *Endurance* is the smaller of the two ships at anchor in King Edward Cove.

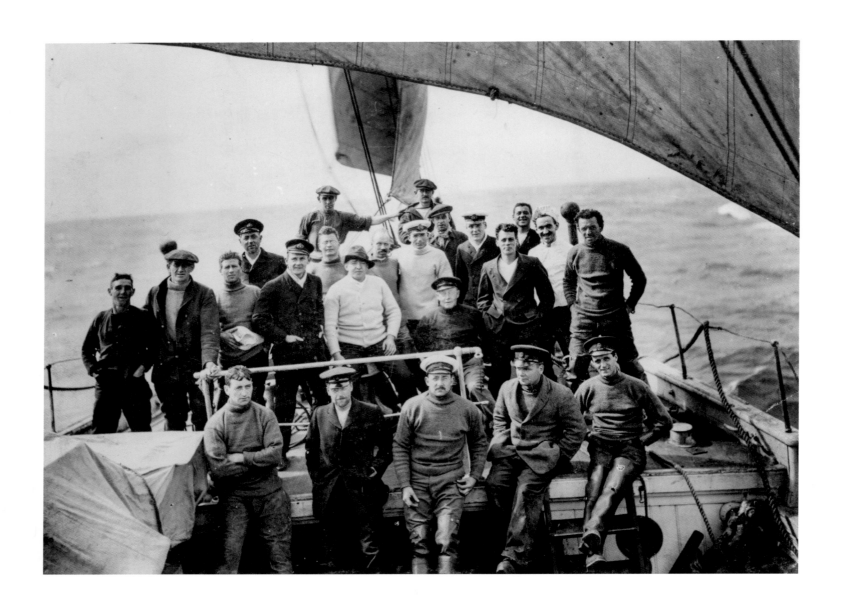

ABOVE: *Endurance* crew members gather on the main deck as they depart Buenos Aires en route to South Georgia and beyond. Shackleton stands in the middle, wearing a dark hat and white sweater. To the right is Frank Wild, the expedition's deputy leader, and, in his captain's hat and white seaman's sweater, Frank Worsley.

OPPOSITE: Frank Worsley, the captain of *Endurance,* served in the Royal Navy Reserve before joining the Imperial Trans-Antarctic Expedition. He also served as captain on *Quest* for Shackleton's final expedition in 1922.

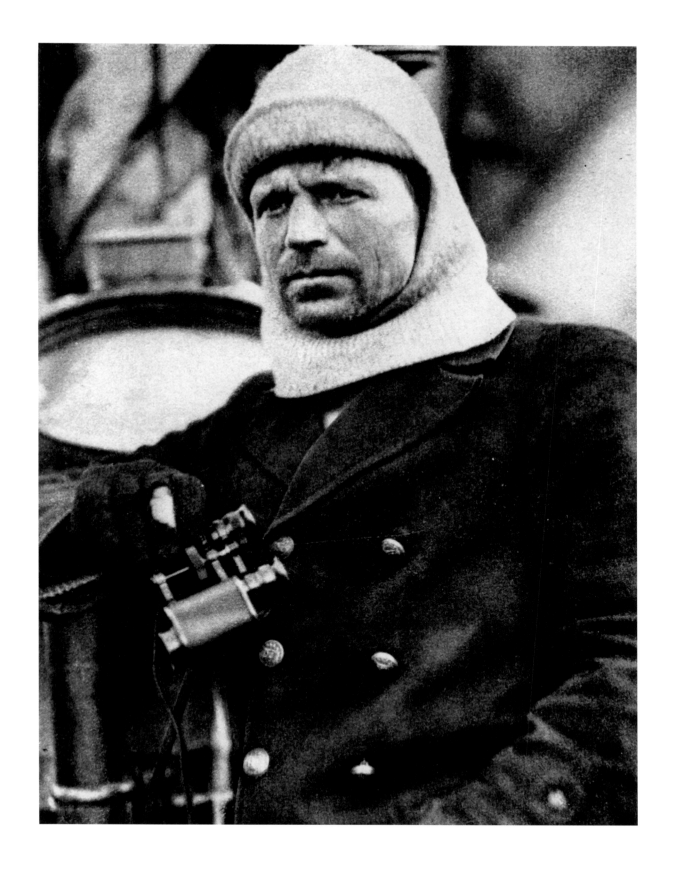

Shackleton's crew used long poles to break the ice around *Endurance*'s hull and push it away from the ship. When this didn't work, Shackleton would sometimes order the men to "sally" the ship: that is, to run back and forth across the deck to rock *Endurance* and break her loose from the ice, according to Shackleton "a ludicrous affair, the men falling over one another amid shouts of laughter."

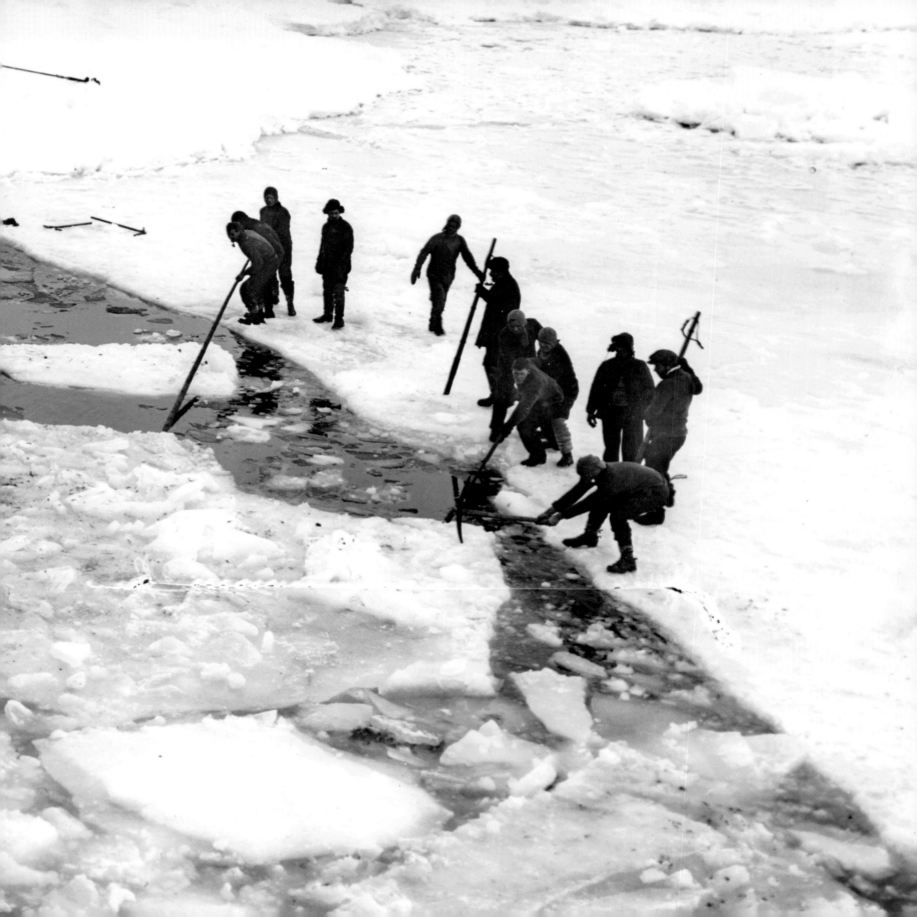

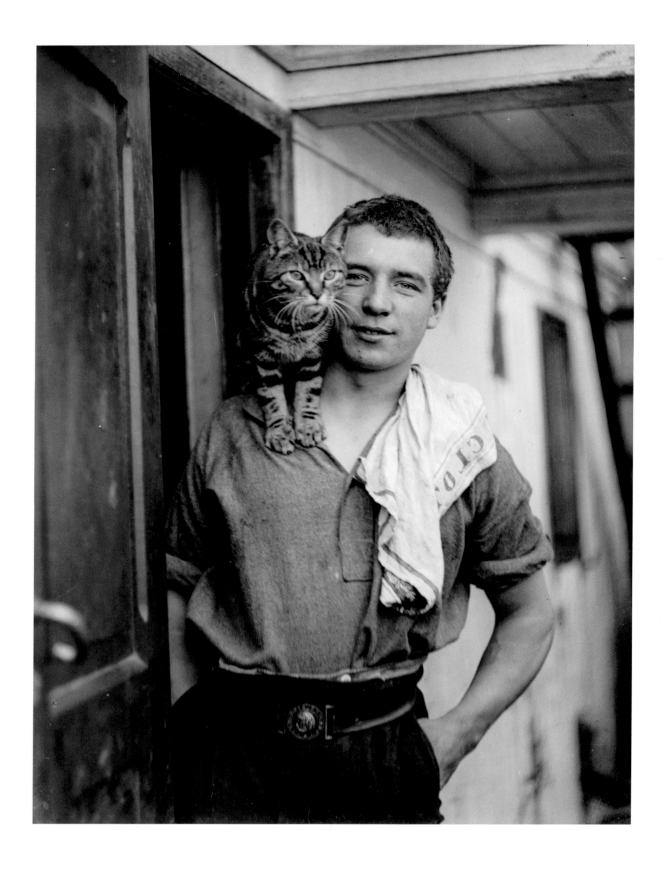

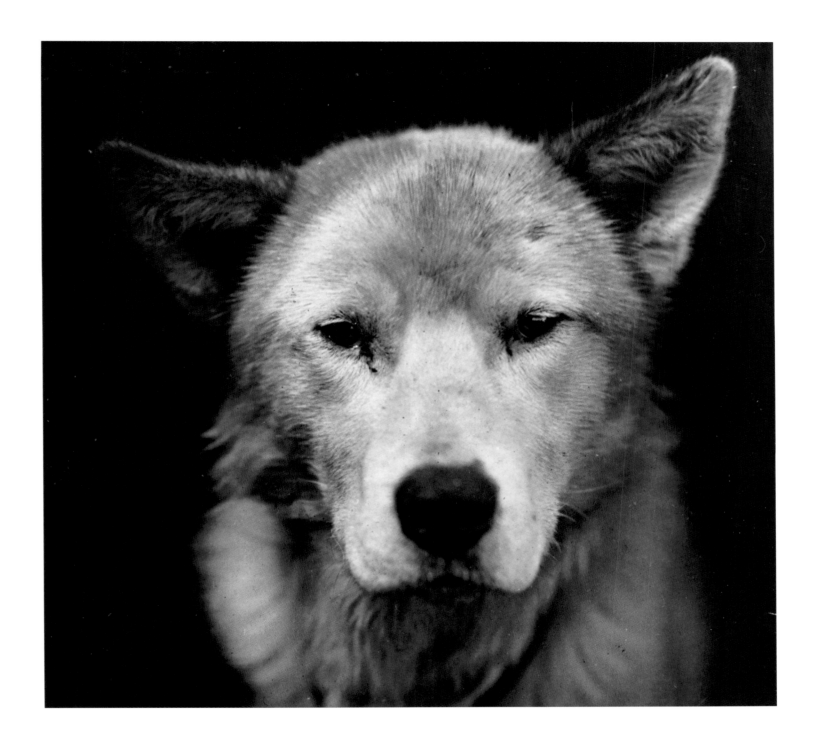

ABOVE: Lupoid, named for his wolflike appearance, served as one of the sledge dogs aboard *Endurance*.

OPPOSITE: Mrs. Chippy, *Endurance*'s resident cat, was in fact male, and he was owned by Henry "Chippy" McNish, the ship's carpenter. Here, Mrs. Chippy poses with crew member Perce Blackborow, a stowaway made ship's steward after Shackleton discovered him hiding aboard.

On October 18, 1915, *Endurance* was forced out of the ice by heavy pressure and heeled over 30 degrees to port. As Shackleton recorded in his diary: "Everything movable on deck and below fell to the lee side, and for a few minutes it looked as if the *Endurance* would be thrown upon her beam ends." Photographer Frank Hurley took to the ice to capture an image of the ship in its precarious state.

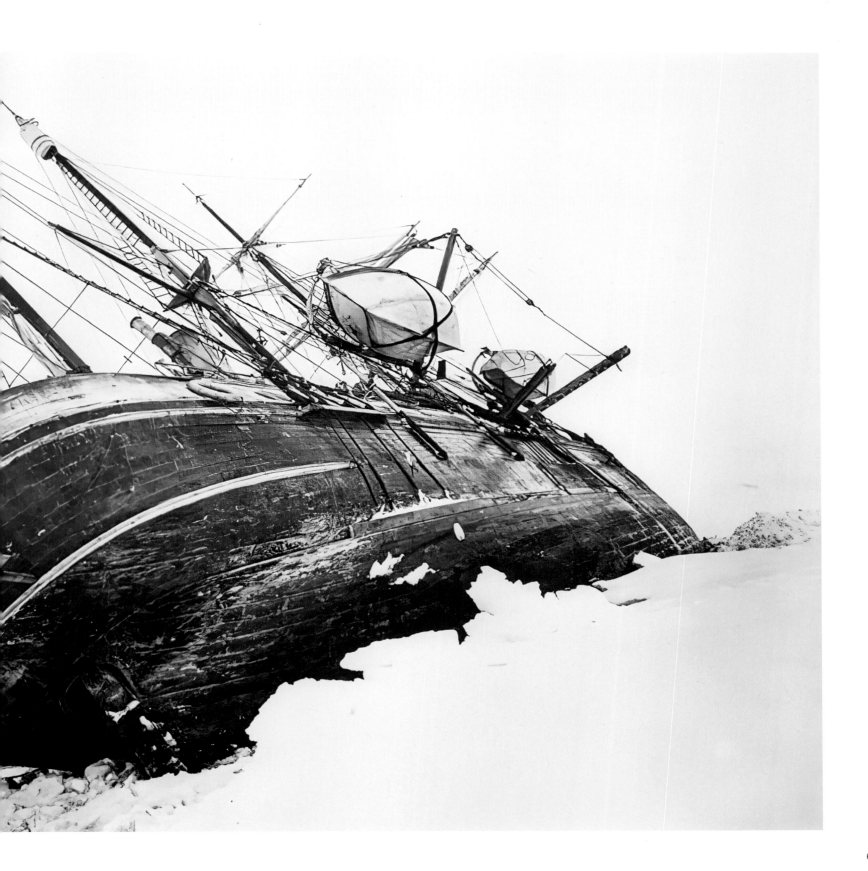

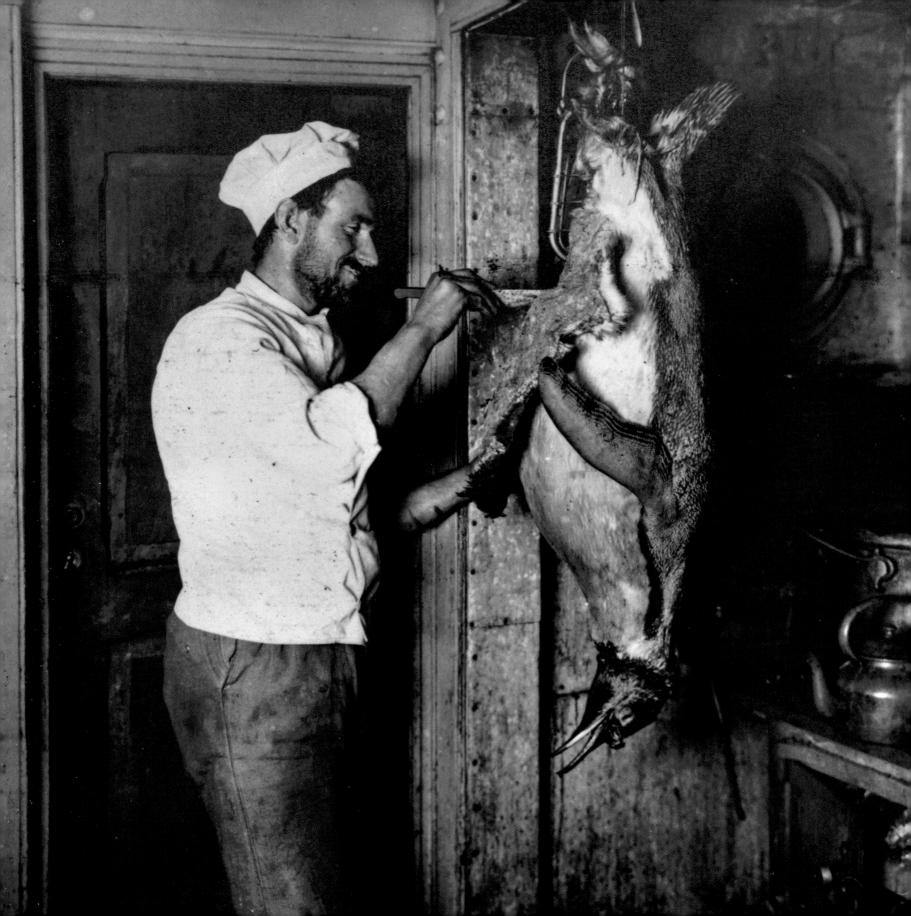

The Cooks and Galleys

Before the Imperial Trans-Atlantic Expedition was forced to abandon *Endurance,* Shackleton's crew dined on hearty meals prepared by Charles Green, the British cook on board the ship. The son of a master baker, Green was a cook in the merchant navy before he joined *Endurance* as a replacement in Buenos Aires. He was a hard worker, well-liked, and his canny improvisations were essential to the crew's survival after *Endurance* sank. He used seal blubber to heat a handmade stove and cook seal stew and penguin steaks at the crew's various ice camps.

In contrast, the Endurance22 crew enjoyed excellent cooked meals three times a day, often with a South African flavor, on board the S.A. *Agulhas II.* Among the galley team's specialties were bobotie—spiced minced meat baked with a creamy egg-based topping—and freshly baked rusks, a type of biscuit, with hot rooibos tea for a delicious afternoon snack.

LEFT: *Endurance* cook Charles Green skins an emperor penguin in the galley.

BELOW: Endurance22 chef Curt Daniels and catering assistant Nosisa Blayi in the galley on board the S.A. *Agulhas II* prepare a birthday cake for Wayne Auton, the expedition's paramedic, who shares a birthday with Shackleton himself—February 15.

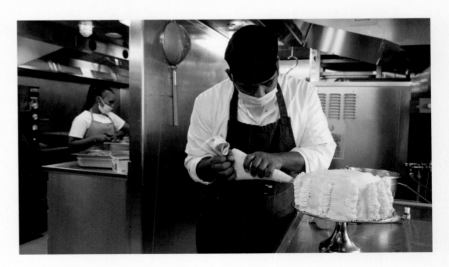

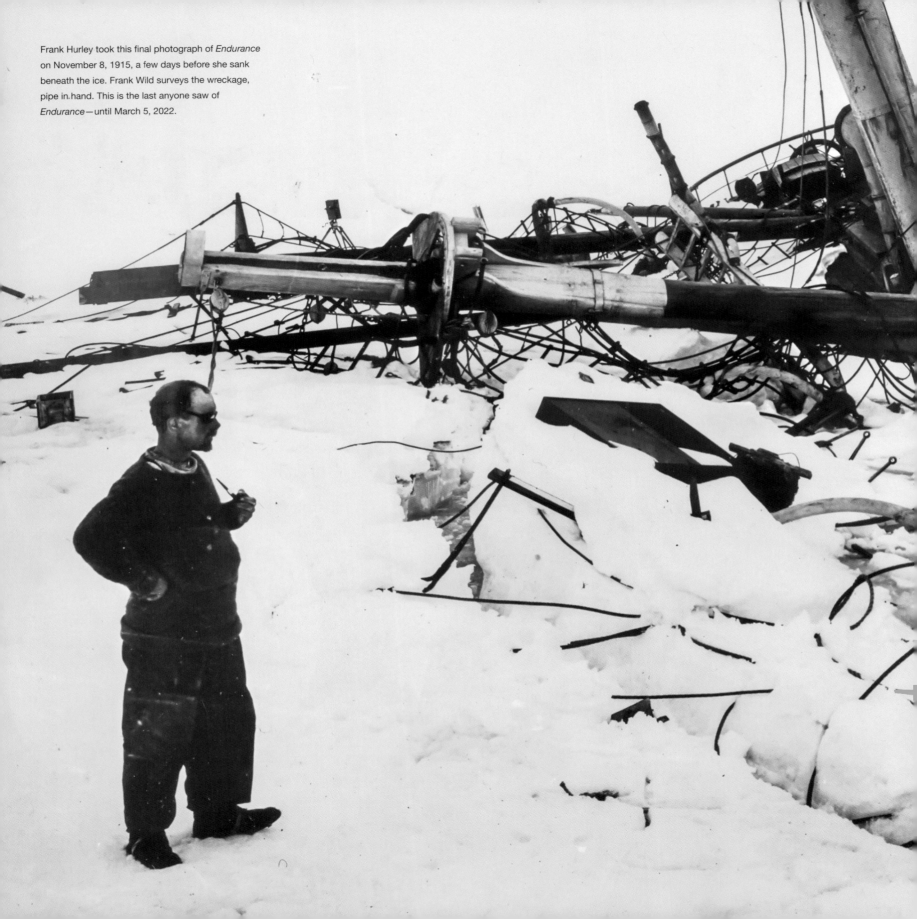

Frank Hurley took this final photograph of *Endurance* on November 8, 1915, a few days before she sank beneath the ice. Frank Wild surveys the wreckage, pipe in hand. This is the last anyone saw of *Endurance*—until March 5, 2022.

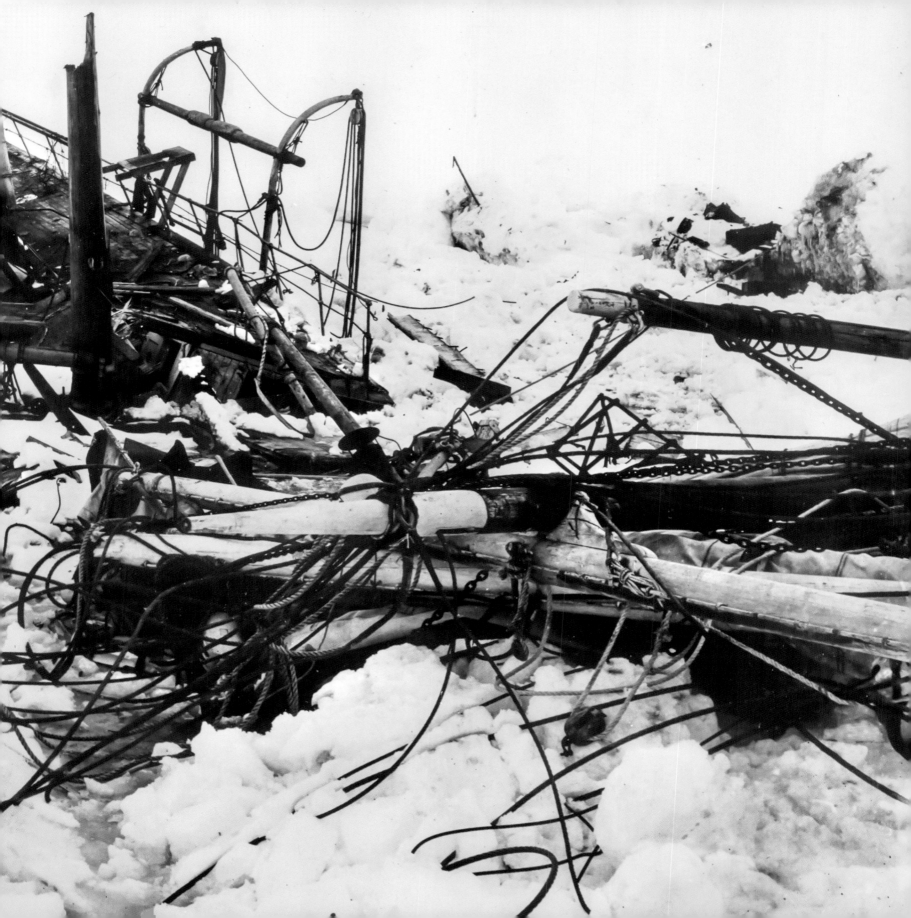

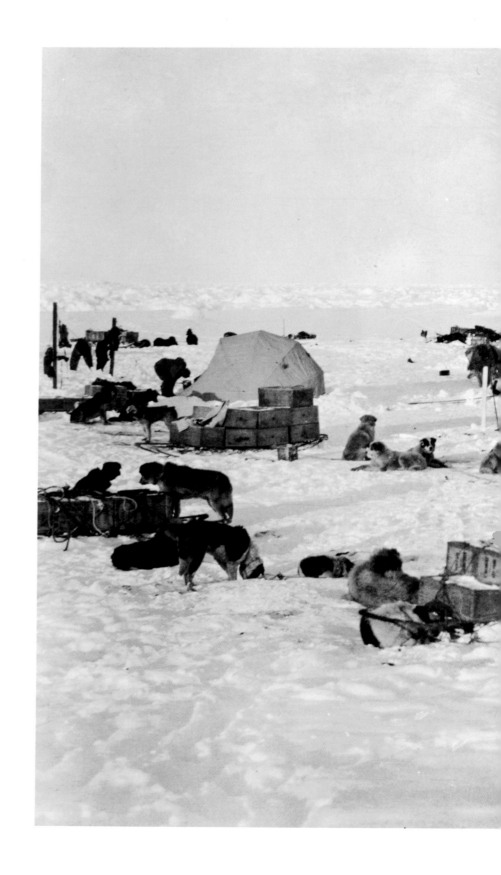

Shackleton's crew established "Ocean Camp" on the sea ice about a mile and a half from the *Endurance* wreck site. In the foreground, the dogs wait beside the emergency sledges, all ready and packed in case of a sudden breakup of the ice.

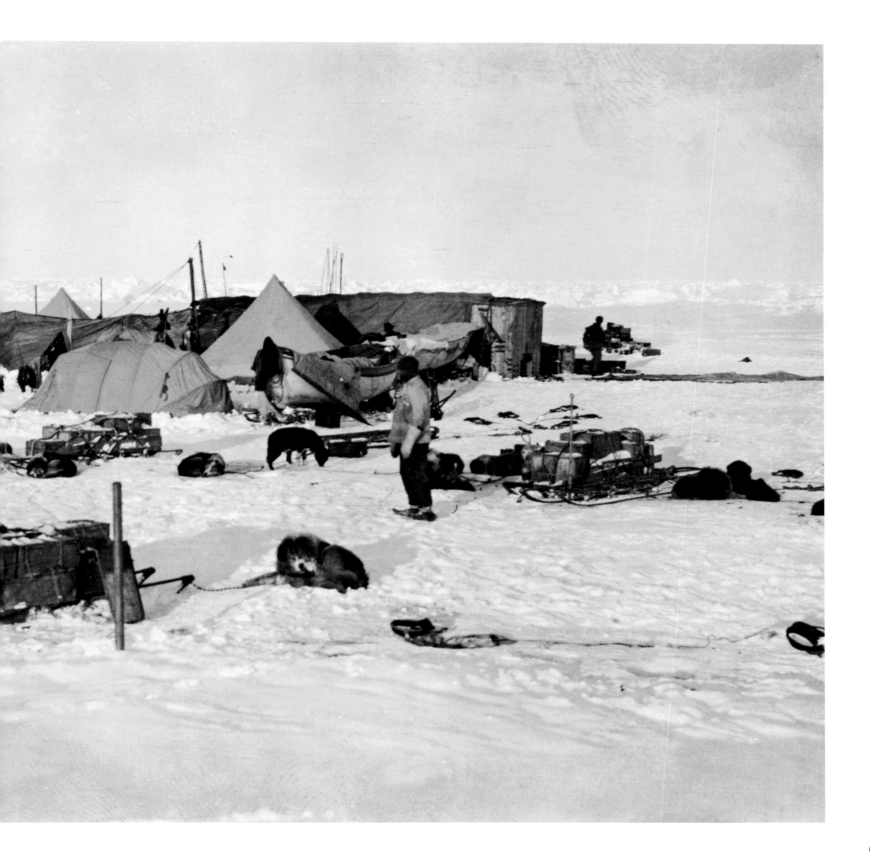

67

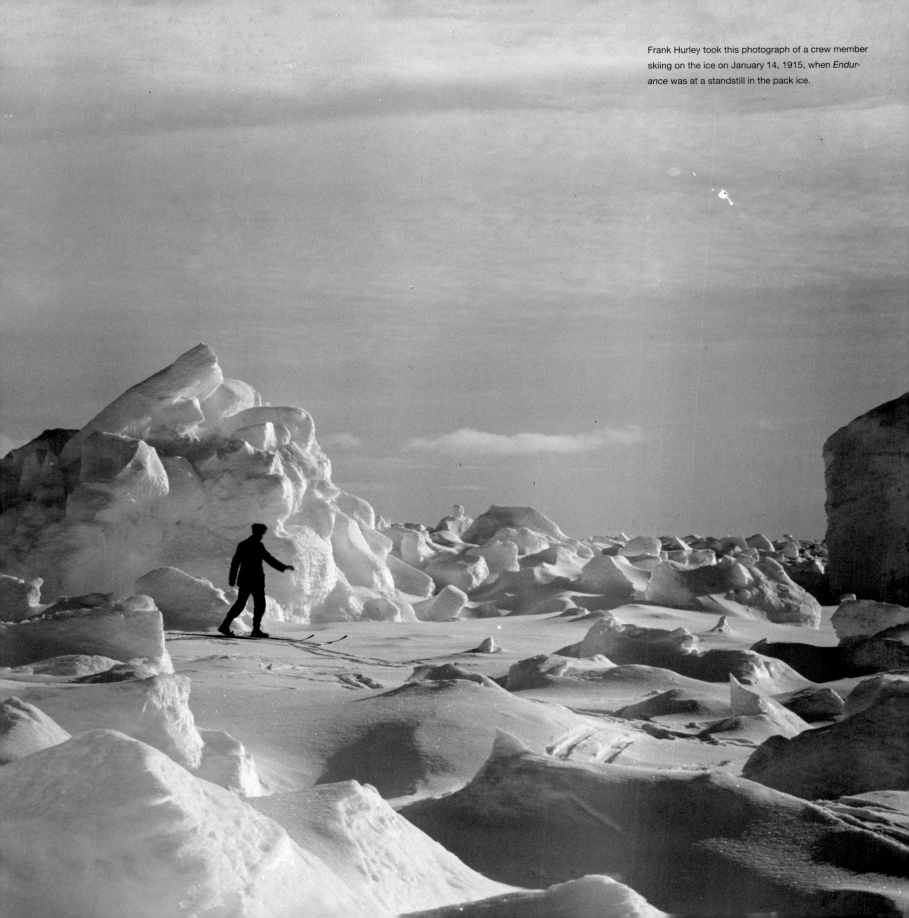

Frank Hurley took this photograph of a crew member skiing on the ice on January 14, 1915, when *Endurance* was at a standstill in the pack ice.

A New Lens on History

NATALIE HEWIT, FILM DIRECTOR AND HEAD OF MEDIA, ENDURANCE22

In the summer of 2021, Little Dot Studios asked me if I'd be interested in making a film about the search for *Endurance*. I had previously spent three months solo in Antarctica shooting a documentary for the BBC, so I knew how challenging the endeavor would be. But much like Frank Hurley, Shackleton's photographer and filmmaker for the original *Endurance* expedition, I jumped at the chance to document this incredible attempt to make history.

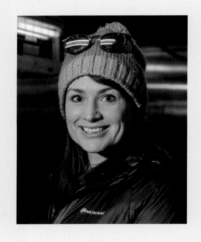

I spent months preparing for the expedition, hand-selecting a tiny team of just myself and two cinematographers, along with three social media experts, a photographer, and an educator. Despite the small size of the media team, we packed more than 40 cases of equipment, including 16 cameras, three drones, and endless spare parts for when our gear inevitably began to break down in the brutal Antarctic conditions.

Throughout the expedition, I was struck by the synergies between our work and that of our predecessor more than 100 years earlier. My team commandeered the ship's library to be our production hub—just as Hurley had improvised a darkroom in *Endurance*'s refrigerator. We regularly had to persuade the explorers and crew members to be patient with us as we strived to get "the shot"—just as Hurley must have had to sweet-talk his teammates into helping him rig up the platform at the front of *Endurance* so that he could capture on camera her battle with the ice in all its glory.

I know our filmmaking endeavors didn't exactly simplify what was already a complex logistics operation, but I think the most important factor in our success as storytellers was how, just like Hurley was on *Endurance,* we were welcomed into the Endurance22 crew as full team members, not a separate entity that lay outside of the expedition's aims and operations. And this, for me, is the key—because inviting a film crew along when you are attempting to cross Antarctica for the first time or, for that matter, trying to find the "impossible shipwreck" might not be everyone's version of a good idea. Inevitably, we will be filming when things go wrong, and reputations are on the line. But in accommodating his photographer, Shackleton demonstrated that he was extremely forward-thinking in his understanding of the media. He knew back then what everyone on social media knows now: that if you don't have photos or video to prove it, it didn't happen! He understood that visual storytelling is essential to engaging people with exploration stories, especially in places like Antarctica where most people will never set foot. I am extremely pleased that the Endurance22 team shared this vision, because it means that I have the great pleasure of helping to share their story with you today through our documentary film.

OPPOSITE: Natalie Hewit prepares to film Dr. Stefanie Arndt, a scientist from the Alfred Wegener Institute in Germany, as she conducts research on an Antarctic ice floe.

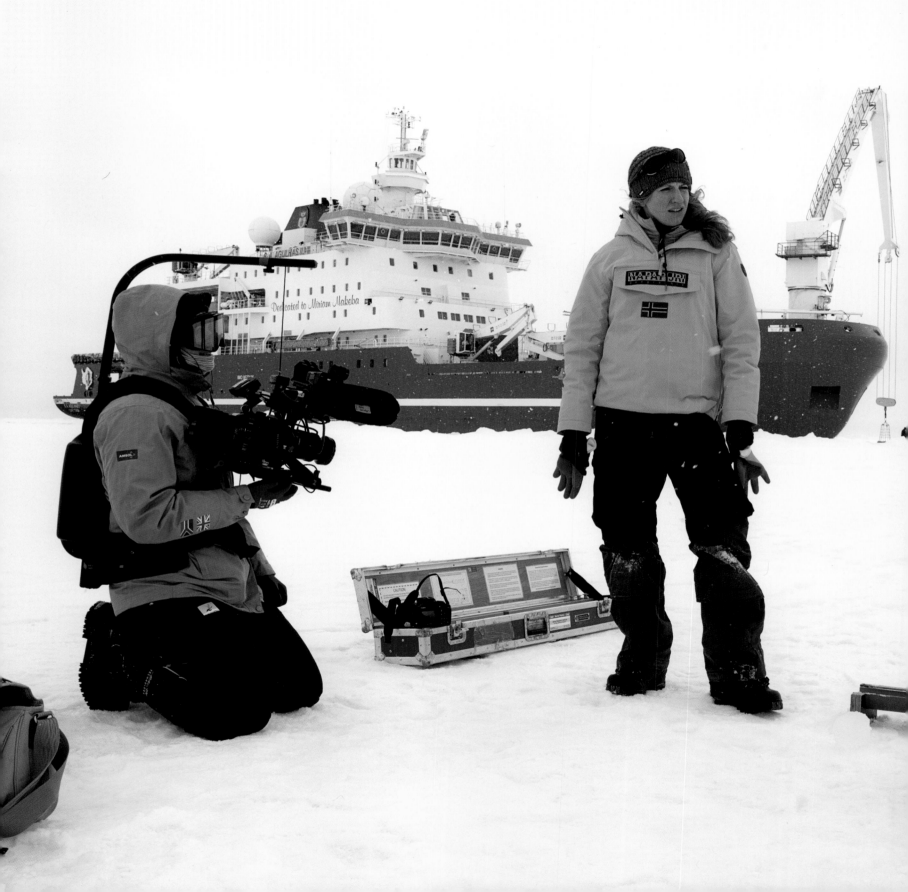

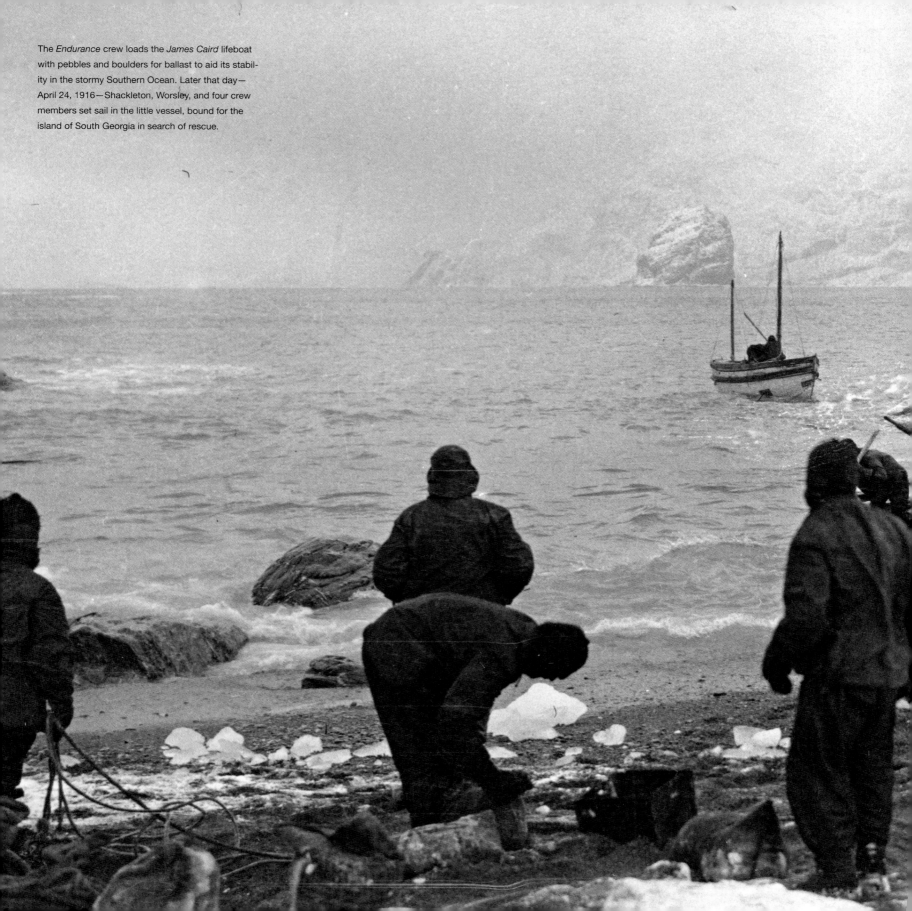

The *Endurance* crew loads the *James Caird* lifeboat with pebbles and boulders for ballast to aid its stability in the stormy Southern Ocean. Later that day—April 24, 1916—Shackleton, Worsley, and four crew members set sail in the little vessel, bound for the island of South Georgia in search of rescue.

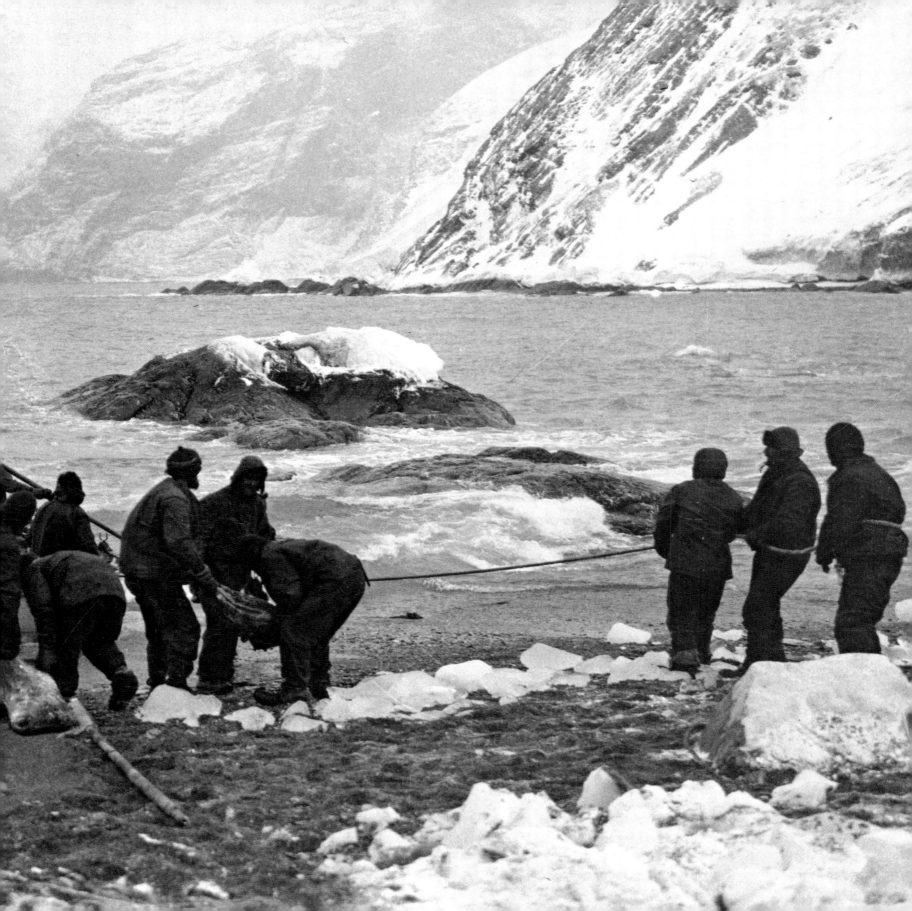

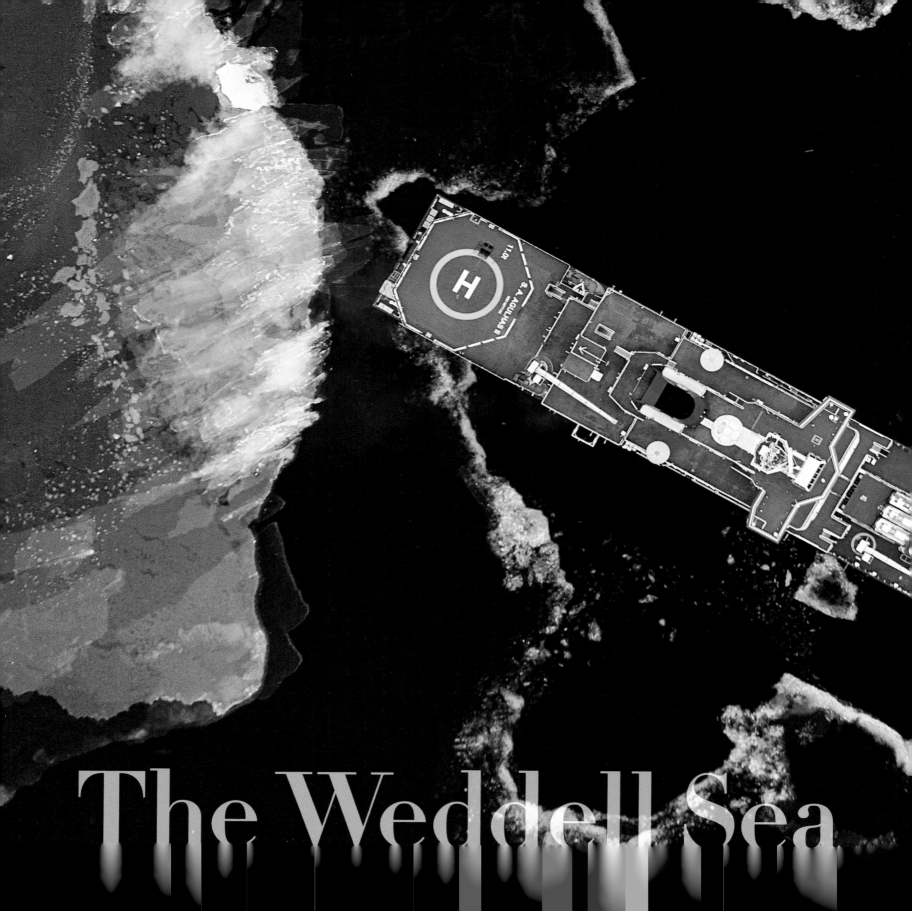

The Weddell Sea

"I BELIEVE IT IS IN OUR NATURE TO EXPLORE, TO REACH OUT INTO THE UNKNOWN. THE ONLY TRUE FAILURE WOULD BE NOT TO EXPLORE AT ALL."

—Sir Ernest Shackleton

An aerial view of the S.A. *Agulhas II* in a narrow open-water lead during the Weddell Sea Expedition 2019

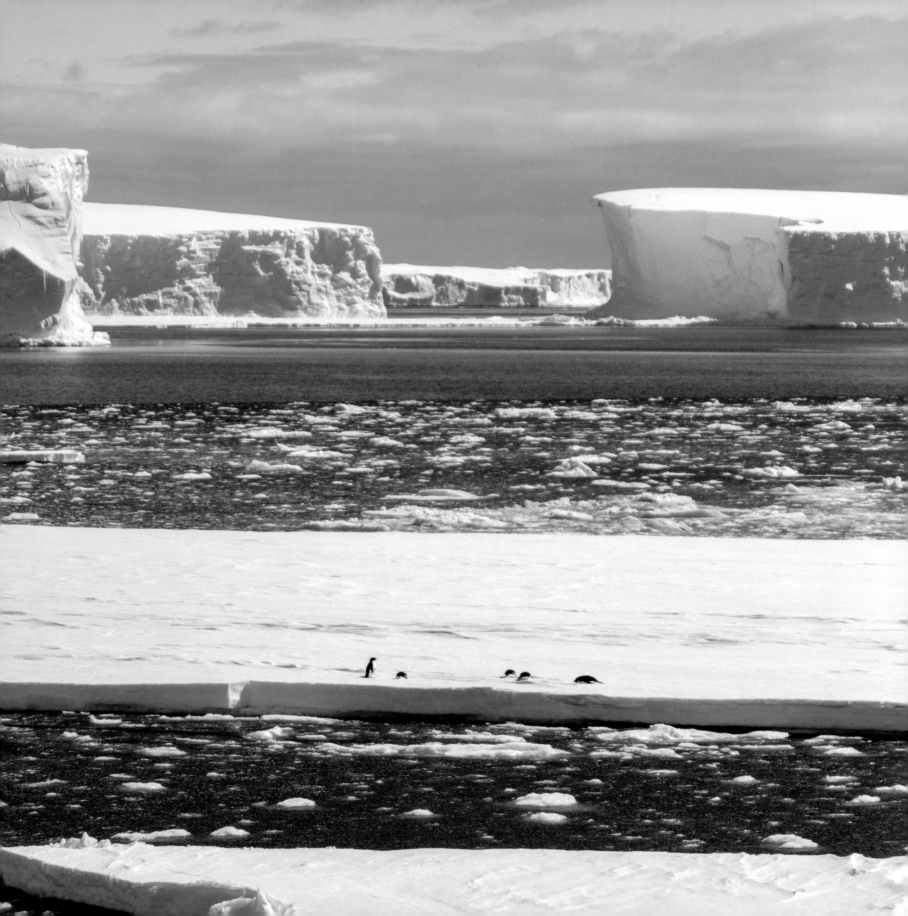

The Weddell Sea

JOHN SHEARS

The Weddell Sea is one of the most remote, hazardous, and difficult-to-reach marine areas in the world. After its discovery in 1823 by the British sailor and navigator Captain James Weddell, it remained unvisited until 1911, when German explorer Wilhelm Filchner reached the ice of Vahsel Bay and charted the route subsequently taken by Shackleton's expedition just three years later.

The Weddell Sea forms a large, slow-swirling basin off the northern coastline of Antarctica. The cyclonic Weddell Sea gyre, a major wind-driven ocean current, moves water, sea ice, and floating icebergs around its expanse in a slow clockwise rotation. Ice surrounds the sea on three sides: the ice shelves of Coats Land to the east, the Filchner-Ronne Ice Shelf to the south, and the Larsen C Ice Shelf and the glaciers of the Antarctic Peninsula to the west. The water depth increases from 300 feet (90 m) deep adjacent to the ice shelves to nearly 17,000 feet (5,180 m) deep in the central abyssal plain of the basin.

The growth and retreat of the sea ice marks the seasons in the Weddell Sea. In winter, air temperatures plummet—sometimes reaching below –30°F (–34°C), and the sea freezes. In September, the depth of winter, thick, dense, and immobile sea ice covers the entire surface of the Weddell Sea, an area of approximately 1.7 million square miles (4.4 million km²). During the coldest winters, the ice can reach as far north as 60° S, the extent of the Southern Ocean, and measures five feet (1.5 m) thick on average. In areas where ice floes ram together and form pressure ridges, the ice can be over 15 feet (4.6 m) thick.

In February, Antarctica reaches the height of summer. Temperatures rise as high as 40°F (4.4°C), and the sea ice melts and retreats to the south, forming loose floes and drifting pack ice across the Weddell Sea. During this season, the ice covers around 550,000 square miles (1.4 million km²), and measures just three feet (0.9 m) thick on average. For the few sailors who venture into the Weddell Sea, these are the best conditions.

Shackleton and *Endurance* entered the pack ice in the Antarctic spring, on December 7, 1914, and found the ice extended far to the north of the Weddell Sea. Shackleton

A small group of Adélie penguins on an ice floe at the Fimbul Ice Shelf, where the Weddell Sea Expedition 2019 began

recorded the ship reaching the ice at 57° 26' S, describing the conditions as "evil."

A NEW EXPEDITION

Even today, only a handful of ships ever sail into the Weddell Sea because of the harsh climate and the dangers of the sea ice. Although the quest to find *Endurance* has long fascinated many explorers, scientists, marine archaeologists, and historians, navigating the Weddell Sea has proved too great a challenge.

But since the turn of the millennium, our scientific knowledge of the Weddell Sea has improved vastly, and there have been tremendous advances in satellite remote sensing, subsea technology, and the strength and power of icebreaking ships. The possibility of an expedition to search for the lost ship was poised to become a reality.

On April 10, 2018, the Weddell Sea Expedition (WSE) was announced to a packed audience of almost 700 people at the Royal Geographical Society in London. It was the first fully equipped and funded expedition to search for *Endurance*. The mission was organized and funded by the Flotilla Foundation, a marine protection charity based in the Netherlands.

The Flotilla Foundation appointed me the expedition leader. Working alongside me were chief scientist Professor Julian Dowdeswell from the Scott Polar Research Institute at the University of Cambridge in the United Kingdom, subsea offshore manager Claire Samuel from Deep Ocean Search in France, and marine archaeologist and director of exploration Mensun Bound.

The WSE combined scientific research and pioneering exploration. It had two main aims. The first: to study the waters around the Larsen C Ice Shelf—a 16,000-square-mile (25,750 km²) floating ice shelf, and the fourth largest in Antarctica. The second: to search for, survey, and image the wreck of *Endurance*.

The scientists on the WSE were concerned about the stability of Larsen C. The ice shelves to the north had suffered major collapses—Larsen A in 1995 and Larsen B in 2022—due to climate warming in the Antarctic Peninsula. Larsen C was now the northernmost shelf in the region, and scientists were worried it might be the next to go. Ice shelves play a vital role in supporting and buttressing the glaciers on land behind them. When the ice shelf is removed, the glaciers flow faster, receding and thinning, discharging large amounts of ice to the ocean.

The glaciers that drain into the Larsen C Ice Shelf hold enough ice to raise global sea levels by around 4 inches (10 cm) if they melt completely. Despite this importance, very few direct scientific measurements and observations had been made around the Larsen C because it is so difficult to access. That would, we hoped, be rectified by the research carried out by the WSE.

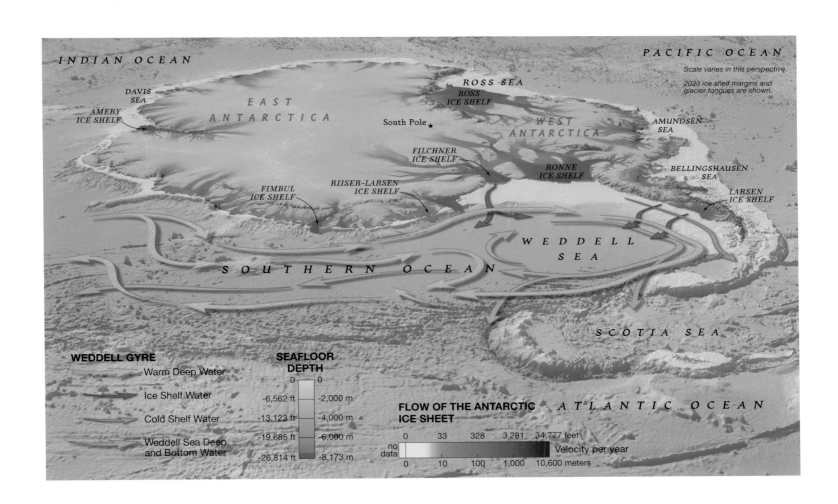

INDIAN OCEAN

PACIFIC OCEAN

Scale varies in this perspective.

2023 ice shelf margins and
glacier tongues are shown.

DAVIS
SEA

ROSS SEA

ROSS
ICE SHELF

AMERY
ICE SHELF

EAST
ANTARCTICA

South Pole ★

WEST
ANTARCTICA

AMUNDSEN
SEA

FILCHNER
ICE SHELF

RONNE
ICE SHELF

BELLINGSHAUSEN
SEA

RIISER-LARSEN
ICE SHELF

LARSEN
ICE SHELF

FIMBUL
ICE SHELF

WEDDELL
SEA

SOUTHERN OCEAN

SCOTIA SEA

WEDDELL GYRE

Warm Deep Water

Ice Shelf Water

Cold Shelf Water

Weddell Sea Deep
and Bottom Water

**SEAFLOOR
DEPTH**

0	0
-6,562 ft	-2,000 m
-13,123 ft	-4,000 m
-19,685 ft	-6,000 m
-26,814 ft	-8,173 m

**FLOW OF THE ANTARCTIC
ICE SHEET**

ATLANTIC OCEAN

| 0 | 33 | 328 | 3,281 | 34,777 feet |

no
data Velocity per year

| 0 | 10 | 100 | 1,000 | 10,600 meters |

THE S.A. *AGULHAS II*

The first task for the expedition was to find a suitable ice-breaker, a ship specially designed to break through sea ice.

The Weddell Gyre ocean current moves water in a clockwise direction around the Weddell Sea, taking pack ice and icebergs with it. The deep bottom water flowing off the ice shelves is supercooled to temperatures as low as 27.5°F (−2.5°C).

The ship had to be able to handle the tough ice conditions in the Weddell Sea during the 45-day mission. George Horsington, the expedition project manager, and I scoured the world looking for a suitable ship. Our investigations took us to Sweden, Germany, Russia, and finally, South Africa. On August 30, 2017, we reached Cape Town, where a large cherry red and white icebreaker was docked at East

THE S.A. *AGULHAS II* IS SPECIALLY DESIGNED FOR BREAKING ICE AND HAS A ROUNDED BOW THAT ALLOWS THE SHIP TO PUSH UP ON TOP OF THE ICE AND USE HER WEIGHT TO BREAK A CHANNEL AHEAD.

Pier on the Victoria and Albert Waterfront. She was the S.A. *Agulhas II,* a polar research and logistics vessel owned by the South African Department of Environment, Forestry, and Fisheries.

The S.A. *Agulhas II* was built in 2012, almost exactly one hundred years after *Endurance,* by the STX yard in Finland, and is managed and operated by African Marine Solutions Group (AMSOL). She measures 440 feet long and 71 feet wide (134 m x 22 m), and is fitted with a wide range of science laboratories, accommodation for 100 passengers, a helicopter deck and hangar, a back deck and winches suitable for deploying subsea vehicles, a small hospital, and a wide range of other facilities on board. The S.A. *Agulhas II* is specially designed for breaking ice and has a rounded bow that allows the ship to push up on top of the ice and use her weight to break a channel ahead. She is powered by four diesel-electric engines, each producing 4,000 horsepower, which give her the capability to break easily through ice over three feet (0.9 m) thick at around 5 knots (6 mph/ 9 kph). Her power dwarfs that of *Endurance,* which had only a single tiny 350-horsepower coal-fired steam engine.

The South African crew of 45 men and women serving on the S.A. *Agulhas II* were equally impressive. Most had sailed on the ship for many years, with considerable experience of operating her in the Weddell Sea. Each year, the S.A. *Agulhas II* sails south from Cape Town to resupply SANAE IV station, the South African Antarctic research

base located in Vesleskarvet, Queen Maud Land, on the northeast coast of the Weddell Sea.

As George Horsington and I toured the S.A. *Agulhas II,* we met the ship's master, the remarkable Captain Knowledge Bengu, up on the bridge. Captain Knowledge grew up in Umlazi township in Durban, South Africa. As a boy, he wanted to be a doctor. However, after being inspired by a neighbor's stories about the sea, he went to marine college instead and joined AMSOL as a young marine cadet in 2001. He rose swiftly through the ranks. By age 33, he was a master mariner and fully qualified ice pilot. He was given command of the S.A. *Agulhas II* in 2013, and since then had undertaken many voyages to Antarctica. George and I outlined the expedition plans to Captain Knowledge, and he was convinced that he, his crew, and his ship could get us to the *Endurance* sinking location. After talking to him for just a few minutes, we knew instinctively we had found our captain and our ship for the WSE. We recommended the Flotilla Foundation charter her immediately.

While George and I were in South Africa, the trustees of the Flotilla Foundation secured the subsea vehicles we would use for the scientific research at the Larsen C Ice Shelf and the search for *Endurance.* We would need two

autonomous underwater vehicles (AUVs) and a remotely operated vehicle (ROV), all capable of diving in both the shallow coastal waters around the ice shelf and the deep water found at the *Endurance* wreck site.

The two free-swimming AUVs, Kongsberg Hugin 6000s, were provided by Ocean Infinity, a marine robotics company in the United Kingdom. The tethered ROV, a GP 50, came from the Eclipse Group in the United States. The Hugin 6000s would use their advanced sonars and echo sounders to search and map the seafloor of the

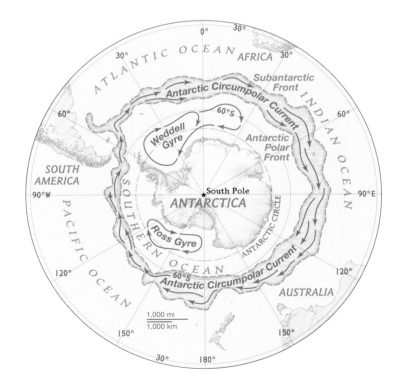

The Antarctic Circumpolar Current flows clockwise around Antarctica. It is the largest wind-driven current on Earth and the only current that goes all the way around the planet and connects the Atlantic, Pacific, and Indian Oceans.

Weddell Sea, while the ROV would carry out visual identification, underwater photography, and filming.

The Hugin would be the primary vehicle searching for *Endurance*. It is a high-technology marine survey robot, and can operate on its own in water down to 6,000 meters (19,685 ft) without a physical connection to a ship or remote control from the surface. Powered by lithium batteries, the Hugin is shaped like a torpedo 20 feet (6 m) long, and it can cruise at a typical speed of 5 knots (6 mph/9 kph) with an endurance of around 48 hours. It is one of the world's most powerful, advanced, and capable AUVs.

DRAWING THE SEARCH BOX

In February 2018, I received special permission for Mensun Bound and myself to access the archives of the Imperial Trans-Antarctic Expedition held at the Scott Polar Research Institute. Their archives hold most of the expedition journals, diaries, documents, and reports from the *Endurance* expedition, and we searched through all of them, particularly those belonging to Shackleton, Frank Worsley, and the chief scientist, Dr. James Wordie.

Worsley's diary contained the exact position of the ship on every day of the expedition, calculated from measurements he made himself using a sextant and chronometer. However, you need the sun to take a sextant reading, and Worsley ran into bad luck around the time of the sinking. For three days prior to the ship going down and a full

19 hours afterward, thick clouds covered the sky, and Worsley was unable to obtain any sun sights. As a result, Worsley gave an *estimated* sinking position for *Endurance* based on his position at noon the following day, when he next obtained a sun sight. It was an incredible thrill for me to see Worsley's diary entry for the day *Endurance* sank—November 21, 1915. For several minutes I stared in silence at the top of the page where he had written in pencil: "5 PM *Endurance* sinks" and in the margins the sinking location of the ship: "68° 39' 30" S, 52° 26' 30" W."

After assessing Worsley's coordinates against a range of other studies and information, Mensun used Worsley's calculation to draw up a search box—the geographical area within which we would search for *Endurance*—measuring 15 by 8 nautical miles (17 x 9 mi/28 x 15 km). If we could reach the box through the ice, then we would launch the Hugin to survey and map the seafloor, and perhaps discover the long-lost ship.

OUR FIRST DISCOVERY

The Weddell Sea Expedition began on January 3, 2019, at Penguin Bukta at the Fimbul Ice Shelf on the East Antarctic coast. Most of the expedition members flew in from Cape Town to meet the S.A. *Agulhas II* moored at the ice shelf. The team comprised 51 people, including scientists, subsea engineers, drone and subsea vehicle pilots, technicians, a medical doctor, a film crew, and research students. One of

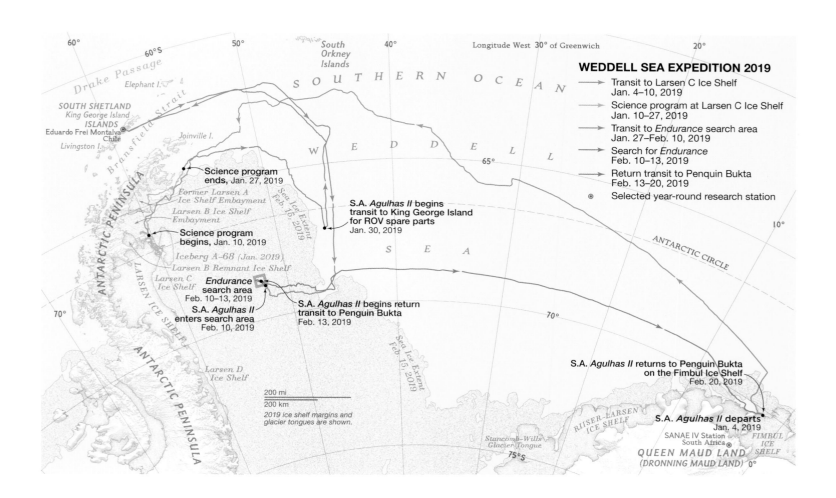

The map contains the following labels:

WEDDELL SEA EXPEDITION 2019

- Transit to Larsen C Ice Shelf
 Jan. 4–10, 2019
- Science program at Larsen C Ice Shelf
 Jan. 10–27, 2019
- Transit to *Endurance* search area
 Jan. 27–Feb. 10, 2019
- Search for *Endurance*
 Feb. 10–13, 2019
- Return transit to Penquin Bukta
 Feb. 13–20, 2019
- ⊙ Selected year-round research station

60° / 50° / 40° / Longitude West 30° of Greenwich / 20°

Drake Passage
60°S
Elephant I.
SOUTH SHETLAND
King George Island
ISLANDS
Eduardo Frei Montalva
Chile
Livingston I.
Joinville I.
Bransfield Strait
SOUTHERN OCEAN
South Orkney Islands
W E D D E L L
65°
S E A
10°
ANTARCTIC CIRCLE
70°
70°
ANTARCTIC PENINSULA
Former Larsen A Ice Shelf Embayment
Larsen B Ice Shelf Embayment
Science program ends, Jan. 27, 2019
Science program begins, Jan. 10, 2019
Iceberg A-68 (Jan. 2019)
Larsen B Remnant Ice Shelf
LARSEN ICE SHELF
Larsen C Ice Shelf
Endurance search area
Feb. 10–13, 2019
S.A. *Agulhas II* enters search area
Feb. 10, 2019
S.A. *Agulhas II* begins transit to King George Island for ROV spare parts
Jan. 30, 2019
Sea Ice Extent Feb. 16, 2019
S.A. *Agulhas II* begins return transit to Penguin Bukta
Feb. 13, 2019
Sea Ice Extent Feb. 15, 2019
Larsen D Ice Shelf
ANTARCTIC PENINSULA
200 mi
200 km
2019 ice shelf margins and glacier tongues are shown.
S.A. *Agulhas II* returns to Penguin Bukta on the Fimbul Ice Shelf
Feb. 20, 2019
RIISER-LARSEN ICE SHELF
Stancomb-Wills Glacier Tongue
75°S
S.A. *Agulhas II* departs
Jan. 4, 2019
SANAE IV Station
South Africa
QUEEN MAUD LAND
(DRONNING MAUD LAND)
FIMBUL ICE SHELF
0°

the most important final additions to the crew was Captain Freddie Ligthelm, our ice pilot. He was an expert on the pack ice of the Weddell Sea, and it was his role to assist Captain Knowledge in the ice and help us reach the *Endurance* sinking location.

The voyage of the S.A. *Agulhas II* during the Weddell Sea Expedition 2019

In 1914, the only way Shackleton could find a way through the maze of ice was to climb up into the crow's nest of *Endurance,* look through his brass binoculars, and shout down instructions. In 2019, we had the latest technology to assist Captain Freddie. A German polar research company, Drift+Noise, provided us with a wide range of satellite remote sensing data, including high-resolution radar

THE PRESSURE HOUSING ON THE ROV FAILED AND IMPLODED, DESTROYING ALL ITS ELECTRONICS. WE MANAGED TO RECOVER THE VEHICLE AND WINCH IT BACK ON BOARD, BUT THERE WAS NO SPARE HOUSING ON THE SHIP.

images, that showed us how the ice was drifting in the Weddell Sea in near real time. We had drones to fly ahead of the S.A. *Agulhas II,* scouting for leads in the ice the ship could follow. The ship itself had its own ice radar.

It took the S.A. *Agulhas II* a week sailing at 16 knots—full speed, around 18.5 miles an hour (29.5 kph)—to reach the Larsen C Ice Shelf, where we could begin our research program in earnest. Larsen C is in a fragile state, melting and thinning and vulnerable to collapse. In 2017, it shed one of the largest icebergs ever recorded, a mammoth named Iceberg A-68 measuring 2,200 square miles (5,700 km²) in area—about three and a half times the size of greater London—into the Weddell Sea. When we arrived, A-68 had just begun drifting northward from the Larsen C toward the warmer Southern Ocean. Our expedition hoped to gather as much information as possible about the Larsen C, A-68, and the adjacent waters to understand what was causing such rapid melting.

Researchers at the Scott Polar Research Institute analyzed data collected by the Ocean Infinity subsea team to make one of our most important discoveries. They used one of the Hugin AUVs and its multibeam sonar to map the seafloor near the ice shelf in unprecedented detail. The AUV dived 1,500 feet (460 m) below the surface of the Weddell Sea and flew about 200 feet (60 m) above the seafloor, recording stunning imagery. The imagery revealed a delicate pattern of ancient sedimentary ridges

on the ocean floor, dating back to the end of the last ice age about 12,000 years ago. The ridges on the map looked like a series of ladders, each rung about five feet (1.5 m) high and spaced 60 to 80 feet (18–24 m) apart. The scientists interpreted these ridges as features generated at the ice grounding zone, the point where glacier ice becomes buoyant and starts to float. As the floating glacier ice rises and sinks with the tides, it presses down on the seafloor and churns up the sediment to create the ridges on the map. The pattern and preservation of the "ladders" means the ice must have been in retreat, and the researchers calculated it was retreating at an astonishing rate of at least 130 feet (40 m) per day. That's roughly 6 miles (9.7 km) per year, 10 times faster than the rate currently observed by satellites today.

TROUBLE IN THE DEPTHS

With our science program completed on January 27, the S.A. *Agulhas II* sailed on to the *Endurance* wreck site. On January 30, just before reaching the edge of the ice and beginning the transit to the search box, we conducted sea trials of the AUVs and ROV. We calibrated the sensors on the vehicles and checked their buoyancy, and tested our subsea tracking system. We also needed to test the ROV in deep water, as this hadn't been done before on the expedition, but when the ROV reached a depth of 9,800 feet (2,990 m), disaster struck. The pressure housing on the

ROV failed and imploded, destroying all its electronics. We managed to recover the vehicle and winch it back on board, but there was no spare housing on the ship. It was a big blow to our plans.

There was no option but for us to head to the nearest airstrip at King George Island in the South Shetland Islands and wait for replacement parts to be flown in. But the weather was not on our side. We spent almost five dismal days at King George Island in sleet and rain waiting for a weather window for the aircraft to fly in. It never arrived. With our allotted expedition time running out, we decided on February 5 to continue without an operational ROV. We would now have to rely on the two Hugin 6000 AUVs to find the wreck. Without the ROV, it would be impossible to photograph or film the *Endurance* wreck if it was discovered. We also wouldn't be able to rescue the AUV from the seafloor in the event of an incident.

We entered heavy pack ice on February 7. At once, the going became slow and difficult. The sea ice covered more than 90 percent of the sea surface, and ice was pressing in all around us as far as the eye could see. The ice thickness ranged from 5 feet (1.5 m)—the average thickness in winter—to 15-foot-high (4.6 m) ice ridges, which we did our best to avoid. Despite the heavy ice, the S.A. *Agulhas II* slowly made headway. To stand at the bow and watch the ship work at full power and smash its way through the ice was spectacular.

But sometimes Antarctica beat us, and we'd get stuck fast. Then there was nothing we could do but sit and wait for the tides and winds to change. Often, as we sat idle, the native wildlife would come to investigate the ship. Hundreds of crabeater seals hauled out onto the ice beside us, sometimes accompanied by pacing emperor penguins. Minke whales surfaced where there was open water and swam around the ship. It was beautiful.

We made steady progress toward the wreck site, but on February 9, the weather and ice conditions grew worse. We slowed down as dense fog surrounded the ship, and soon found ourselves stuck in the pack ice for almost 18 hours. We were trapped, just like Shackleton and his crew had been a century before. We knew the S.A. *Agulhas II* was strong, but the ice seemed unbreakable. As a last resort, Captain Knowledge tried a canny idea. He ordered the ship's crane to lift a 20-ton (18 t) fuel container and swing it from side to side across the bow to rock the ship. Eventually, the ice frozen hard to the sides of the hull cracked and broke away in pieces, and we were able to continue.

The next day, we finally reached the sinking site of *Endurance*. It was an incredible achievement. Only two other icebreakers had been at or close to the site since 1915. There wasn't time to celebrate, however. The delays caused by the problems with the ROV meant we only had around 50 hours on-site, time for just two AUV dives.

Much to our surprise and relief, the search box contained several large areas of open water, as well as wide leads and channels for navigation. We could begin subsea operations straightaway. We prepared and launched one of the Hugin 6000s, AUV7, at 12:30 p.m. We programmed it to search the seafloor on the eastern side of the search box for 42 hours.

The usual search procedure in open water is for the ship to continuously follow and track the course of the AUV on the seafloor. However, the tough ice conditions over the *Endurance* search box didn't allow this, and instead the ship had to break through the ice and intersect with the AUV at each of 11 underwater survey lines. At each of these checkpoints, the subsea team would make an acoustic contact, called a "handshake," with the vehicle to ensure it was safe and on track. The challenge was navigating the ship to the checkpoints through the pack ice.

We made the first seven checkpoints without incident. The AUV had been searching for 30 hours as we made our way to checkpoint eight. But when we attempted the handshake, the AUV failed to make contact. We had lost it, along with all the seafloor imagery and data it had collected and stored on its onboard computer. We had no idea—and still have no idea—what happened. The AUV had disappeared without a trace. Perhaps the batteries had failed and it had fallen to the seafloor, or it had made

an emergency ascent and become trapped under the ice without communications.

It was devastating. I was having dinner in the dining room when I received the news from Claire, and I felt sick with concern and could no longer eat. All our high hopes of finding *Endurance* had been crushed in an instant. We were so close but so far.

Over the next 40 hours we carried out an intense and desperate search for the AUV, with no luck. But the weather and sea ice conditions were deteriorating hour by hour. Surface air temperatures had dropped well below -4°F (-20°C) and the sea was freezing around us. I discussed what to do next with Captain Knowledge, but we both knew we had no choice. On February 13, at 6:15 p.m., we called off the search. Captain Knowledge ordered a dejected and beaten crew to set sail, and we left the search box. By February 15, the S.A. *Agulhas II* was free from the pack ice, and by February 22, the team was back in Cape Town. The expedition was over.

We had some incredible experiences on the Weddell Sea Expedition. Our expedition team and the ship's crew had worked together well in one of the most hostile environments on Earth. We had pioneered significant scientific research at the Larsen C Ice Shelf, and raised public awareness of the importance and pristine status of the Weddell Sea. Perhaps most impressively, against all the odds we had reached the sinking location of *Endurance*. However,

I was truly disappointed that we had not found the ship. It was a hard and bruising defeat to take.

I thought it would be years before there would be another attempt at finding the wreck. Any return looked even more remote when the COVID-19 pandemic struck and effectively canceled or postponed almost all expeditions to Antarctica.

But then, on August 7, 2020, I received a phone call out of the blue from Donald Lamont, the chairman of the Falklands Maritime Heritage Trust, a U.K. charity dedicated to preserving the seafaring history of the Falkland Islands and neighboring seas. Donald is a proud Scotsman, a former senior British diplomat and U.K. governor, with great knowledge of the Falkland Islands and Antarctica. We had worked together previously, so I knew him very well. Donald usually only phones me when he has something important to say. But on that day, with the Weddell Sea Expedition long finished, I had no idea what he might be calling me about.

"John," he said. "We need to meet. Can you come to a garden lunch at my home in a few days? I'd like to talk to you in person, in confidence. You see, the trust has just agreed to begin a big, bold, new enterprise. I can't give too many details over the phone, but it's a major project in the Weddell Sea. Timing early 2022."

A huge grin spread across my face. I couldn't believe what I was hearing. The hunt for *Endurance* was back on!

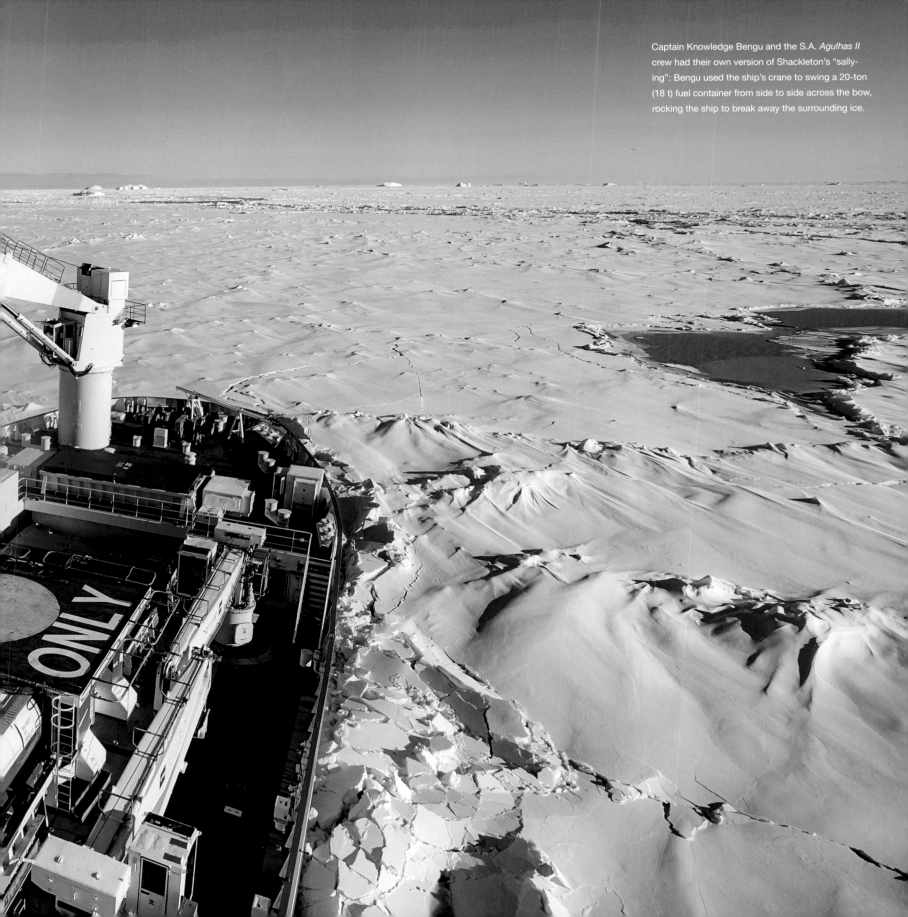

Captain Knowledge Bengu and the S.A. *Agulhas II* crew had their own version of Shackleton's "sallying": Bengu used the ship's crane to swing a 20-ton (18 t) fuel container from side to side across the bow, rocking the ship to break away the surrounding ice.

The S.A. *Agulhas II*'s fast-response craft (at left), designed for quick deployment in case of an emergency, tows the Hugin 6000 AUV back to the ship after a dive during the Weddell Sea Expedition 2019.

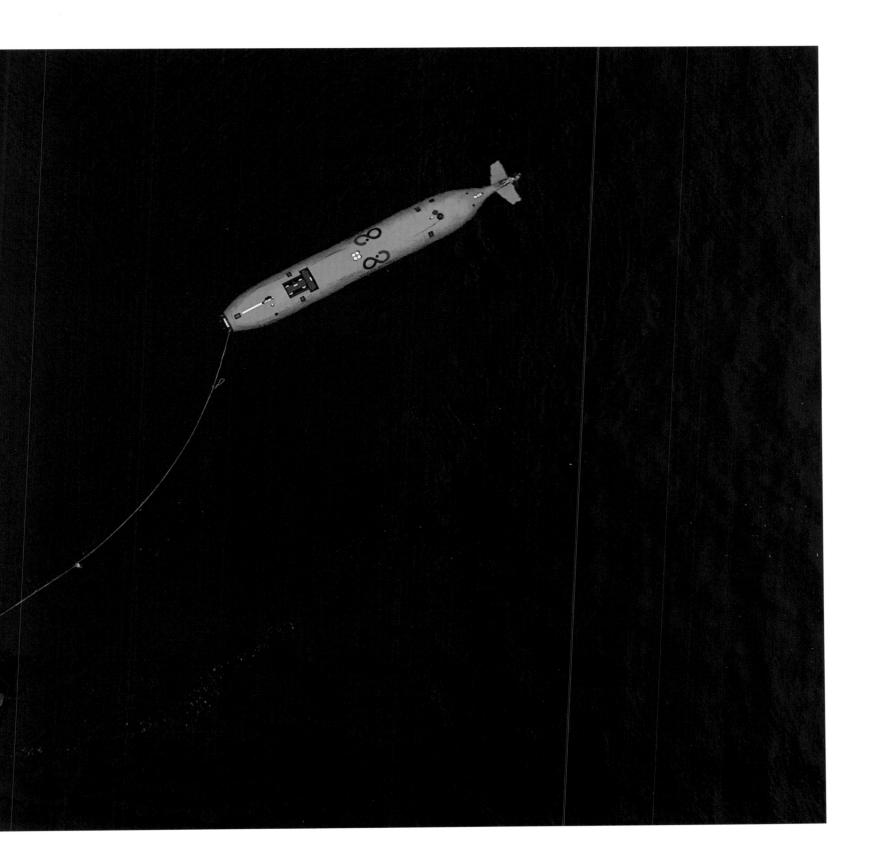

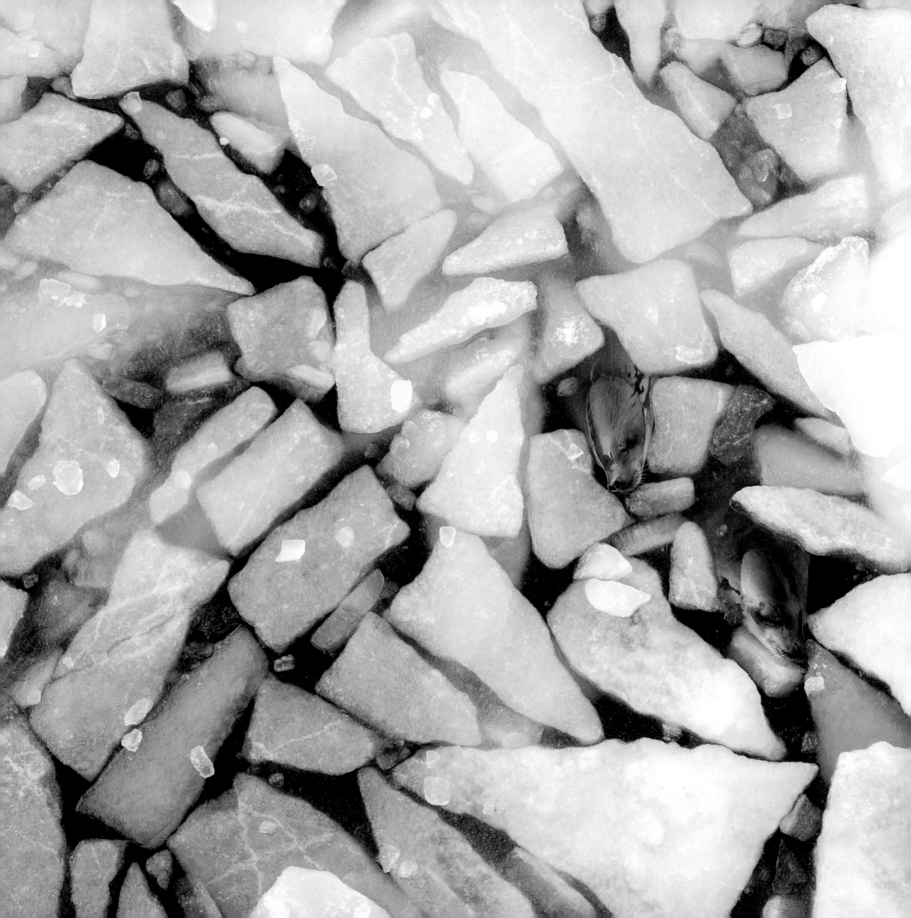

Two crabeater seals take a quick nap amid brash ice next to the
S.A. *Agulhas II* on the Weddell Sea Expedition 2019. In 1915, the
Endurance crew hunted these animals and ate them to survive, but
today they are protected by the Antarctic Treaty.

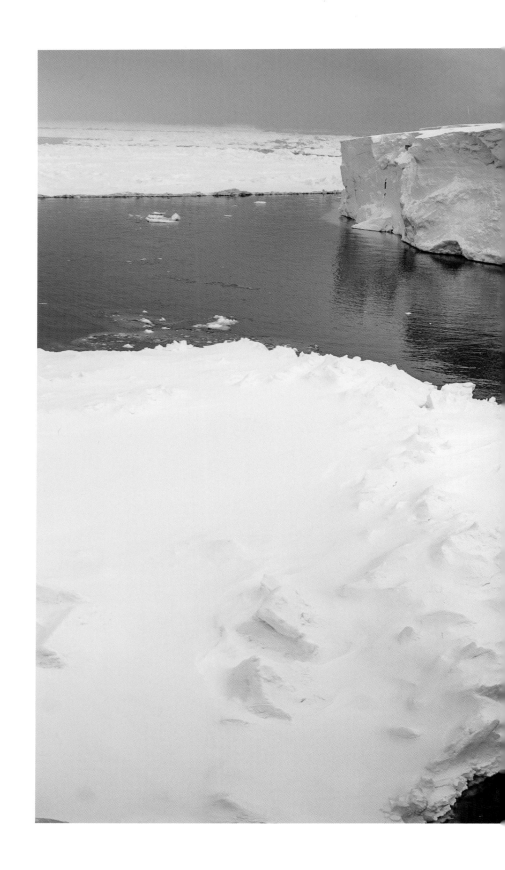

As Captain Knowledge Bengu looks on from the bridge during the Weddell Sea Expedition 2019, the S.A. *Agulhas II*'s fast-response craft noses an encroaching sea ice floe away from the ship. Nearby looms the huge A-68 iceberg, near the Larsen C Ice Shelf.

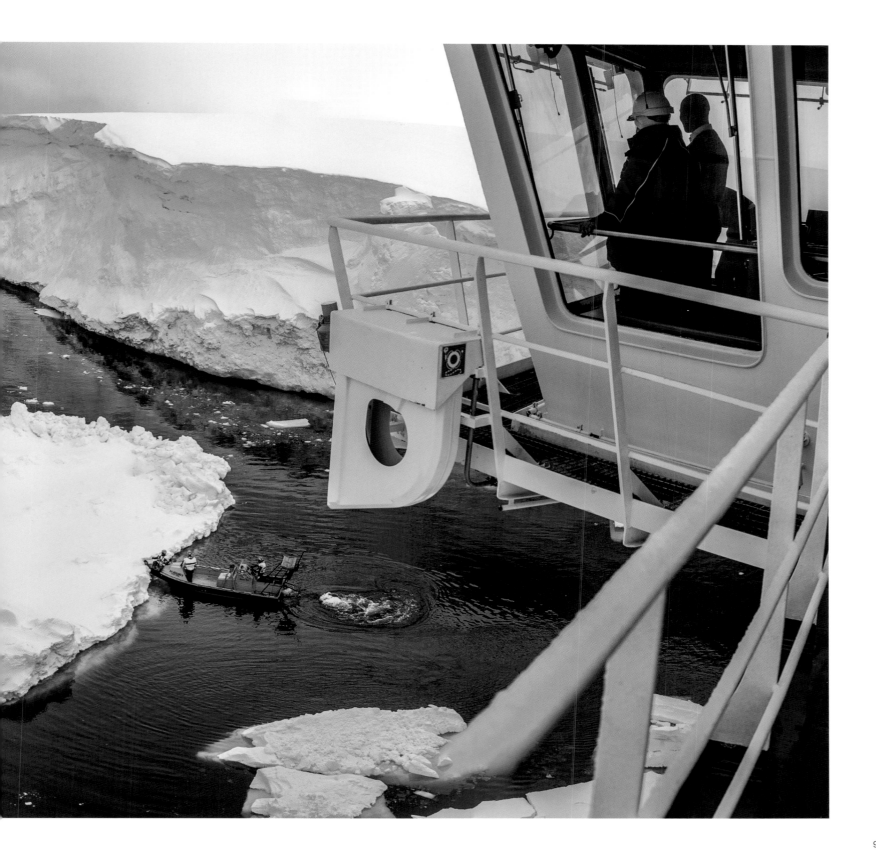

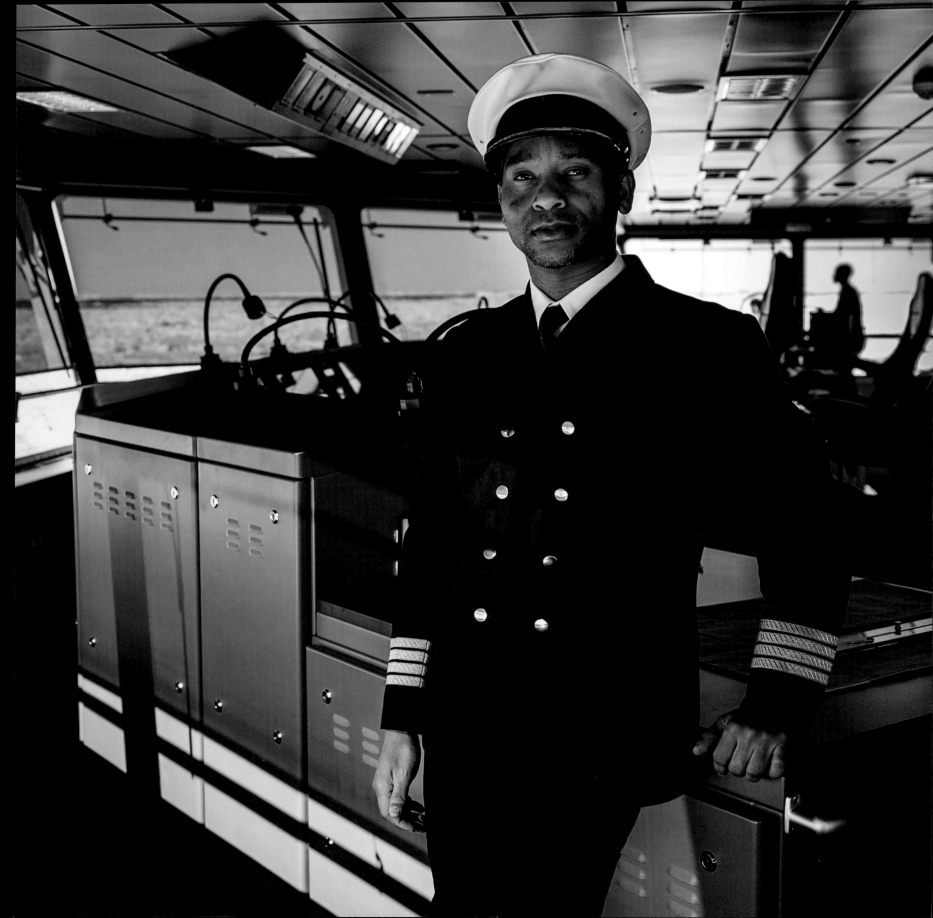

Captain Knowledge Bengu on the bridge of the S.A. *Agulhas II*

97

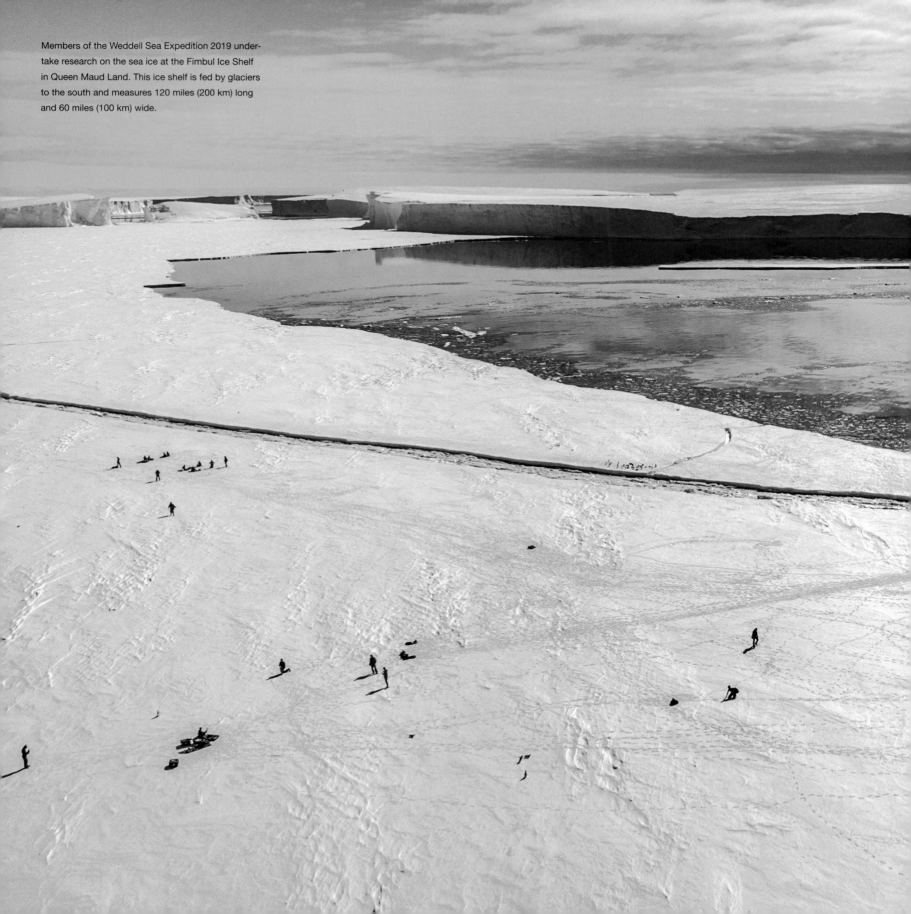

Members of the Weddell Sea Expedition 2019 undertake research on the sea ice at the Fimbul Ice Shelf in Queen Maud Land. This ice shelf is fed by glaciers to the south and measures 120 miles (200 km) long and 60 miles (100 km) wide.

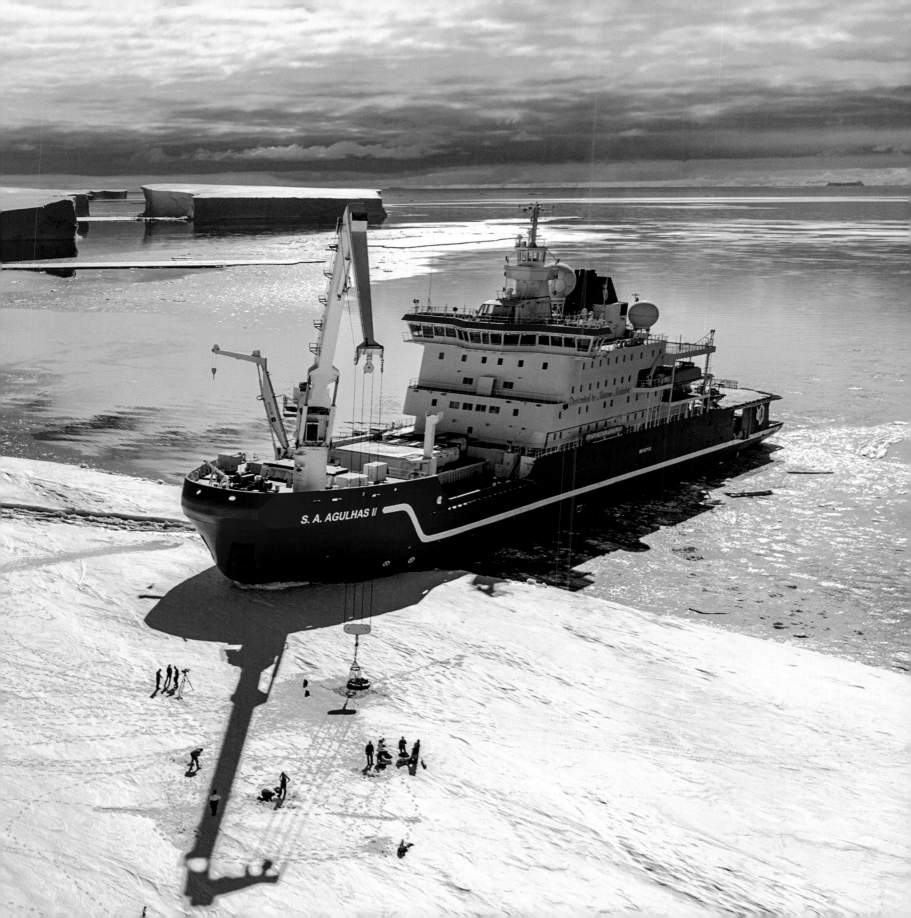

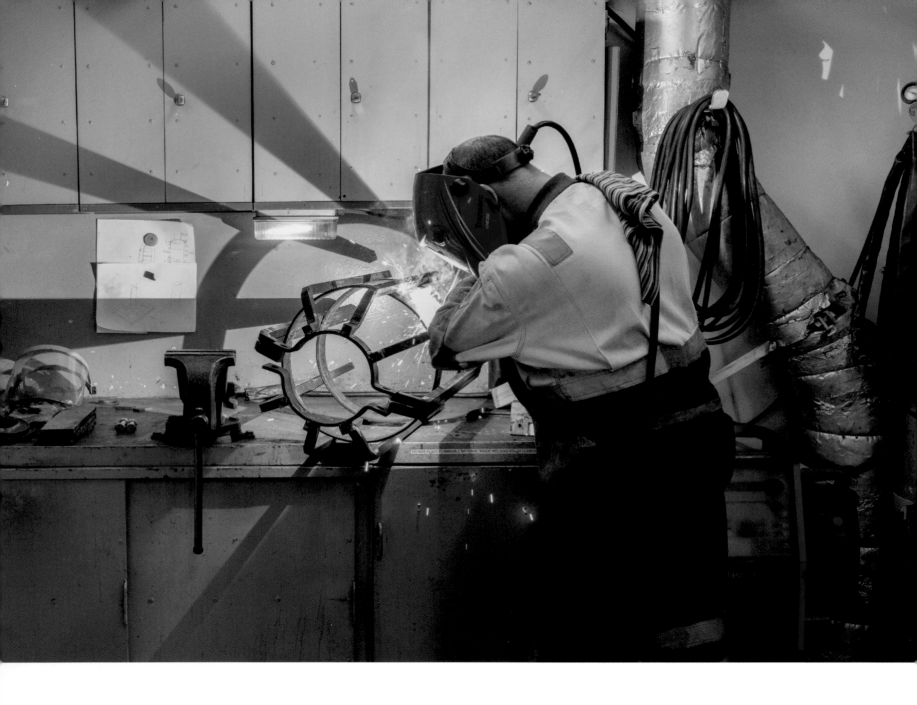

Engineer Zaahir Kaffoor welds a new mount for the subsea
team's acoustic transducer in the ship workshop during the
Weddell Sea Expedition 2019.

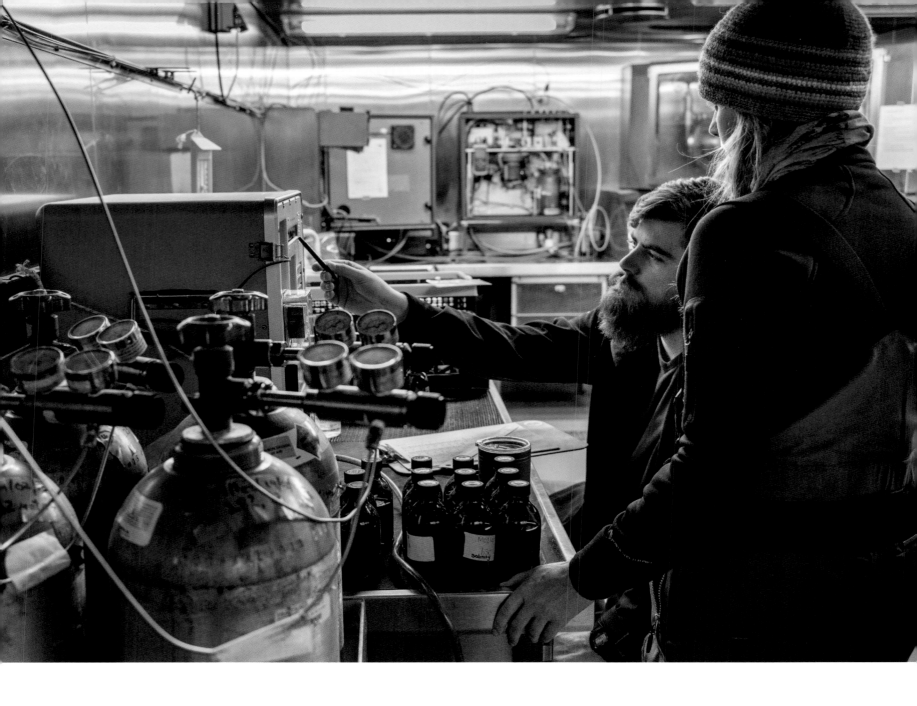

Weddell Sea Expedition marine scientists Harry Luyt (seated)
and Lucy Woodall carry out an analysis of seawater samples
in the wet biology laboratory on board the S.A. *Agulhas II*.

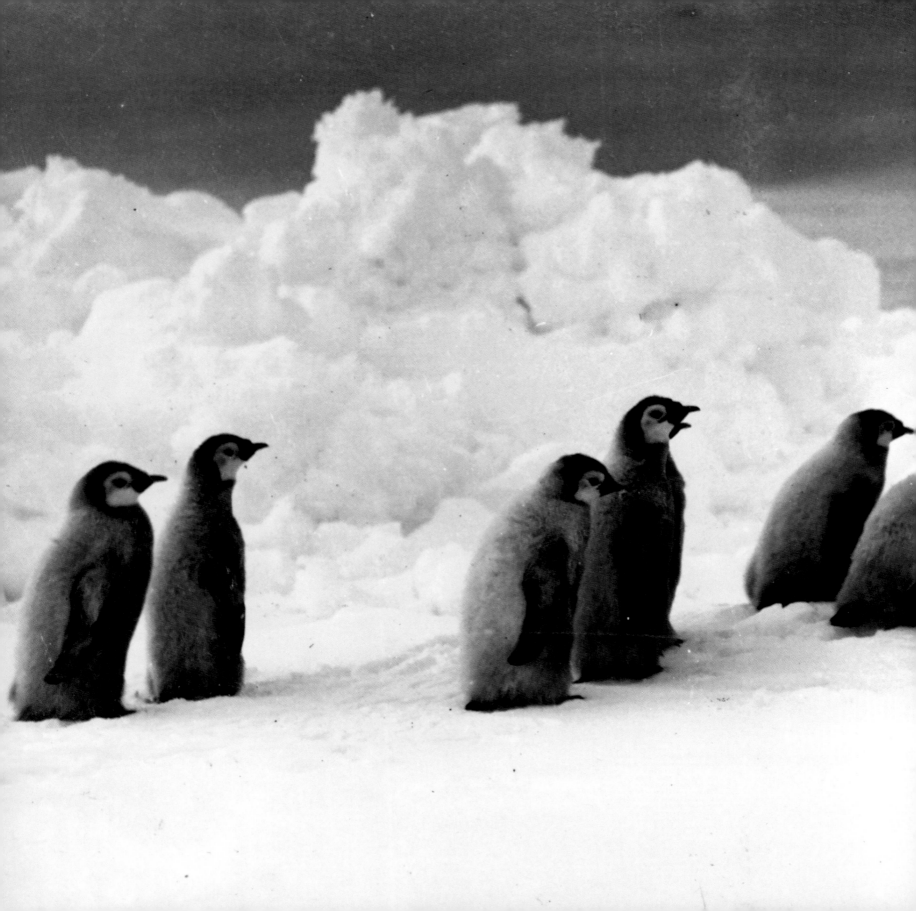

The Emperor Penguins

Both the *Endurance* and the Endurance22 crews frequently encountered emperor penguins in Antarctica. Emperors are the largest penguin species, standing about four feet (1.2 m) tall and weighing as much as 100 pounds (45 kg) when fully grown. They are also the deepest-diving bird species on Earth, swimming to depths of 1,800 feet (550 m) when hunting for fish, krill, and squid.

Found only in Antarctica, emperor penguins are unique among birds because they incubate their eggs and raise their chicks on the sea ice. Recent research by scientists at the British Antarctic Survey has discovered the penguins' colonies are dwindling and even disappearing, threatened by the rapidly melting sea ice. Scientists predict that if global temperatures continue to rise, with further major melting of sea ice, up to 90 percent of emperor penguin colonies may disappear by the end of the century.

LEFT: Young emperor penguins gather on an ice floe in January 1915. When Shackleton saw these chicks for the first time, he thought they were a new species of Antarctic bird.

BELOW: This adult emperor penguin seems curious about Endurance22 photographer Esther Horvath. Emperor penguins usually live about 15 to 20 years in the wild.

Claire Samuel (at right), offshore manager for the Weddell Sea Expedition 2019, supervises a dead vehicle recovery procedure after a failure of the Hugin 6000 AUV.

Drifting With the Ice

DR. MARC DE VOS, OCEANOGRAPHER AND WEATHER FORECASTER, ENDURANCE22

The Weddell Sea ice pack seems more like a living, breathing entity than an inert, frozen surface. As temperatures fluctuate, ice forms and melts. As the tide rises and falls, the ice might diverge and fracture, or mesh with itself and thicken. The ice might drift under the influence of the wind and currents, or trace intricate spirals due to Earth's rotation.

Scientists have made great strides in polar research over recent decades, but our incomplete knowledge of the physics involved still hinders detailed predictions of sea ice motion. Regular, real-world measurements are key inputs to forecast models, but the harsh weather and remoteness of the Antarctic make collecting data there extremely tough. Without updated measurements to refer to, computer models must make future predictions based on previous guesses, thereby accumulating error.

Despite the difficulty, anticipating changes in the ice cover is central to specialized operations in the Weddell Sea. No ship can withstand Weddell Sea ice at its worst. Crews must cooperate with the ice, rather than fight it. During Endurance22, searches lasting many hours directed the AUV over areas of the seafloor, but as the underwater vehicle searched, the ship's overhead position changed constantly due to sea ice motion. Failure to account for this ice drift during surveys could therefore bring the team, quite literally, to the end of their (or the AUV's) tether. That made relying on any single, imperfect source of weather or ice information for operational planning unwise. To form a coherent picture of the environment and how it might change during surveys, we had to gather and weigh a diverse range of information. Success demands a blend of data analysis and intuition. At times, sea ice planning feels more like an art than a science.

Late in the expedition, we found an opportunity to apply a contemporary method to Shackleton's century-old story. Throughout Endurance22, we used a modern algorithm to predict ice drift based on the latest weather forecasts. This sparked the idea of applying historical weather data from diaries and a backward-looking computer model to the new algorithm. In this way, we were able to simulate the unknown drift of *Endurance* over the three days prior to its sinking. The results, while inherently uncertain due to limitations in the input data, were plausible. They provided just one more fragment of information for expedition leaders to ponder amid the ever shifting world of the Weddell Sea.

OPPOSITE: Dr. Marc de Vos, senior meteorologist on Endurance22 (at left), shows the latest weather data to JC Caillens, offshore manager (middle), and Nico Vincent, expedition subsea manager (right), as they plan the next dive of the Saab Sabertooth AUV.

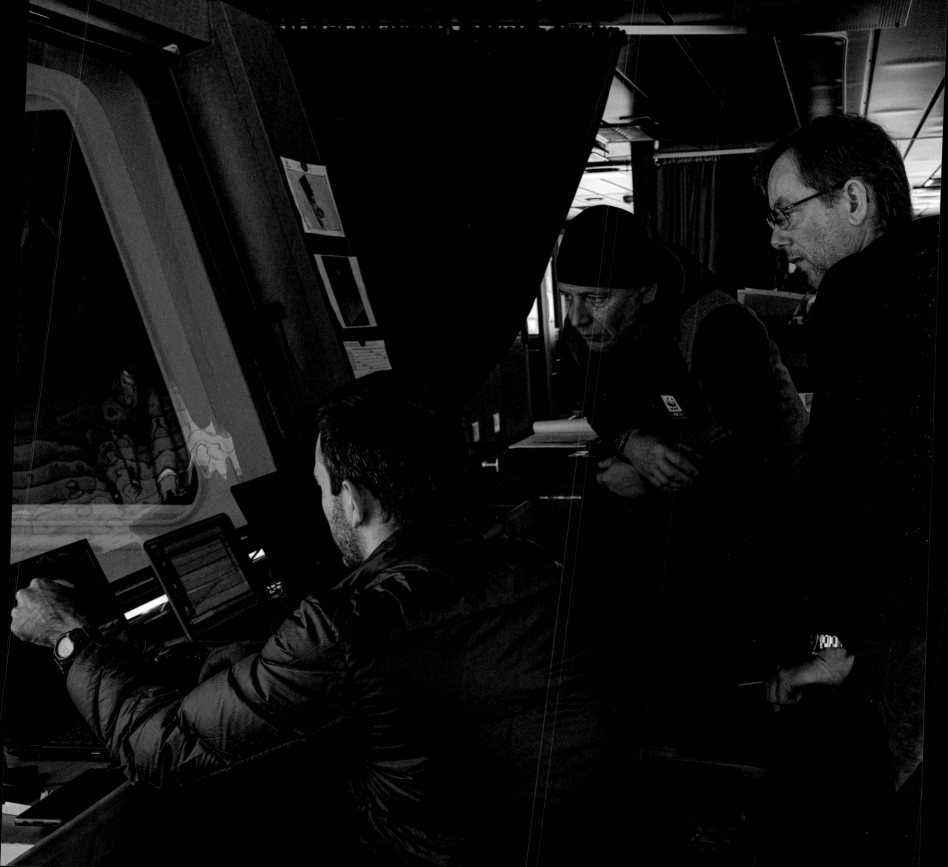

The Weddell Sea Expedition 2019 research team pulls ice cores—cylinders of ice collected vertically through the floe—from sea ice at the Fimbul Ice Shelf.

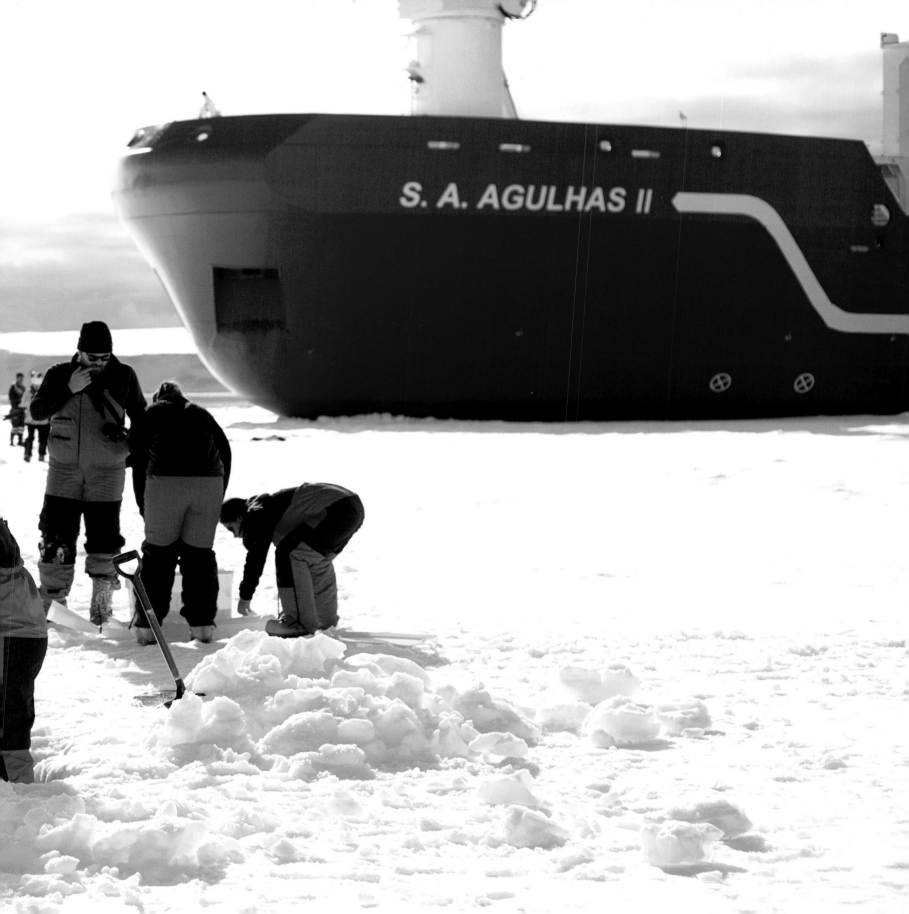

The Second Chance

"I LOVE
THE FIGHT,
AND WHEN
THINGS ARE EASY,
I HATE IT,
THOUGH
WHEN THINGS
ARE WRONG
I GET WORRIED."

—Sir Ernest Shackleton

Early morning aboard the S.A. *Agulhas II* as she
prepares to leave Cape Town, South Africa, to
begin the Endurance22 expedition

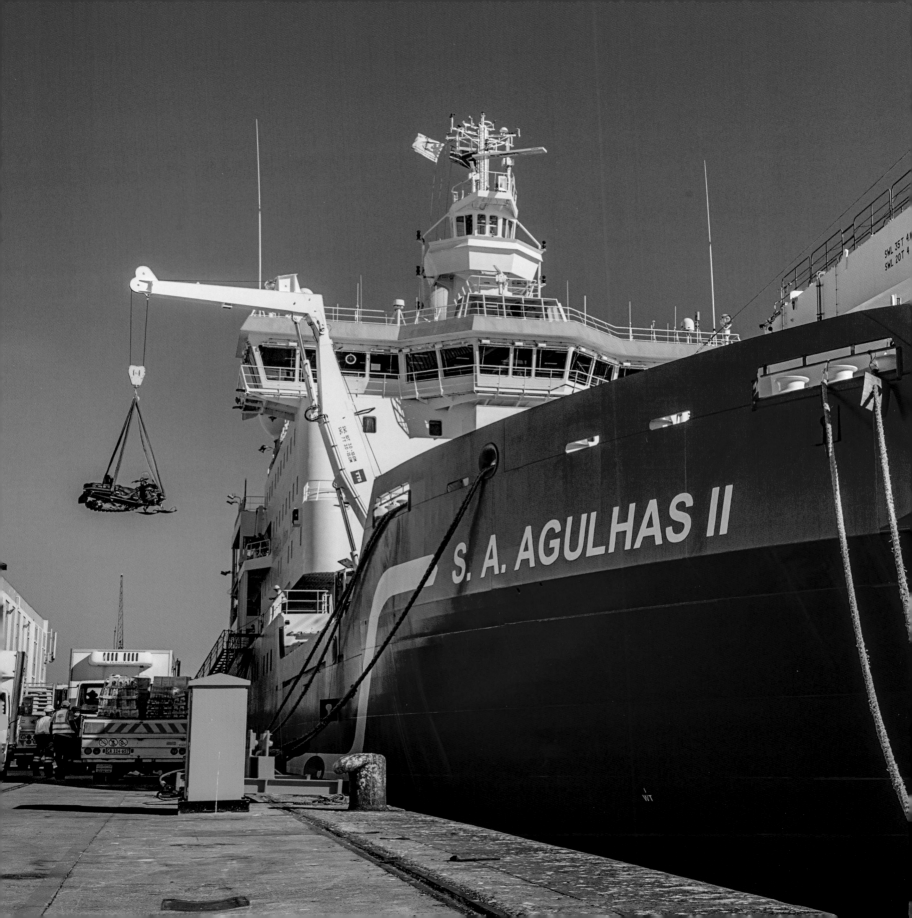

The Second Chance

JOHN SHEARS

The Falklands Maritime Heritage Trust called the new expedition Endurance22 and named me the expedition leader. The trust contracted with the marine robotics company Ocean Infinity to provide the underwater vehicles, and the deepwater survey and salvage company Deep Ocean Search to manage the subsea operations. Nico Vincent would be our subsea manager in charge, handpicked and appointed for his skill in finding solutions to unique deepwater challenges. Nico was entrusted with full control over the choice of underwater vehicles and subsea equipment, as well as the freedom to select the best search team.

Nico is a brilliant marine engineer, diver, and surveyor with more than 30 years of experience working on deep-sea projects. The new search for *Endurance* would be in excellent hands. He has led the discovery and survey of several of the world's deepest shipwrecks, including the deepest

recovery of lost cargo in history—100 tons (90 t) of silver coins from the S.S. *City of Cairo* at a depth of 17,000 feet (5,180 m) in 2013 on behalf of the U.K. government.

To plan for Endurance22, Nico consulted former subsea offshore manager Claire Samuel's comprehensive "Lessons Learned" report from the Weddell Sea Expedition in 2019. She had written a "bible" of sorts detailing the shortcomings of the previous search attempt, and offering recommendations for future missions into the Weddell Sea. Nico kept the report close at hand. We needed to look across all our expedition operations to ensure every possible point of failure was addressed and the problems that befell the 2019 expedition didn't repeat themselves.

A challenge Claire highlighted was the need for the expedition to change how we deployed the AUV so our subsea operations would work with the pack ice rather than against it, as our efforts in 2019 had proven fruitless. To change this operating philosophy, we needed continuous and accurate forecasts of the pack ice in the Weddell Sea, so in January 2021, I renewed contact with Dr. Lasse

The S.A. *Agulhas II* at East Pier on the Victoria and Albert Waterfront in Cape Town, South Africa, ready to receive cargo and supplies for the Endurance22 expedition

Rabenstein and his company at Drift+Noise in Germany to see if they could help. Nico wanted daily forecasts of the sea ice conditions and high-accuracy predictions of how the ice floes would drift across the search box. Luckily, in the years following the WSE, Drift+Noise had developed a new forecast system called PRIIMA (PRedicted Ice IMAges). This computer system merged near-real-time satellite radar images with a mathematical wind and ice drift model to produce high-resolution sea ice forecasts and ice drift trajectories. In simple terms, the system would give us an updated 72-hour ice forecast every six hours.

What's more, Nico and I decided it was important to have Lasse and scientists from his company on board the vessel for the Endurance22 expedition so they would always be on hand to help with ice navigation and interpreting the satellite imagery and computer model outputs. At our invitation, Lasse became chief scientist on Endurance22, and he put together an international team of expert sea ice researchers and engineers from Drift+Noise, the Alfred Wegener Institute in Germany, Aalto University in Finland, Stellenbosch University in South Africa, and the South African Weather Service.

Nico's greatest challenge during the expedition planning was to identify the best AUV for us to use. We could have tried the Kongsberg Hugin 6000 again—just one dive would cover the entire search box—but Nico decided, based on Claire's report, that it wasn't suitable for operations under ice because of the lack of control of the robot once it was underwater.

Nico decided to seek an alternative vehicle. He wanted a more robust, rugged, and reliable AUV, one that could dive to a depth of 3,000 meters (9,842 ft) and be controlled from the surface, with its position always known. Ocean Infinity came back with a new type of hybrid AUV, the Sabertooth manufactured by Saab in Sweden, which could operate in deep water either as an autonomous vehicle, or by manual control via a fiber-optic tether. Using the tether meant the subsea team were always in control; they could receive the precious subsea survey data as soon as it was collected, and in case something went badly wrong, they could recover the vehicle and haul it in from deep water.

Next, I wanted the search box reassessed. In January 2021, I asked the Falklands Maritime Heritage Trust to commission experts led by John Kingsford at Deep Ocean Search to review the existing records, documents, charts, and data on the box's location. After considering a wide range of historical information, then analyzing all the possible variations due to chronometer errors and ice movements, they produced a revised rectangular search box measuring 15 nautical miles (17 mi/28 km) by 8 nautical miles (9 mi/15 km) offset to the east and south of Worsley's estimated sinking location. The new search box was in a slightly different position to the one used in 2019.

Finally, we developed a backup plan in case the ice conditions in 2022 prevented the ship from reaching the search box. Under these circumstances, we would use two helicopters to fly in a portable ice camp, drill a hole in the ice, and launch the AUV from there. Building the ice camp required new engineering technology and methods never used before in Antarctica. Nico's team designed a hydraulic drill auger that could bore a 10-foot-wide (3 m) hole through ice over 16 feet (5 m) thick, and they built a sled-mounted launch-and-recovery system for the AUV that we could pull across the ice. All of this equipment came with a strict logistics requirement: No one item could weigh more than 1.5 tons (1.36 t), the maximum underslung load the helicopters could carry off the ship. It took most of 2021 to put together all the technology and equipment required, and in the end, Nico's team provisioned two ice camps, "Ocean Camp" and "Patience Camp," named after those used by Shackleton and his crew.

We had planned for every scenario, and we were well prepared for Endurance22. This time, we wouldn't let the "evil" ice of the Weddell Sea surprise and defeat us.

THE ANNOUNCEMENT

The trust publicly announced the Endurance22 expedition on July 5, 2021. We would sail from Cape Town, South Africa, in February 2022 to search for the wreck of *Endurance*. I was confirmed as the expedition leader, Nico the deputy leader and expedition subsea manager, Lasse the chief scientist, and Mensun Bound the marine archaeologist and director of exploration. On my recommendation, the trust also chartered the S.A. *Agulhas II* as the expedition ship, as she, Captain Knowledge, and her crew had already proven capable of reaching the wreck location.

Endurance22 would have three objectives: First, to locate, identify, and survey the wreck of *Endurance*. Second, to bring the story of Shackleton to a new generation through a major international educational and outreach campaign. Third, to investigate and study the remote western Weddell Sea ecosystem.

Following the launch, hundreds of schools and colleges across the world became interested in following the expedition and getting involved. As a result, Donald and the trust partnered with the U.S. education organization Reach the World to produce regular livestream broadcasts from on board the S.A. *Agulhas II* for a series of teaching modules to be used in classrooms. An experienced educator at Reach the World, Tim Jacob, would come on the expedition to lead these activities directly from the ship.

In addition to the student program, the trust partnered with Little Dot Studios in the United Kingdom to film the expedition. Award-winning documentary filmmaker Natalie Hewit was appointed the film director, and Dan Snow, a U.K.-based television presenter and historian, led our social media campaign. With so many eyes on

BASED ON NO MORE THAN A HUNCH, AND ANTICIPATING THE WORST-CASE SCENARIO, NICO ASKED SAAB TO REPAIR THE WINCH AND RENT IT TO OUR EXPEDITION AS AN EMERGENCY BACKUP, JUST IN CASE OUR TWO BRAND-NEW WINCHES SOMEHOW FAILED.

Endurance22, the stakes were high, but I was quietly confident that this time we would find Shackleton's ship.

TRIALS AND TRAINING

One of the most important aspects of our preparation was the comprehensive testing of the AUVs and training for the subsea team well before our arrival in Antarctica. Beginning in August 2021, Nico worked flat out for six months to ensure the team was ready for departure on time.

In September 2021, Nico and the subsea team went to Motala in northern Sweden, where Saab houses their subsea test center. Here, the team learned how to set up, deploy, and operate the two Sabertooth vehicles specially built for the expedition. When the vehicles were ready to leave the test center, we followed a long tradition at Saab and gave the vehicles names, "Ellie" and "Doris."

During training in Motala, Nico made an on-the-spot decision that proved vital to the wreck search. At the back of the test center's massive warehouse, he noticed a 20-year-old winch hidden under a ragged tarpaulin. It was an old model once owned by the Finnish Navy and unused for many years. Based on no more than a hunch, and anticipating the worst-case scenario, Nico asked Saab to repair the winch and rent it to our expedition as an emergency backup, just in case our two brand-new winches somehow failed.

From Sweden, the subsea team moved to the port of Toulon in the south of France for deepwater and ice camp trials in early October. Offshore, the team tested the Sabertooths in multiple deep dives. Then the team moved to a barge moored in the port to simulate Sabertooth dive operations from an ice floe and test the vehicles' sled-mounted launch and recovery system. Next they practiced deploying and dismantling an ice camp on a plastic ice rink a few miles inland. Finally, they brought in massive ice cubes—about 530 cubic feet (15 m³) each—to test the hydraulic drill rig. Frédéric Bassemayousse, our drill and deck master, was in charge of the drill tests.

Training concluded in early December with Fred and Jean-Christophe "JC" Caillens, the offshore manager of the subsea team, traveling with Nico to Tignes, a town high in the French Alps. Here beneath a frozen lake, Fred and JC had lessons in under-ice scuba diving just in case something went wrong with the field camp operations in Antarctica—perhaps a Sabertooth getting stuck under the ice next to a dive hole.

The testing and trials were a huge success, and by the end of December, we were ready to ship all the expedition equipment, materials, and supplies to South Africa. The entire cargo weighed nearly 50 tons (45 t). The final item squeezed in was the Endurance22 team mascot, "Samson," an oversize plush toy husky named after Shackleton's most powerful sledge dog on *Endurance*.

LAST-MINUTE HICCUPS

But just when we thought we might be able to grab a couple days of Christmas holiday, we were hit by two last-minute problems, both of which threatened to halt the expedition.

First, we learned that the shipping of our expedition equipment and cargo from Europe to South Africa might not happen at all. The impact of the COVID-19 pandemic was still reverberating around the world, causing massive disruption and long delays to international shipping. There was no space for our gear on any container ship going to South Africa for several months. Fortunately, Nico had anticipated this might happen, so he actioned our backup plan and chartered a heavy-lift aircraft to fly all 50 tons (45 t) of our equipment overnight from Liège in Belgium to Cape Town. The plane landed on Christmas Day. Nico had delivered a wonderful Christmas present.

The second problem arose on December 28, when our South African heavy-lift helicopter was withdrawn unexpectedly from the expedition to aid in firefighting duties on the Western Cape. We canceled New Year celebrations as we scoured the world for a suitable replacement. After an intensive search, we found a Kaman K-MAX helicopter available for immediate charter. Unfortunately, it was on the other side of the world in Sacramento, California. The team wasted no time. In just two weeks, we had the K-MAX dismantled, trucked to Chicago, then sent in pieces by

commercial air freight from Chicago to Johannesburg. Once in South Africa, the pieces were trucked down to Cape Town, where the K-MAX was reassembled and flight-tested. It was an extraordinary effort.

CAPE TOWN

By January 2022, we were all ready to start mobilizing the expedition in Cape Town, loading all the equipment and cargo, pumping the maximum fuel possible into the ship's tanks for the voyage ahead, landing the two helicopters on board, and embarking the 65 members of the expedition team on the S.A. *Agulhas II*.

On January 22, Nico and the subsea team of 16 engineers, technicians, and surveyors arrived to reassemble the Sabertooths and prepare them for the expedition. To comply with aircraft safety regulations, the batteries in the two AUVs had to be removed for the flight to South Africa. Now the team had to refit, repower, and test the systems. This proved to be much more complicated than expected. By this time, both vehicles had been without their batteries for 2 months, and for a reason we couldn't discern, they wouldn't work when the batteries were reinstalled. One of the AUVs, Doris, never completely recovered from the flight, and the other, Ellie, needed several days of intensive repair work to get her batteries and electronic systems working properly again. In the aftermath of the repairs, we identified Ellie as our primary

search AUV and Doris as our backup. Thanks to the huge efforts of the Saab engineers, we left Cape Town with both AUVs ready to dive.

Meanwhile at the ship, final urgent preparations for the expedition were being completed, including engineering and welding work on the back deck, the installation of all the expedition containers and equipment, and the loading of drummed fuel, stores, and supplies, All of this work was supervised by Seb Bougant, the expedition's logistics manager, and he ensured everything was done quickly and efficiently. Without him we would never have left Cape Town on time.

I flew out from London to Cape Town on January 29, 2022. I was in good spirits and confident in our plans, but I was nervous as well. I knew from my long experience of expeditions to Antarctica we would need to overcome numerous unexpected challenges in the Weddell Sea if the search mission was to succeed.

After undergoing strict COVID-19 protocols and testing, I boarded the S.A. *Agulhas II* on January 31, followed by Nico and the subsea team the next day. By February 4, all 65 members of the expedition were successfully embarked on the ship. It was an amazing group of world-leading experts from 10 different countries, comprising engineers, technicians, surveyors, scientists, helicopter pilots, drone pilots, field guides, filmmakers, a photographer, and a doctor. We joined the 45 experienced South African officers and crew

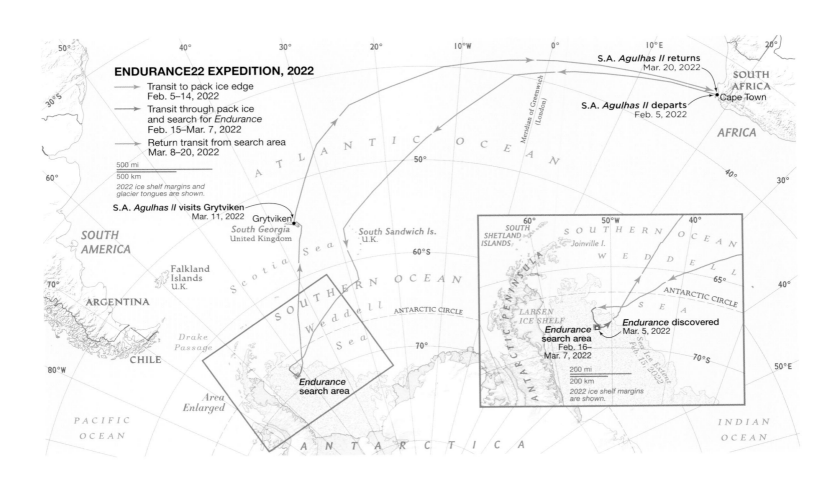

ENDURANCE22 EXPEDITION, 2022

Transit to pack ice edge
Feb. 5–14, 2022

Transit through pack ice
and search for *Endurance*
Feb. 15–Mar. 7, 2022

Return transit from search area
Mar. 8–20, 2022

2022 ice shelf margins and glacier tongues are shown.

S.A. *Agulhas II* visits Grytviken
Mar. 11, 2022

S.A. *Agulhas II* returns
Mar. 20, 2022

S.A. *Agulhas II* departs
Feb. 5, 2022

Endurance discovered
Mar. 5, 2022

Endurance
search area
Feb. 16–
Mar. 7, 2022

2022 ice shelf margins are shown.

Endurance
search area

Area Enlarged

Chart of the voyage of the S.A. *Agulhas II* during the Endurance22 expedition

of the S.A. *Agulhas II* to form a total team of 110 men and women, all united in our quest to find *Endurance*.

At 9 a.m. on February 5, 2022, the S.A. *Agulhas II* cast off from East Pier and nudged her way out from the dock. We were on schedule and heading for the Weddell Sea, 3,000 nautical miles (3,450 mi/5,560 km) to the southwest, with a long sea voyage ahead of us across the vast Southern Ocean. That evening, I went out on deck to watch the sunset. Behind us, Cape Town's Table Mountain faded away in the dusk, and I had a quiet moment to reflect. In just 18 months, and despite the added difficulties of the COVID-19 pandemic, we had organized the largest nongovernmental expedition to Antarctica ever undertaken. I was already proud of what the expedition had achieved and encouraged

by the great team spirit we had already fostered on board. I was excited for the great adventure ahead.

RETURNING TO THE WEDDELL SEA

We made good progress the first two days of the voyage, sailing southwest in calm seas. The S.A. *Agulhas II* averaged a speed of 16 knots (18.5 mph/29.5 kph), and we traveled nearly 800 nautical miles (920 mi/1,480 km). But in just a few hours on February 8, the weather changed, and we hit the edge of a nasty midlatitude cyclone. The ship had to slow down as it crashed through waves 20 feet (6 m) high and was battered by winds gusting over 40 knots (46 mph/ 74 kph). Captain Knowledge changed course to the west on the advice of our South African meteorologist, Dr. Marc de Vos, to avoid sailing directly into the center of the cyclone. Despite missing the brunt of the weather system, our back deck was hit by giant waves, and several feet of water flooded the containers and equipment stored there. Skirting around the cyclone set back our arrival at the search area by 24 hours.

On February 11, we had ventured well beyond latitude 50° south and were back sailing at 16 knots (18.5 mph/29.5 kph) toward the remote South Sandwich Islands. The sea was calm, and the sun shone. Everything was going well. But my high spirits fell when I checked my e-mails. The *Times* had published a report saying our expedition "may be looking in the wrong place" based on a new data analysis. The researchers were suggesting we should shift our search area several kilometers to the east. I discussed the analysis with Nico and Mensun, and then we made our own judgment. We decided not to change our plans. We were confident in the expedition's independent research and certain that our search box, agreed on by the Falklands Maritime Heritage Trust well before we left Cape Town, was correct.

We reached the ice edge in the Weddell Sea on the afternoon of February 14. Here, Nico and the subsea team began testing the buoyancy of the AUVs and their underwater tracking system. There was no use entering the pack ice until we were sure the AUVs were operational. But to test the AUVs we had to open the ship's moon pool and deploy an acoustic tracking beacon that would monitor the vehicle's location. The moon pool is a hole in the bottom of the ship allowing scientific instruments and other equipment to be positioned underwater. The pool has two sets of hydraulically operated watertight doors, one at the bottom and one at the top, but during testing, one of the bottom doors wouldn't open because a locking pin was stuck. If we couldn't fix it, the expedition might have to return to port for repairs.

Immediately, the ship's engineers emptied the water from the pool, and two of them, Kobla Dlamini and Orlando February, volunteered to climb down into the chamber with a sledgehammer to dislodge the pin by brute force. It was a risky thing to do, because if the pin was released too sud-

denly, the door could fly open, flood the pool, and trap them. They took it in turns to hit the pin hard with a large sledgehammer. Eventually, the pin moved to the open position and the door was unlocked safely. It was an unconventional and courageous repair, and with the moon pool fully open the beacon could be deployed and the AUV tests completed. At last, we could sail on through the pack ice toward the search box.

On the morning of February 16, Captain Freddie Ligthelm, our experienced ice pilot and navigator, was at the controls of the S.A. *Agulhas II,* keeping the ship in open water and weaving between the ice floes. He told me he expected the ship to arrive at the *Endurance* wreck site at 5 p.m. that evening. The ice conditions were very different from those we had faced on the Weddell Sea Expedition in 2019. We were making 7 to 9 knots (8–10.5 mph/ 13–16.5 kph) through the pack, and to my surprise, there was very little of the thick multiyear pack ice or the massive ice floes we had experienced in 2019. Instead, it was thin first-year ice, between three and five feet (1–1.5 m) thick, which was easy for the ship to break. There were also large channels, or leads, of open water for us to sail through. I had thought it would take us at least three days to traverse the 60 nautical miles (70 mi/110 km) from the start of the ice edge on to the search box, but instead, it took just over 24 hours. Even better, the favorable ice conditions would allow the ship to move and operate all across

the search box in the coming weeks. There would be no need for the ice camps.

I decided to organize a reconnaissance flight on our Bell 412 helicopter to check out the ice conditions on the search box, and took off with Lasse and four members of the science team. After 20 minutes in the air, the helicopter dropped us off on a large ice floe at the sinking location of *Endurance.* As I walked out across the ice, the cold wind blew hard into my face, and I realized in amazement I was perhaps tracing the footsteps of Shackleton and his crew. The floe was flat, a huge white football field, and there were no pressure ridges. It was a majestic white desert stretching to the horizon. We used an ice drill to measure the ice thickness and check the floe was safe to walk across, then installed an ice monitoring buoy, called "Mrs. Chippy" after the cat on board *Endurance,* to provide real-time data on the location, speed, and direction of the ice drift. This data would be vital to calibrating and checking the PRIIMA ice drift computer model and help the S.A. *Agulhas II* navigate through the pack ice as we searched for the wreck.

The ship arrived at the search box exactly when Captain Freddie predicted: at 5 p.m. on February 16. I felt huge relief and pride that I had got the team safely to the site and completed one of my most important tasks as the expedition leader. But now Nico's moment had arrived. The success of his subsea operations would decide whether we found Shackleton's lost ship.

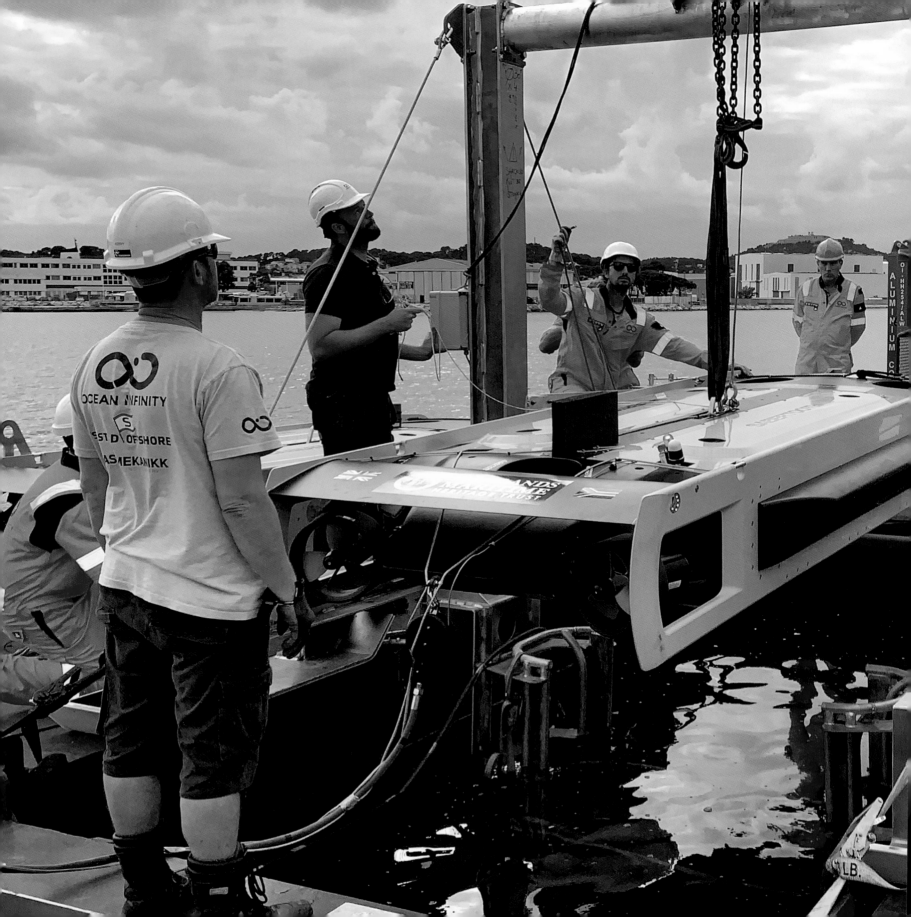

The Saab Sabertooth AUV needed a special sled-mounted launch and recovery system for deployment through the sea ice. The subsea team practiced on a barge in the port of Toulon, France, in October 2021.

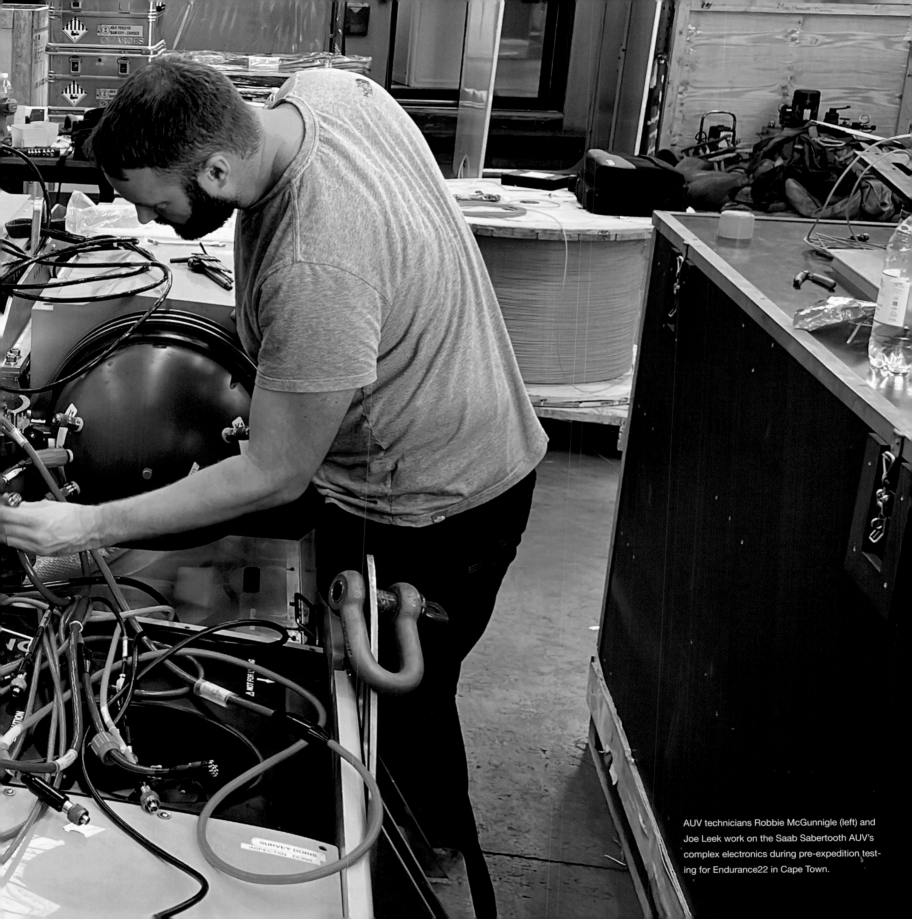

AUV technicians Robbie McGunnigle (left) and Joe Leek work on the Saab Sabertooth AUV's complex electronics during pre-expedition testing for Endurance22 in Cape Town.

The components of this ROTAK Kaman K-MAX heavy-lift helicopter were airfreighted from the United States to South Africa especially for the Endurance22 expedition. The helicopter had to be reassembled in Cape Town and flight-tested before the S.A. *Agulhas II* departed for Antarctica.

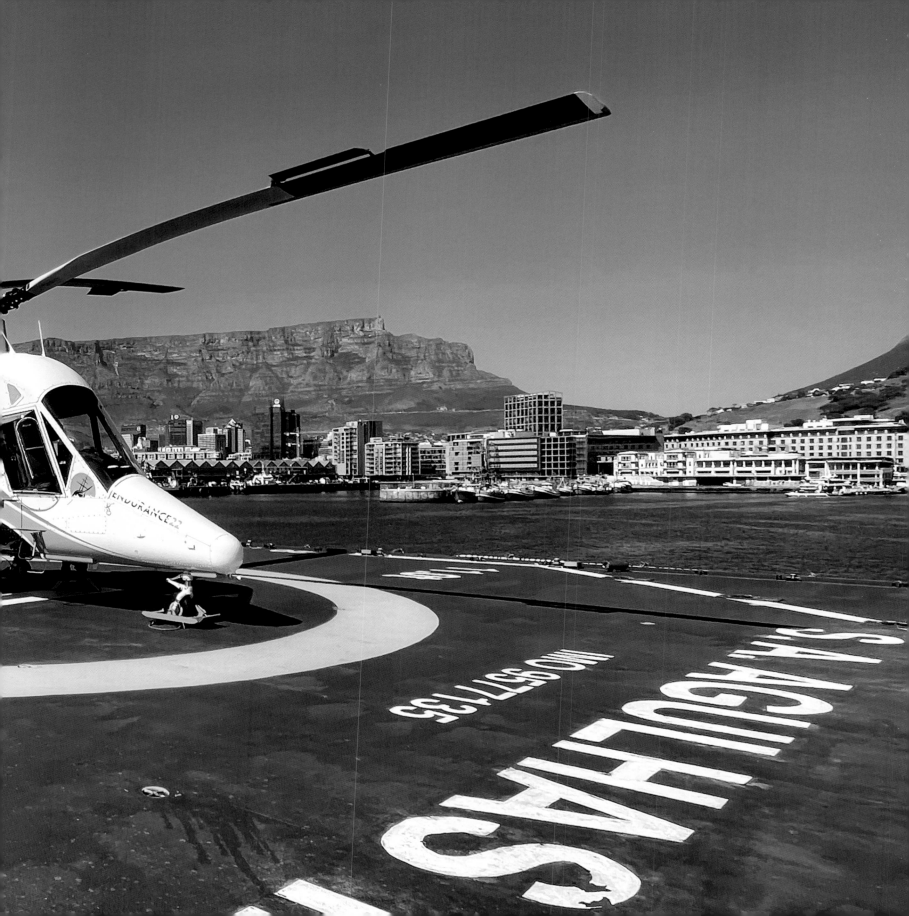

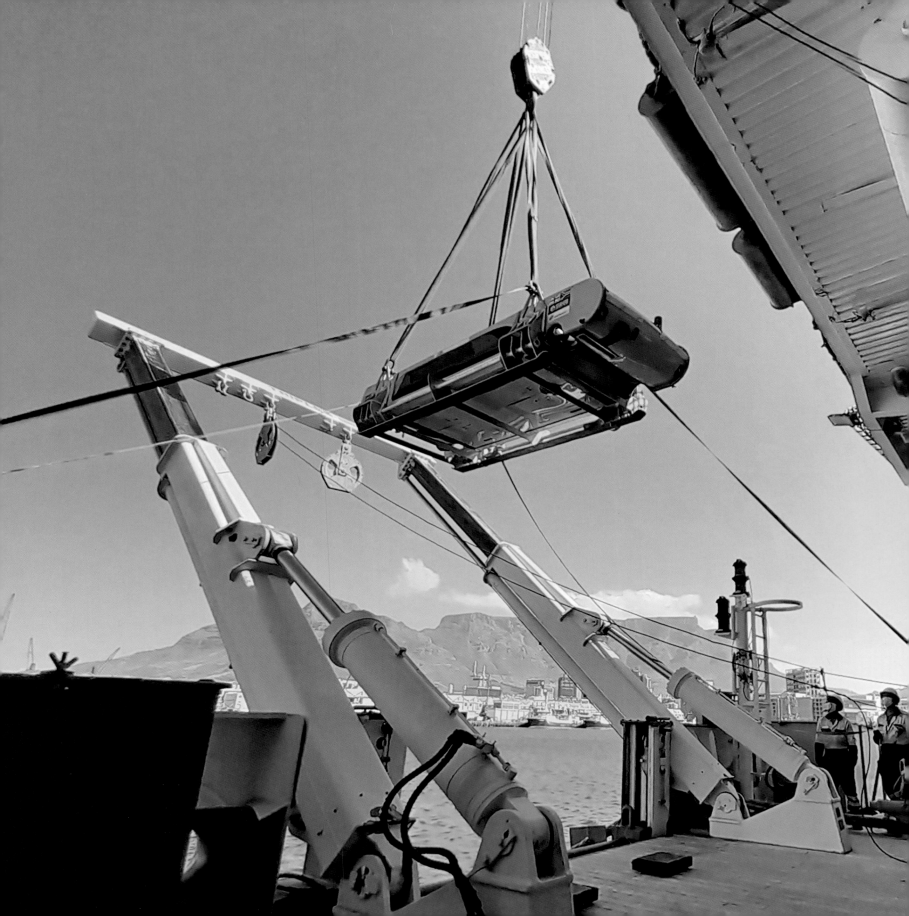

A crane lifts Ellie the Saab Sabertooth AUV aboard the S.A. *Agulhas II* in Cape Town. The Endurance22 expedition took two of the multimillion-dollar underwater vehicles to search for *Endurance,* each weighing 3,750 pounds (1,700 kg).

As the sun sets on February 5, 2022, the S.A. *Agulhas II* and the Endurance22 expedition team leave Cape Town.

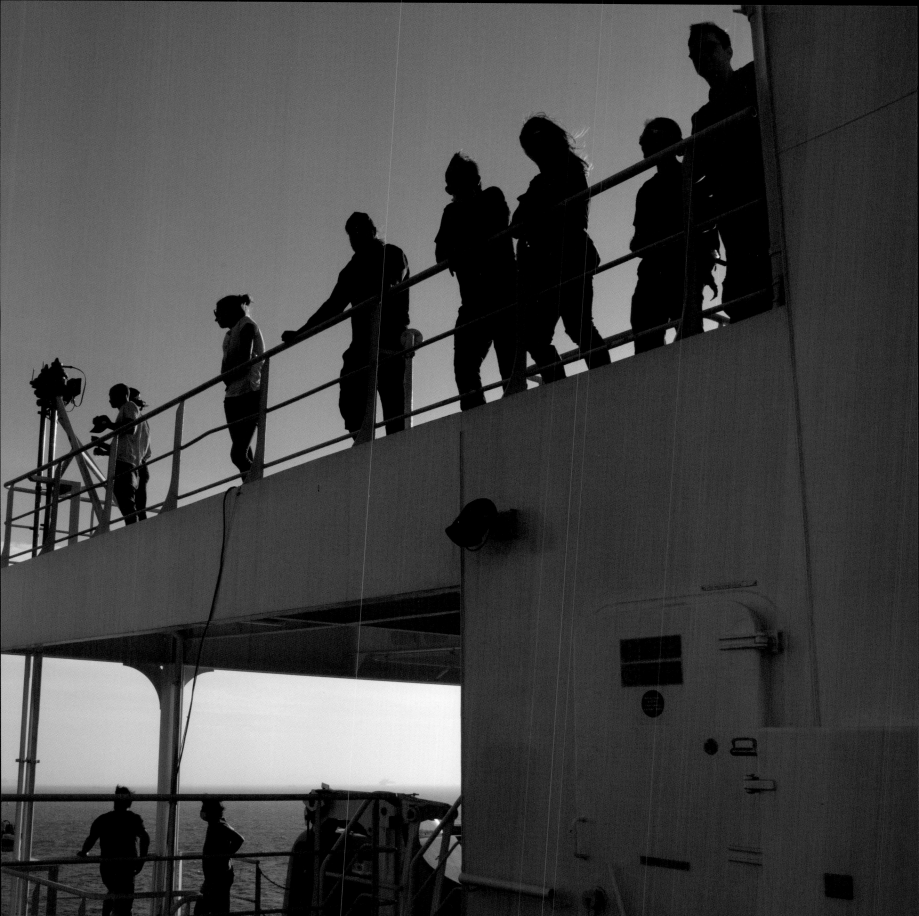

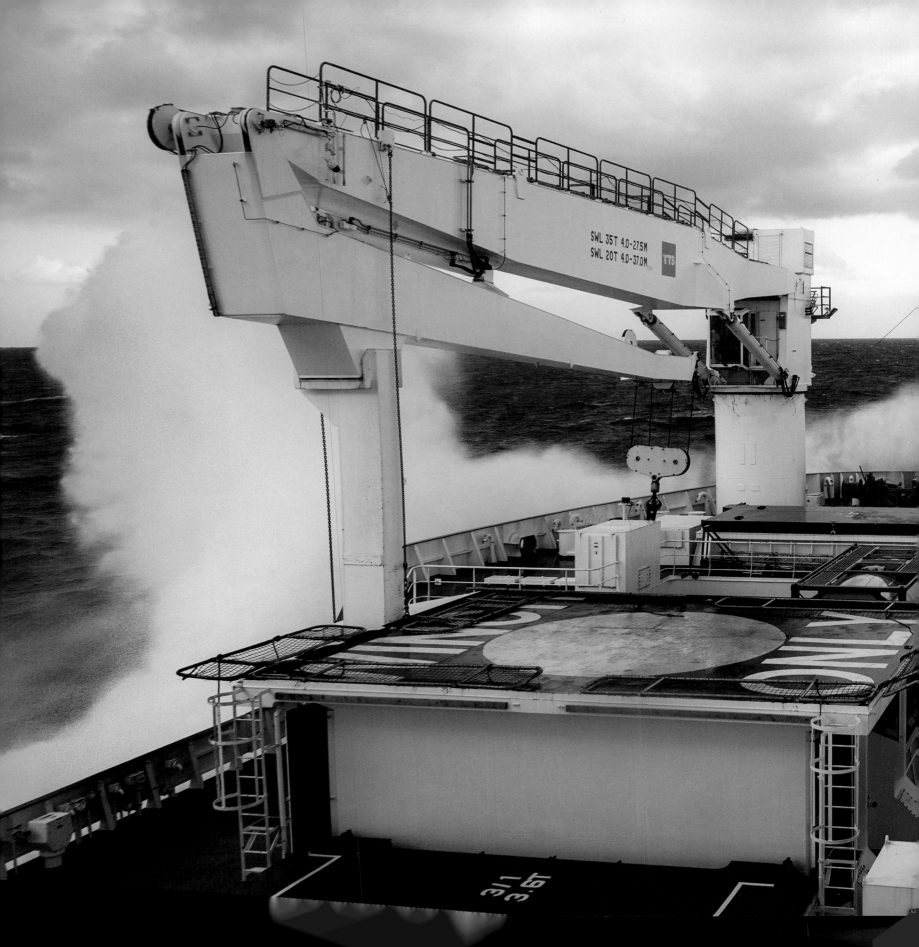

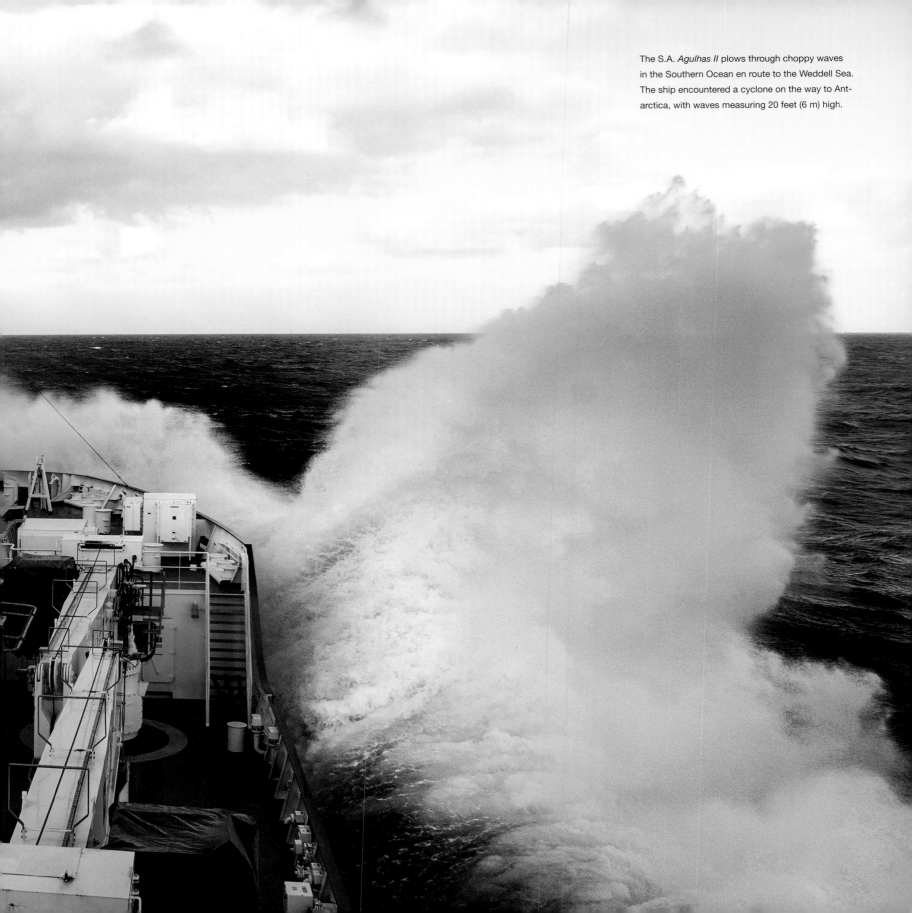

The S.A. *Agulhas II* plows through choppy waves in the Southern Ocean en route to the Weddell Sea. The ship encountered a cyclone on the way to Antarctica, with waves measuring 20 feet (6 m) high.

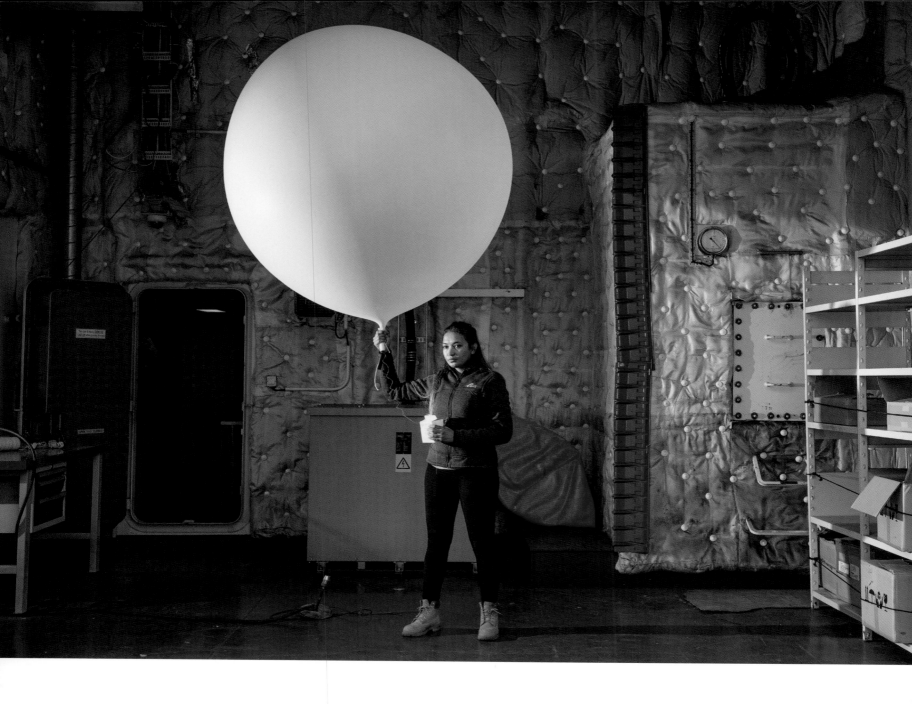

Carla-Louise Ramjukadh, a meteorologist and oceanographer from the South African Weather Service, launches a scientific weather balloon filled with helium gas as the S.A. *Agulhas II* prepares to enter the Weddell Sea pack ice.

Ship's officer Nhlanhla Phakathi (right) and cadet
Thembelihle Kunene (left) check the S.A. *Agulhas II*'s
charts during night watch on the Endurance22 expedition.

Clément Schapman, senior surveyor, runs off the back deck of the S.A. *Agulhas II* after a wave hits the ship on her voyage south to the Weddell Sea.

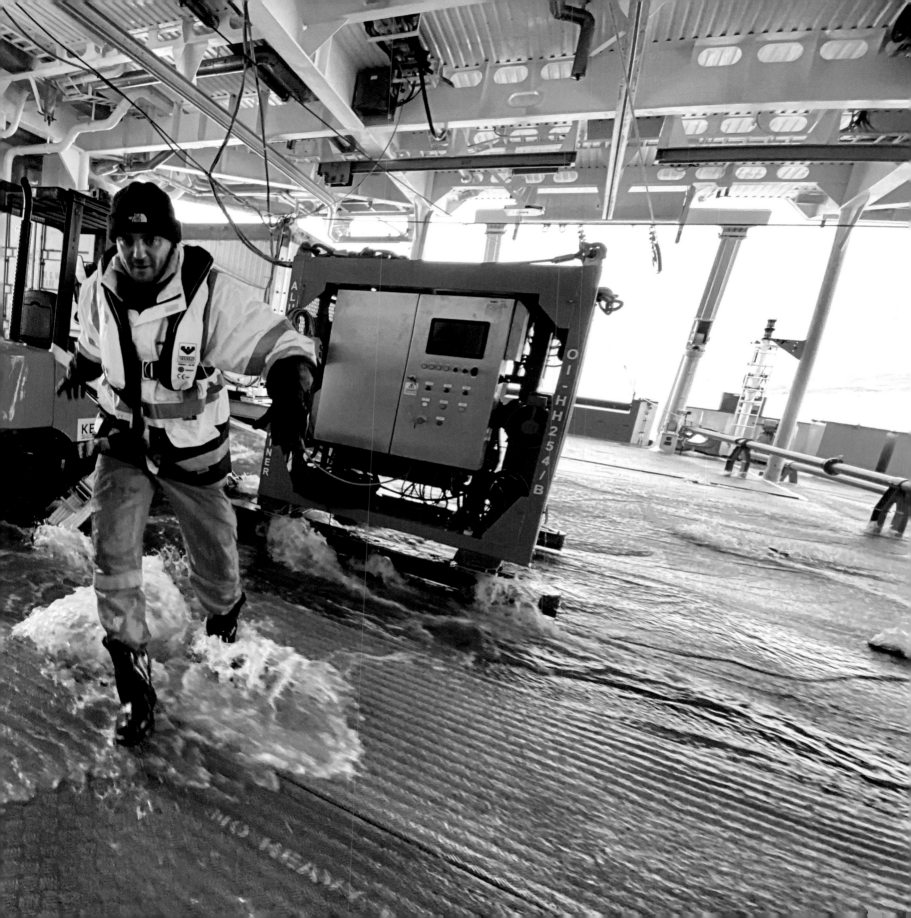

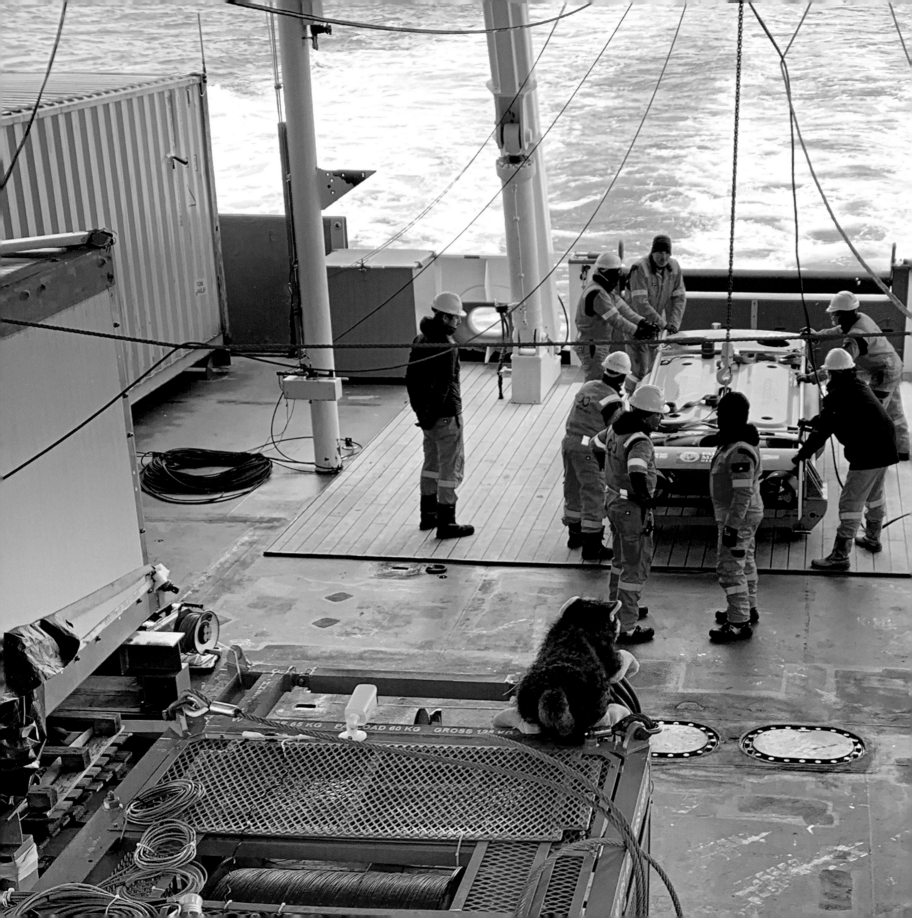

The Endurance22 subsea team prepares to test the Saab Sabertooth AUV on arrival at the ice edge in the Weddell Sea on February 14, 2022. Samson, the team's plush toy mascot, watches closely from on top of the winch.

Crew Recreation

When the *Endurance* crew was stuck in the ice, Shackleton thought recreation was critical to morale, so he organized football (soccer) matches, with the port watch crew playing against the starboard watch crew. One team wore red armbands; the other wore white. Dr. Alexander Macklin, one of the ship's two surgeons, was the referee. Crew diaries record that Dr. Macklin had been badly bitten by a dog and was disappointed he was unable to play.

Members of the Weddell Sea and Endurance22 expeditions also enjoyed football matches and kickabouts on the ice. Team members participated in other outdoor activities, including cricket matches and cross-country skiing. On board the S.A. *Agulhas II*, the crew staged a table tennis tournament in the helicopter hangar. The ship also had an excellent indoor gym, equipped with exercise bikes, so the crew could keep fit in all weather.

RIGHT: Games of football (soccer) kept *Endurance* crew members entertained on days when the ship couldn't proceed through the pack ice.

BELOW: Endurance22 expedition members enjoy a kickabout on the sea ice.

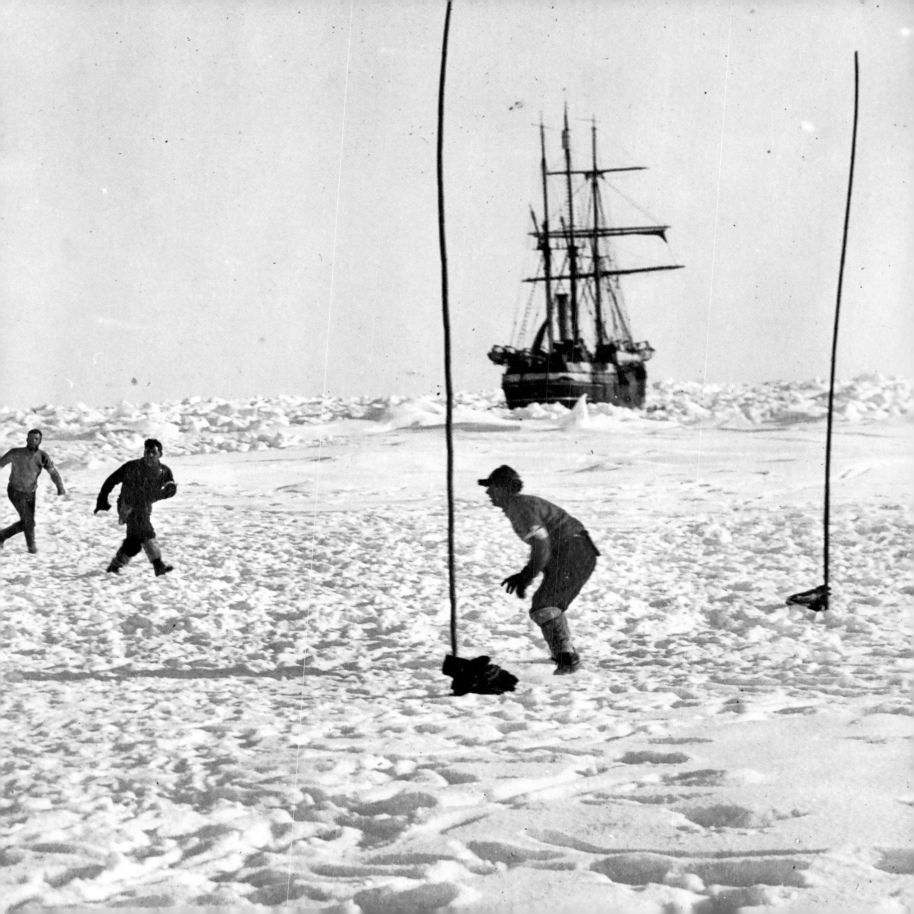

The Bell 412EP helicopter trails the S.A. *Agulhas II* as she enters the pack ice in the Weddell Sea during the Endurance22 expedition.

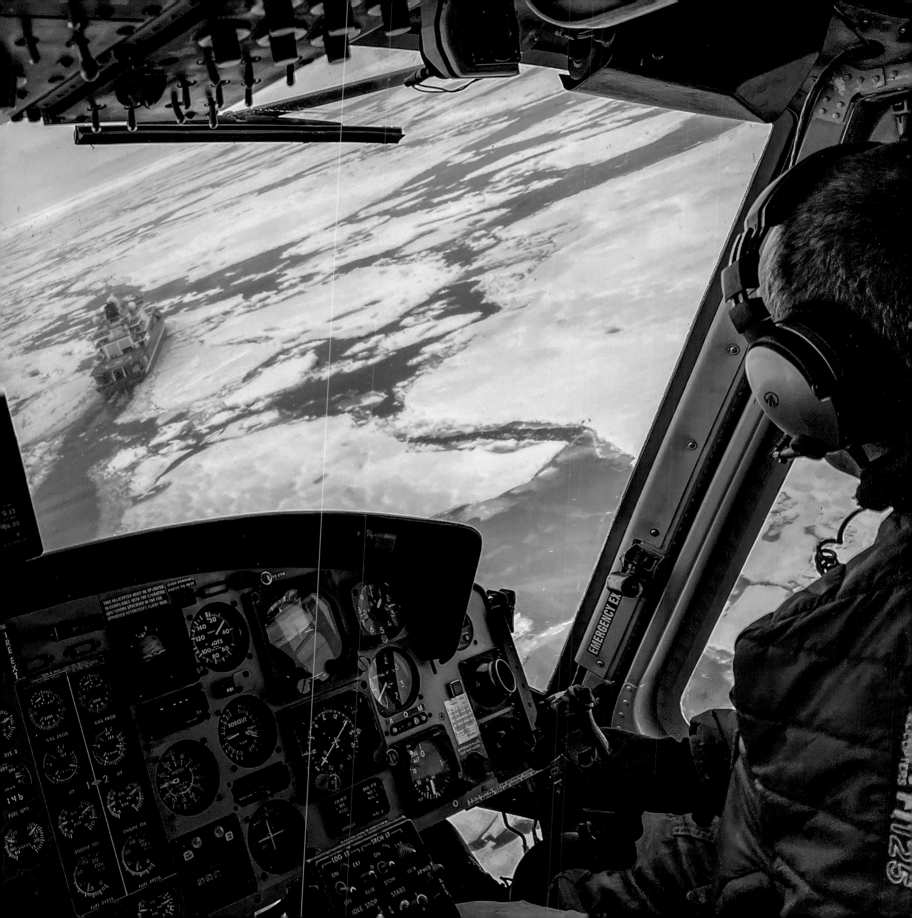

Navigating the Unknown

FREDDIE LIGTHELM, ICE PILOT, ENDURANCE22

The Weddell Sea—the great unknown, the uncharted area—is one of the most challenging of areas to navigate by ship known to man. The Endurance22 team needed to traverse these ice-covered waters to locate and explore a shipwreck beneath its surface—a daunting task that many considered impossible.

We had technology, belief, and a group of very determined people in our favor. But venturing into these parts of our oceans with the S.A. *Agulhas II*—a purpose-built, ice-classed, strong and powerful vessel—still did not alleviate the feeling of fear, uncertainty, pressure, and eventual exhaustion as we strived to do the unthinkable. It makes you think how Sir Ernest Shackleton and his men must have felt in 1915 aboard a wooden, underpowered vessel venturing in this hostile environment. I personally think they must have been scared to the bone. In those days, the ships may have been made out of wood, but the men were made out of steel.

The S.A. *Agulhas II* is equipped with numerous technologies that make it ideal for the Weddell Sea: GPS, electronic chart display systems that show us the latest navigational display information, specialized ice radars, daily satellite ice images, electromagnetic ice thickness measurements in real time, and polar area satellite and radio communication systems—all this

over and above the ship's impressively strong hull and propulsion strength.

Shackleton and his men, meanwhile, were at the mercy of a magnetic compass—prone to errors the closer you go to the magnetic poles—and a handheld sextant with navigation tables. Even though Captain Frank Worsley was an expert navigator with these instruments, his approach to the Antarctic continent might have been different if he had the information available today. He would have known his crew was running into danger before they actually did.

I will forever remain proud that a South African ship with a South African crew could collaborate with an international team on such an epic, challenging, and unforgiving venture. Keeping the crew and team united and the vision of the final goal alive was of the utmost importance. To be successful in the historic discovery of *Endurance* was amazing, but it was only achieved by the collaboration, hard efforts, and teamwork of all involved.

OPPOSITE: Up on the bridge of the S.A. *Agulhas II*, ice pilot Captain Freddie Ligthelm discusses a route through the sea ice with Reagan Paul, chief officer.

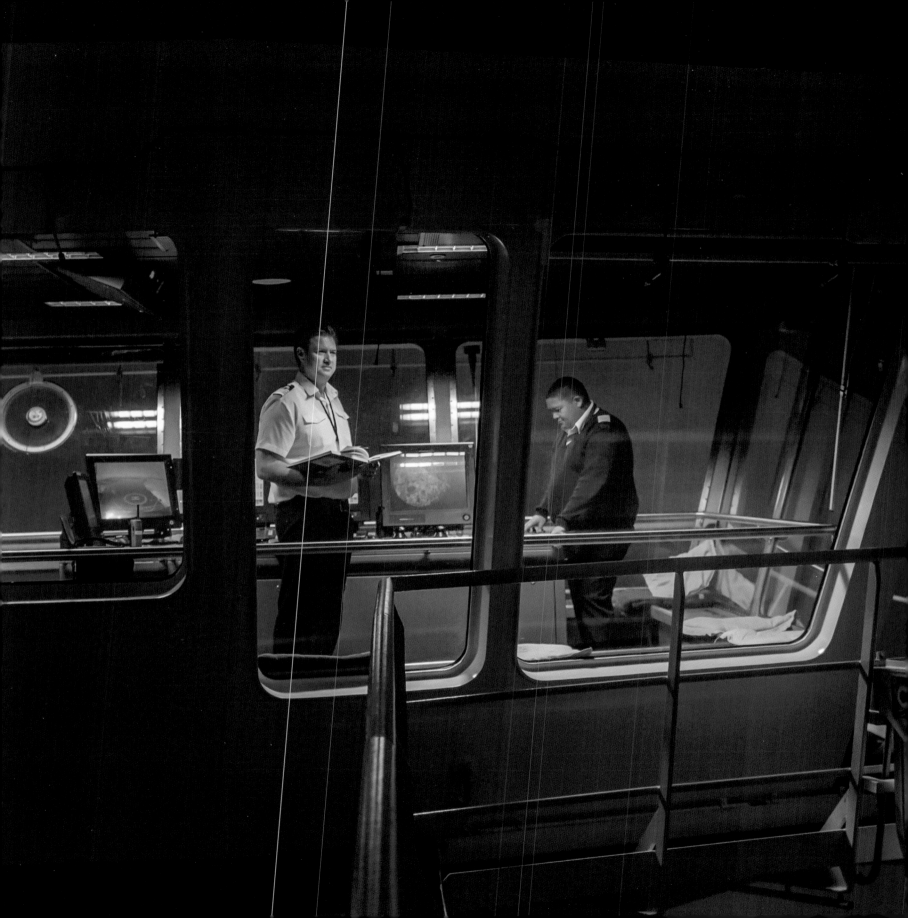

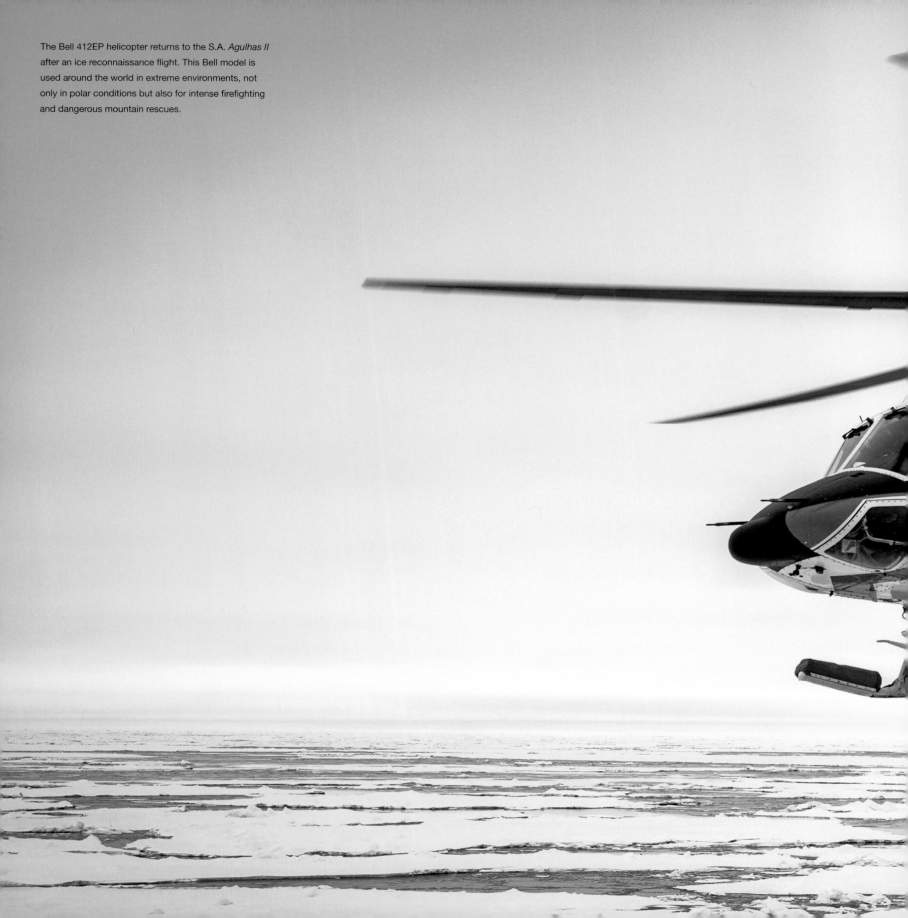

The Bell 412EP helicopter returns to the S.A. *Agulhas II* after an ice reconnaissance flight. This Bell model is used around the world in extreme environments, not only in polar conditions but also for intense firefighting and dangerous mountain rescues.

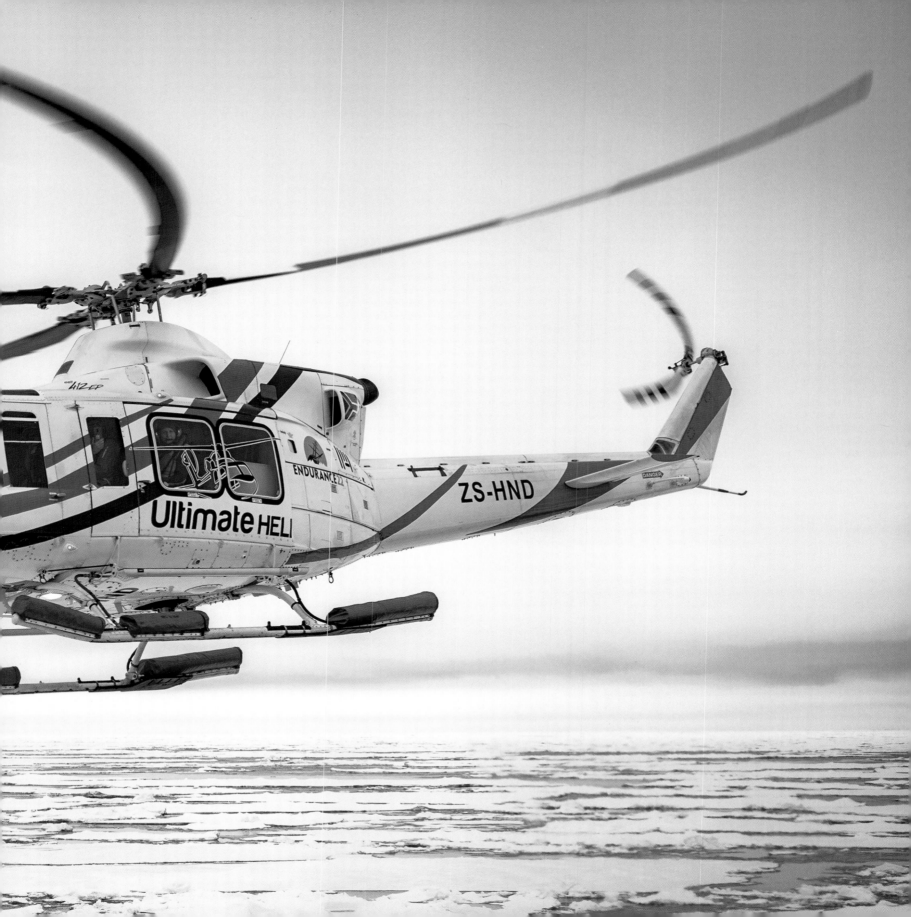

The Discovery

"DIFFICULTIES
ARE JUST
THINGS TO
OVERCOME
AFTER ALL."

—Sir Ernest Shackleton

The Endurance22 decision-makers discuss
search strategies in the Weddell Sea:
left to right, Captain Knowledge Bengu,
Captain Freddie Ligthelm, Dr. John Shears,
Mensun Bound, and Nico Vincent.

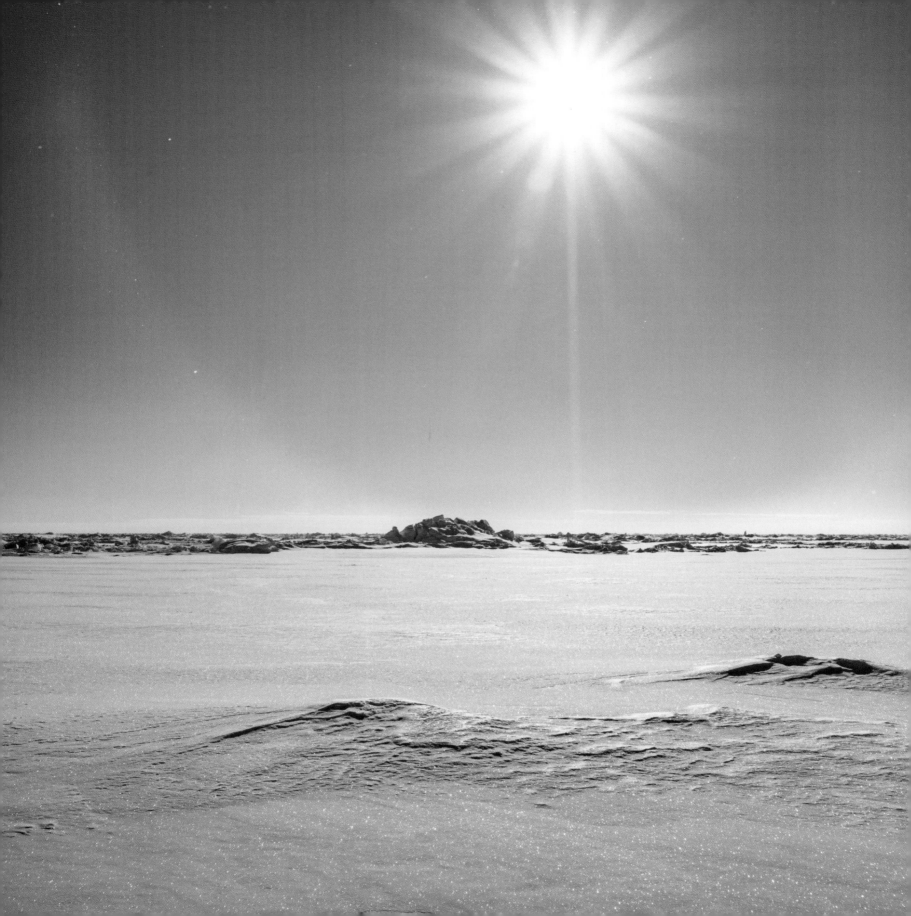

The Discovery

NICO VINCENT

Searching for *Endurance* in 2022 was not just a matter of snapping our fingers and resuming our 2019 expedition. I'd been carefully planning the subsea operation and technical solutions for three years. It was time for action.

I decided we must be single-minded and maintain a laser-sharp focus on the search for the wreck. Therefore, I stopped all other simultaneous operations for Endurance22—no helicopter operations and no scientific research. Nothing could be allowed to interfere with our chances of finding the wreck, and we had to avoid any incident that could jeopardize the short 12 days we had scheduled on-site.

Our chief scientist Lasse was not happy, nor was our helicopter team. But I like to say that I never have a plan B, only a plan 2. If you use a plan B, and plan C, and so on, you are limited to 26 plans. We had to be prepared to use more than 26 plans in order to find *Endurance.* Already during the past two days, the subsea team had battled technical issues with the winches and the AUVs. Before we had even started our first dive, we were on plan 3, and would use up many more plans as we searched for the wreck.

THE FIRST DAY

We began dive operations at 6 p.m. on February 16. Captain Freddie had steered the S.A. *Agulhas II* into an ice floe and broke the ice at our stern to produce an open pool of water, ideal to launch one of our Saab Sabertooth vehicles.

Ocean Infinity had offered the Sabertooth to specifically replace the Kongsberg Hugin 6000 used on the Weddell Sea Expedition. The Hugin was a Formula 1 racing car, but we needed an all-terrain vehicle. Not only are the Sabertooths rugged and robust, but they can also be deployed using a fiber-optic tether so they are in permanent contact with the ship, allowing for real-time manual control and data acquisition—perfect for our needs. The Weddell Sea Expedition in 2019 tried to adapt a standard open-water subsea system between the S.A. *Agulhas II* and the Hugin. But using this

Frozen pack ice in the Weddell Sea entirely covers the sinking location of *Endurance.* On this day a halo, or ring of light, appears around the sun as light refracts off ice crystals high in the atmosphere.

system, the support ship must follow the subsea vehicle to stay in acoustic tracking range. As a result, the subsea vehicle is effectively the master of the operation and controls the course and speed of the ship on the surface.

But in the Weddell Sea, ice conditions make it impossible for the ship to follow the underwater vehicle or reach a specific rendezvous location. Here the ice dictates the operation. The ship can get stuck in the ice and drift well away from the underwater vehicle, as we discovered to our cost in 2019.

In Claire Samuel's "Lessons Learned" report, she emphasized that as well as finding an AUV better suited to working under ice, we should also take advantage of the rapid advances in subsea technology. For Endurance22, we would choose the latest sensors, instruments, and cameras to be carried on our AUV.

The Sabertooth is an amazing subsea vehicle. It can operate in deep water to 9,842 feet (3,000 m). It's a highly maneuverable robot and can carry a wide range of instruments and sensors. For our purposes, these included a side-scan sonar, which uses acoustic pulses to image the seafloor, a 4K broadcast camera able to zoom into details and points of interest, and a 3D laser scanner able to produce a digital 3D model of the wreck with an incredible 1 mm resolution, never accomplished before in deep water. The Sabertooth is powered by 30 kilowatts of lithium batteries, enough to work in the frigid waters of the Weddell Sea for about nine hours before requiring a recharge.

The launch that first day, February 16, was quick and smooth. We attached Ellie the Sabertooth to her fiber-optic tether and lowered her into the water. The uppermost section of the tether was enclosed inside a floating steel pipe to protect it from the ice. In October 2021, during our deepwater trials in France, we thought hard about how best to protect the tether from getting entangled, trapped, or broken by ice floes. If we couldn't protect the cable, we could lose the AUV at the bottom of the ocean. To stop this from happening, the engineering team designed a protective steel collar, comprising a 15-foot-long (4.6 m) pipe equipped with a circular yellow buoy on top to keep it afloat and show its position. It was like a big fishing float.

As the AUV descended into the depths, three members of the subsea team sat in a tiny operation control container fixed to the aft deck of the S.A. *Agulhas II,* where they piloted the vehicle, monitored the incoming data on multiple computer screens, and prepared to switch on the side-scan sonar and watch a real-time image of the seafloor. The operations container was only about nine feet long by seven feet wide (2.7 x 2.1 m)—small enough to be airlifted to the ice camps if needed.

Ellie reached the seabed after an hour-long dive to 9,514 feet (2,900 m), a record depth for a Sabertooth. But just as survey work was about to begin, we heard the major

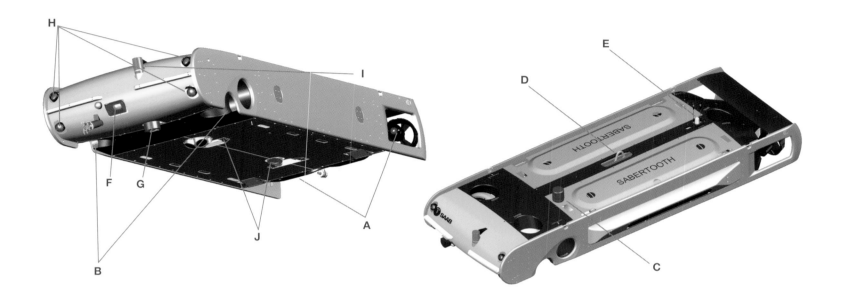

SURVEY MODE SABERTOOTH	
A: Main propulsion	D: Lift point
B: Vertical thrusters	E: Flashlight
C: Tracking beacon	

INSPECTION MODE SABERTOOTH	
F: 4K broadcast camera	I: Forward-looking sonar
G: 4K still camera	J: Lidar laser scan system
H: LED lights	

The Saab Sabertooth, a state-of-the-art hybrid autonomous underwater vehicle (AUV) specially designed for deepwater exploration, was key to the search for *Endurance*, sending real-time sonar data, video, and laser scans to the S.A. *Agulhas II* from the depths of the Weddell Sea.

failure alarm. One of Ellie's six thrusters had stopped working, making it unable to maneuver properly. We had to surface the vehicle, examine and repair the damage, and start the process all over again. We swapped in a new thruster for the faulty one, recharged the Sabertooth's batteries, and repositioned the ship for another try the following day.

February 17 marked Ellie's first successful survey dive. She flew 230 feet (70 m) above the seafloor at a speed of 3 knots (3.5 mph/5.5 kph), using her side-scan sonar to map the seabed below. Her data was transmitted through the fiber-optic cable up to the ship, where Pierre Le Gall, one of the surveyors, watched the incoming sonar data on his computer—in essence, a real-time picture of the ocean floor. That day's imagery showed a completely flat and

WHEN THE SUB-BOX WAS SEARCHED, THE TEAM WOULD THEN HAVE TO RECOVER THE AUV FROM BENEATH THE ICE AND RETRIEVE IT FROM AN OPEN-WATER POOL THE SIZE OF A BASKETBALL COURT.

uniform seafloor, consisting of little more than mud, low mounds, and the occasional small boulder. Nondescript, but promising: It was the perfect background for *Endurance* to stand out on the sonar. The AUV searched for five hours until we had to surface it to recharge its batteries. There was no sign of the wreck yet, but we were encouraged by the Sabertooth's successful operation.

As we debriefed after that first dive, we identified another problem to tackle. The winches were putting too much tension on the tether, forcing the AUV to consume more power, as it had to pull harder than necessary to move underwater. We needed a different way to pay out and wind in the tether.

It was JC Caillens, the offshore manager of the subsea team, who suggested we try the old Finnish winch recovered from the warehouse in Sweden. JC is a key member of my subsea team. He is a former French Navy captain, and for more than 20 years he has worked with me on some of the toughest underwater projects in the world.

The Finnish winch had been flooded with seawater during the storm on our way south, but our Saab engineers managed to repair its electric motor and got it to work again. Not only did the Finnish winch produce much less tension on the tether, but it also reduced the pullback on the AUV, giving us extra battery life for longer dives underwater.

There was one bug to the old winch, however: Because of its age, it didn't take kindly to the freezing Antarctic air. So to protect it, we erected one of the ice camp tents over it with an air heater inside to keep the winch warm.

THE TICKING CLOCK

The subsea team now had a fully working setup, but the search was taking far too long. My initial calculations required 22 days for us to cover the complete search box, but our charter agreement for the S.A. *Agulhas II* only gave us 12 days on-site before we had to head back to South Africa.

The team was learning fast. After a few days, based on the PRIIMA ice forecast, they were able to predict the ice movement with sufficient accuracy thanks to the real-time drift data collected by Mrs. Chippy, our ice buoy—but we needed to rethink our strategy. Initially, we had intended the AUV to survey a path across the search box aligned as closely as possible to the predicted ice drift trajectory of the ship. To follow this course required a lot of daily planning, real-time data handling, and continuous communication between the ice forecasters and the subsea team. We had a strong workflow and great teamwork, but our predictions still weren't close enough to reality to complete the search in our given time frame. So Jeremie Morizet, our subsea engineer, subdivided the rectangular search box into a set of 70 smaller sub-boxes. These boxes were sized proportion-

ally to the AUV's six-hour dive endurance and also better fitted to the periodic updates from the PRIIMA computer model. This meant a much simpler operation. First, we would examine the ice forecast and the latest satellite imagery, move the ship to where the ice conditions were easiest to navigate, then deploy the Sabertooth. Implementing this new strategy required enormous technical skill by the subsea team. It required the Sabertooth to be launched multiple times, with sometimes up to five miles (8 km) of tether paid out, while the vehicle surveyed the sub-boxes as the support ship drifted. When the sub-box was searched, the team would then have to recover the AUV from beneath the ice and retrieve it from an open-water pool the size of a basketball court. It was a subsea solution never before attempted.

But streamlining the search meant we could allow the scientists back on the ice. So on Saturday, February 19, I gave Lasse and the scientists the green light to get back to their fieldwork. Each day, after the AUV had descended to survey the seafloor, the scientists climbed into a rope basket and were lowered from the ship onto an adjacent ice floe to begin their work. They measured ice thickness, density, temperature, and salinity, and collected snow samples and ice cores (short cylinders of ice collected vertically through the floe). Then, when the AUV ascended, they would return to the ship.

All the while, as operations across the expedition resumed in full force, François "Fanche" Macé, our senior

sonar analyst, searched the incoming survey data for signs of the wreck. There were two possibilities in his mind for how *Endurance* might appear on the sonar. Some experts had suggested she would appear as a scattered debris field because she might have disintegrated when she sank. Others, including Mensun, were convinced that the ship would appear in one piece, a massive ping on the sonar. Fanche kept his eyes on the data for either possibility.

THE PING IN THE NIGHT

Just after midnight on Sunday morning, February 20, our surveyor Pierre Le Gall woke me with a knock on my door. His face was red and his breath was short. "We have found the *Endurance,*" he gasped.

I jumped out of bed and followed him to the aft deck. The crew were in a state of excitement. I went straight to the sonar display. The results looked intriguing—the sonar signature didn't look like any wooden ship I'd ever seen before. And the team pointed out the signature was unique to anything we had sensed for miles around. Even more compelling: The site in question was only 1,499 feet (457 m) from Worsley's last calculated position of *Endurance*.

John was fast asleep in his cabin when JC roused him awake and told the exciting news. He got dressed in seconds and hurried with Mensun to the operations container on the aft deck to see the imagery. They were met by cheering, laughing, and handshakes. All of the subsea team were

convinced we had found the wreck. John raced to the bridge to tell Captain Knowledge, and just after 1 a.m., all the crew awoke to our expedition leader's voice booming over the PA system: "We have found the *Endurance*. Well done, and congratulations to you all."

The subsea team couldn't wait to lay eyes on the wreck. We launched Ellie as fast as we could to get a high-frequency sonar signature and make the first visual inspection of the ship. The subsea team crowded around the AUV's camera feed, but when the video appeared, they were dumbfounded: There was no visible wreckage. All the Sabertooth found were several long, thin humps in the seafloor, a small piece of wood poking out of the mud, and a few lumps of what looked like coal. We spent hours with Mensun inspecting the footage, scratching our heads, trying to make sense of what we were seeing in terms of what we had expected *Endurance* to look like. Ultimately, Mensun concluded that while this might be debris from *Endurance*—maybe parts of the masts buried in the mud—it was not the ship itself. We were all greatly disappointed, though I felt a twinge of encouragement: If this really was debris from the ship, then the main wreck site could well be nearby.

We began the search again, but the day went from bad to worse. That same morning, the ship became stuck on a large ice ridge and couldn't move. On a powerful icebreaking vessel such as the S.A. *Agulhas II,* this kind of situation is not a safety concern, but for as long as we were stuck, we

could not carry out any further AUV dives, and the clock was still ticking. It could be a major blow to our mission.

In the end, Captain Knowledge's ingenuity saved the day. He deployed the same rocking maneuver he had used in 2019, ordering the main crane aboard the S.A. *Agulhas II* to lift a 20-ton (18 t) fuel tank and swing it across the bow. The momentum seesawed the entire ship, and after an hour of dogged persistence, we slid off the ridge and settled back into the water.

ON THE BRINK

Four days later, February 24, we still hadn't found *Endurance*. Following discussions with Captain Knowledge, John and I together made the decision to call for an extension to the expedition. It was a final throw of the dice. John contacted Dave Murray, the ship operations manager at AMSOL, and made a case to extend our charter of the S.A. *Agulhas II* for an extra 10 days. From AMSOL's perspective, it would be a risky proposition. Another 10 days when we could get stuck in the ice, or something could go wrong with the ship, resulting in us returning late to Cape Town. To our surprise, however, Dave replied immediately and AMSOL agreed to the extension, giving us until March 11 at the latest to remain within the search box, provided Captain Knowledge didn't think the ship was in danger. It was a massive break. Even so, we had to hurry; there would be no more extensions.

By this point, we were deploying Ellie the AUV on a regular 12-hour cycle. It required three hours for battery charging, one hour for maintenance and setup, and one hour to launch and descend. Then it could spend six hours surveying the seabed, followed by an hour-long ascent and recovery. It was punishing for the subsea team out on the back deck. They worked for 24 hours a day in two teams working in 12-hour shifts, fighting the freezing cold and often missing meals, breaks, and off-duty activities. Gradually, the Sabertooth covered the 70 sub-boxes, one by one, but found no further debris. Just flat and empty ocean floor.

The calendar flipped to March. Temperatures fell. The weather worsened and the days shortened. On Thursday, March 3, the air temperature in the Weddell Sea plummeted to 6.6°F (−14.1°C). The wind outside blew at 17.7 knots (20.4 mph/32.8 kph) to equal a brutal wind chill of −13.5°F (−25.3°C). Conditions like that could cause frostbite to any exposed skin in 30 minutes. Even bundled in countless layers of hats, gloves, and goggles, deck team members had to shelter inside every half hour and try to warm themselves up with a hot drink and snack. The Antarctic winter was bearing down on us with a vengeance.

DISCOVERY

Saturday, March 5, arrived. We had been hunting for *Endurance* for 17 days with no success. The AUV had covered 81 percent of the search box, an area of nearly

I ASKED ROBBIE TO SWITCH ON ELLIE'S ONBOARD CAMERA. IT WOULD DRAIN THE REST OF HER BATTERIES, I KNEW, BUT WE HAD TO TAKE THE CHANCE TO CONFIRM IT WAS *ENDURANCE*. ROBBIE THREW THE SWITCH.

120 square miles (310 km²), about the same size as inner London or half the city of Chicago. No one, anywhere, had completed such a large subsea survey using AUVs under drifting ice. But we still had not found our quarry.

With the freezing temperatures and deteriorating ice conditions, John and I knew we had just three more days before we would have to abandon the search and leave the Weddell Sea. The weather could turn against us at any moment, and we were already battling high winds and blizzards. To make the situation even worse, a huge, multi-year ice floe had drifted over the search box, covering a third of the eastern side of the area. Among the crew, each of us in our own way fought against a growing sense of resignation and despair. But the subsea team continued to work around the clock. We couldn't give up hope.

At the daily captain's meeting, at 7 a.m. on March 5, I briefed Captain Knowledge, John, and Mensun on the overnight operations: Nothing found. With time fast running out, our focus was to finish surveying the sub-boxes in the southern part of the search area as quickly as possible.

The ship sailed through thick sea ice to the next dive location, about one kilometer to the east, and docked into a large ice floe. At 11:51 a.m., the subsea team deployed Ellie the Sabertooth for her 30th dive. John and Mensun, restless with worry over the looming deadline and anxious about the progress of the search, set off across the ice on

foot to investigate a nearby iceberg. John told me later that as they turned around to walk back to the ship, his mood had lifted and he'd suddenly smiled and said to Mensun: "Today will be a good day. I think she's beneath our feet!"

Meanwhile, way below the S.A. *Agulhas II,* the Sabertooth scanned the ocean floor. Senior surveyor Clément Schapman and AUV pilot Robbie McGunnigle supervised the search from the operations container. At 4:05 p.m., Robbie noticed something odd come up on the sonar screen. It was mounds of mud on the seabed. Robbie sat up. As he watched the data, bits of debris emerged. Robbie shouted for Clément to come and see. This sonar return was big.

This time, everyone heeded discovery protocol. There was no instant PA announcement. Instead, Robbie and Clément notified JC and the news sped up the chain of command to me. I entered the room at 4:15 p.m. The team had already started to double-check the data by engaging the Sabertooth's high-frequency sonar for a more detailed picture of the scene. This time, there was no doubt: The sonar clearly showed a wreck. This could be *Endurance.*

Despite my excitement, I needed to keep cool and not rush to complete the job. We still had to secure all the data acquired by the Sabertooth and carry out a visual inspection of the wreck. It was important not to trip ourselves up in our haste and excitement. I asked JC to go on sentry duty outside the container to ensure the incredible news remained, for the next few minutes at least, top secret. But by this time the Sabertooth's batteries were running critically low. Robbie requested we start its ascent, but I wanted to see the wreck for myself and receive ultimate confirmation. A visual contact now would allow us to go into inspection and laser scanning mode on the very next dive. I asked Robbie to switch on Ellie's onboard camera. It would drain the rest of her batteries, I knew, but we had to take the chance to confirm it was *Endurance.* Robbie threw the switch.

An image of the seabed met our eyes on the computer screen as the AUV flew low over the bottom of the ocean. The camera swept its lens across the terrain. We saw debris, then wood. Nobody was breathing in the shelter. All I could hear was the low hum of the computers and my own heart thumping hard in my chest. And then the port-side midship of the wreck came into view.

There on the monitor, *Endurance* appeared out of the darkness. She was intact, upright and majestic. Robbie skimmed the camera across the main deck, then turned and flew over the bow. She was beyond our wildest dreams. The hull sat proud on the seafloor, pristine, still coated in the original black paint, with masts, stays, ropes, pulleys and rigging, and her funnel all lying haphazardly on the deck. The Sabertooth flew for 30 seconds over the wreck, and they were without doubt the best 30 seconds of my life. The

vessel lying on her keel, where she had rested in peace for over a century, was a vision from a fairy tale.

We were the first people to see *Endurance* since Shackleton and his crew had lost her 107 years before. On November 21, 1915, as Shackleton watched *Endurance* sink, he shouted: "She's going, boys." And on March 5, 2022, as I watched the first incredible images of *Endurance,* I whispered, "She is here, guys." She was magnificent.

After a few glorious moments, the batteries on the Sabertooth ran out completely. It took an emergency ascent procedure to recover the AUV, but I knew those brief glimpses of the wreck were worth the effort. We had found *Endurance*!

TRIUMPHANT MOMENTS

As we were first laying eyes on *Endurance,* John and Mensun were returning from their walk out on the ice. They were totally oblivious to the momentous events that had just happened on the ship. As soon as I knew they were back on deck, I asked Captain Freddie to call them on the PA system: "Shears and Bound to the bridge immediately. Shears and Bound to the bridge immediately."

John and Mensun rushed onto the bridge, looking concerned and alarmed. I fixed my face into a grim frown. "What's happened?" John cried. He told me later that he had feared the worst: a bad accident, or another AUV lost on the seafloor.

I stood slowly. John stared into my face. Then I broke into a smile and held up my phone: "Gents, let me introduce you to *Endurance.*" My mobile screen showed the beautiful high-frequency sonar image of the wreck, with the ship complete and her funnel and masts visible.

John was absolutely stunned. He laughed and embraced me. Together, we had done it. We had found *Endurance* and completed the most difficult shipwreck search in the world.

John and Mensun then came into the operations container to view the video of the discovery with me. They were at a loss for words—silent for 10 straight minutes. Only when we went out to the aft deck to greet the recovered Sabertooth with the rest of the crew did they come back alive, cheering, shouting, and applauding along with everyone else as the AUV returned aboard. Esther Horvath, our expedition photographer, took official photos with me, John, Mensun, and the wildly excited subsea team and deck crew. It was a moment of utter joy.

ENDURANCE REVEALED

We discovered *Endurance* at a depth of 9,869 feet (3,008 m). The ship's location was 68° 44' 21" S, 52° 19' 47" W, just 5.4 nautical miles (6.2 mi/10.1 km) southeast of Worsley's sinking position. We found her within the search box our team at Deep Ocean Search had defined, and the Falklands Maritime Heritage Trust approved, before we left Cape Town. We were proven right not to be distracted by

the claims we were searching in the wrong position. Later it was confirmed the wreck was not within the primary search box used in 2019, and the lost AUV could not have scanned *Endurance*. Had the AUV not failed and had there been more time, the wreck might have been detected in the planned extension box to the south. Our 2022 search was the definition of a perfect plan, accomplished. We had made history!

But our work on the seabed was not over after the discovery. We had two more days on-site before the S.A. *Agulhas II* had to start the long journey back to Cape Town, and we had a lot to do in that short time. We still had to inspect, photograph, film, and scan the whole wreck.

The subsea team worked through the night to change the sensors on the Sabertooth from survey to inspection mode. They took out the sonar and replaced it with the digital still camera system, the 3D laser scanner, and the 4K broadcast digital video camera. During training, the team had taken 36 hours to swap the sensors, but now, under intense pressure, they did it in 13 hours. We launched the Sabertooth at 11:40 a.m. on March 6 for the first inspection dive.

First, the Sabertooth's laser scanner produced a 3D digital model of the wreck at 1 mm resolution, and its digital still camera took 25,000 high-quality digital photographs. It was the first ever full-size digital scan of a deepwater shipwreck, and it promised a virtual 3D model of the wreck

of *Endurance* at a level of detail unimaginable up to that point in history. We had pioneered a new era in deepwater exploration for others to follow.

The second inspection dive on *Endurance*—the 32nd overall dive for the Sabertooth and our final dive on this expedition—took place early the next morning, at 1:30 a.m. on Monday, March 7. We were working against time, still running an around-the-clock operation. For this dive the subsea team activated the 4K broadcast camera system. Specially designed for deepwater filming, this system could transmit high-quality video through the fiber-optic tether up to the surface in real time. The results were stunning. We saw new details on the ship that brought it vividly back to life but frozen in time: the ship's wheel, with all its spokes, still in place on the

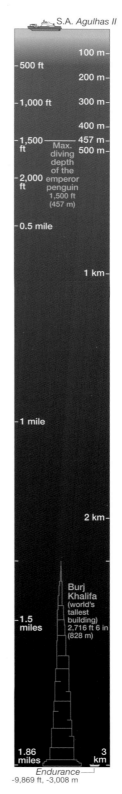

One of the many challenges in finding *Endurance* was the extreme depth of the Weddell Sea in the search area. The wreck was found nearly two miles down—9,869 feet (3,008 m) underwater—a depth more than 3.5 times the height of the world's tallest building, the Burj Khalifa, a skyscraper in Dubai that stands some 2,717 feet (828 m) tall.

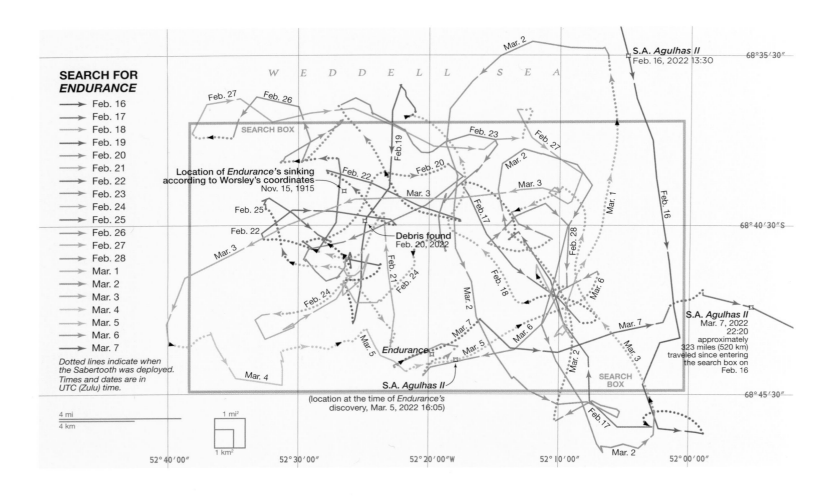

SEARCH FOR ENDURANCE

- → Feb. 16
- → Feb. 17
- → Feb. 18
- → Feb. 19
- → Feb. 20
- → Feb. 21
- → Feb. 22
- → Feb. 23
- → Feb. 24
- → Feb. 25
- → Feb. 26
- → Feb. 27
- → Feb. 28
- → Mar. 1
- → Mar. 2
- → Mar. 3
- → Mar. 4
- → Mar. 5
- → Mar. 6
- → Mar. 7

Dotted lines indicate when the Sabertooth was deployed. Times and dates are in UTC (Zulu) time.

4 mi
4 km

1 mi²

1 km²

WEDDELL SEA

S.A. *Agulhas II* Feb. 16, 2022 13:30

68°35′30″

SEARCH BOX

Location of *Endurance*'s sinking according to Worsley's coordinates Nov. 15, 1915

Debris found Feb. 20, 2022

Endurance

S.A. *Agulhas II* (location at the time of *Endurance*'s discovery, Mar. 5, 2022 16:05)

S.A. *Agulhas II* Mar. 7, 2022 22:20 approximately 323 miles (520 km) traveled since entering the search box on Feb. 16

SEARCH BOX

68°40′30″S

68°45′30″

52°40′00″ 52°30′00″ 52°20′00″W 52°10′00″ 52°00′00″

aft well deck; both anchors and chains and the capstan visible at the bow. The incredible camera resolution revealed many artifacts lying on the main deck: cooking

ABOVE: These lines track the S.A. *Agulhas II* within the *Endurance* search box between February 16, 2022, and March 7, 2022. Solid lines indicate when the ship had her engines on and was breaking ice. Dashed lines indicate when the ship had her engines idling and was drifting in the pack ice with the Saab Sabertooth AUV diving underwater.

LEFT: The S.A. *Agulhas II* encountered a low sea ice extent in the Weddell Sea in 2022. It was one of the lowest ever sea ice extents on record.

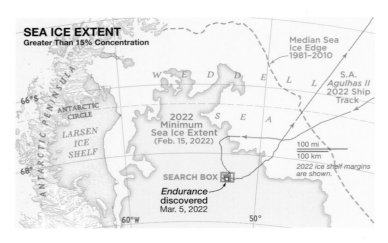

SEA ICE EXTENT
Greater Than 15% Concentration

Median Sea Ice Edge 1981–2010

S.A. *Agulhas II* 2022 Ship Track

ANTARCTIC CIRCLE

WEDDELL SEA

ANTARCTIC PENINSULA

LARSEN ICE SHELF

2022 Minimum Sea Ice Extent (Feb. 15, 2022)

66°S

68°

100 mi
100 km

2022 ice shelf margins are shown.

SEARCH BOX

Endurance discovered Mar. 5, 2022

60°W 50°

pots, plates, mugs, rolled-up pieces of linoleum, a flare pistol, the galley bell, and leather boots that perhaps belonged to Frank Wild. These were objects no one had seen in over a century. Most amazing of all, we could read the ship's name, *ENDURANCE*, in gleaming brass arced across the stern, and below that the five-pointed star, Polaris, a symbol of her original name.

Over the coming months, fresh analysis of the digital photographs and the 3D laser data using artificial intelligence software would lead to the identification of many additional artifacts: Glass portholes, a telescope, even a sewing machine have all emerged. Every day working on the full 3D digital reconstruction of *Endurance* has revealed new, exciting discoveries. It is our hope the 3D digital model becomes the lasting testimony of our expedition and awakens a wide audience and new generations to Shackleton and the *Endurance* story.

GOODBYE TO THE WEDDELL SEA

The AUV surfaced and returned aboard at 11 a.m. on March 7. The crew greeted it with loud cheers and a big round of applause. John even gave it a kiss to say thank you. Ellie had been a huge part of my life for three years, and this amazing marine robot's role in the finding of *Endurance* gives her a unique place in the history of subsea exploration. With that glorious final homecoming for Ellie, we ended our subsea operations.

Our team had accomplished what many experts said was impossible. We had not only found *Endurance* under the pack ice, but had also surveyed, scanned, and filmed her without touching or damaging the wreck. We had not suffered any accidents, either. It was an incredible achievement. For my part, I was proud we had kept the AUVs safe, too.

That night, the S.A. *Agulhas II* turned north, setting sail out of the ice of the Weddell Sea and heading for the remote island of South Georgia, 980 nautical miles (1,130 mi/1,810 km) to the north-northeast. Sitting in my cabin, I was reminded of the philosophy of the Boss and of his love of discovery. Like Sir Ernest, I think today we need more exploration and less conflict on this planet.

The visit to South Georgia had not been part of our original voyage itinerary, but in the wake of our momentous discovery, Captain Knowledge and John had immediately thought to go there—because that is where Shackleton is buried. The Boss, as Shackleton was called by his crew, lies in a small cemetery at Grytviken whaling station on the east coast of the island. Visiting his grave would be a fitting and proper way to end our historic expedition. Normally, it would take a year to arrange for an icebreaker like the S.A. *Agulhas II* to make a call at Grytviken. The government of South Georgia approved our visit in just three days.

It seemed we had Shackleton's very own blessing.

The S.A. *Agulhas II* has all her search lights on at night as she slowly maneuvers her way through the pack ice and repositions to the next launch site to deploy the Saab Sabertooth.

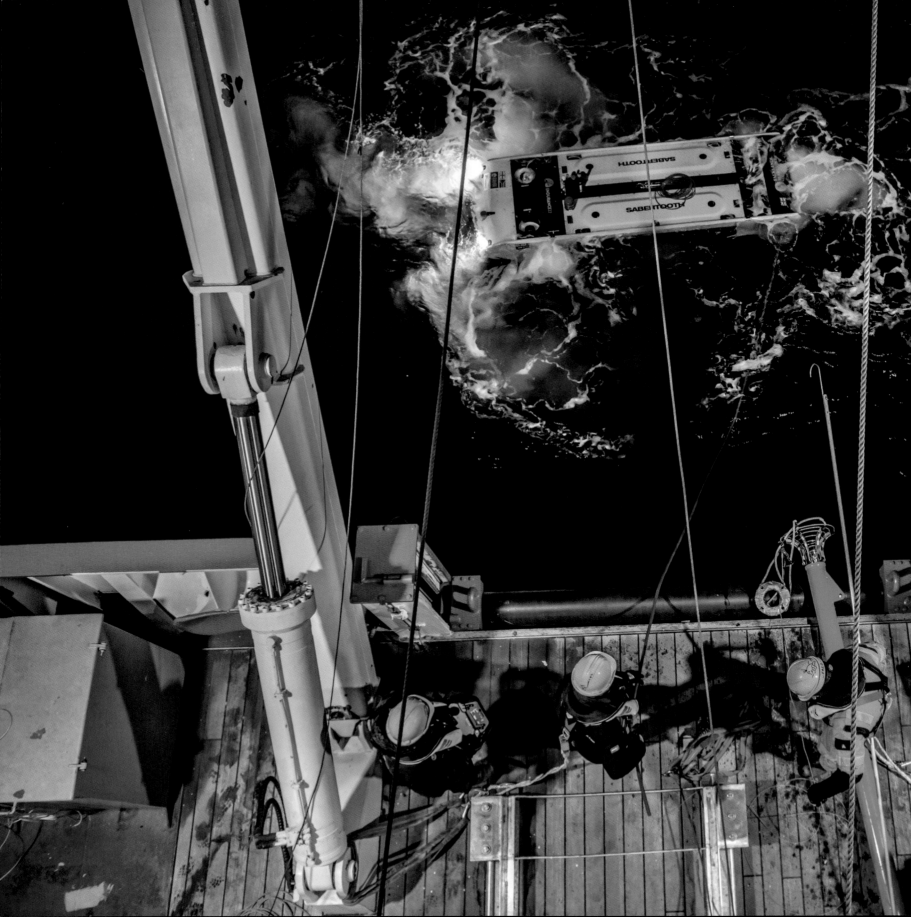

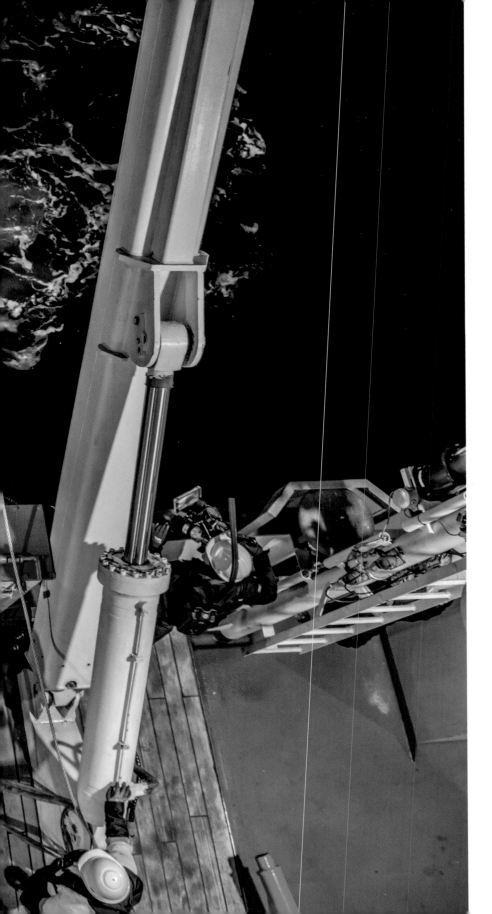

Members of the Endurance22 subsea team maneuver the Saab Sabertooth into position at the stern of the ship to hoist it back on board.

JC Caillens (far left), Frédéric Bassemayousse (second from left), and Gregoire Morizet (far right) deploy the fishing float, a steel tube protecting the Saab Sabertooth's fiber-optic cable from damage by the sea ice.

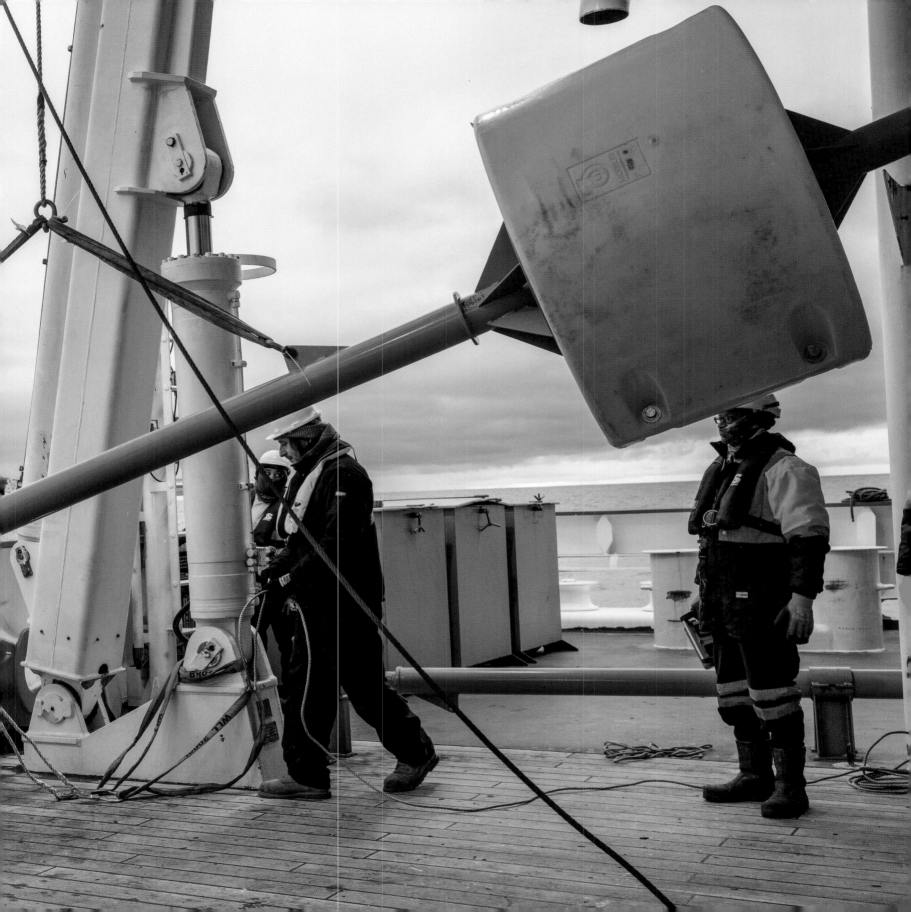

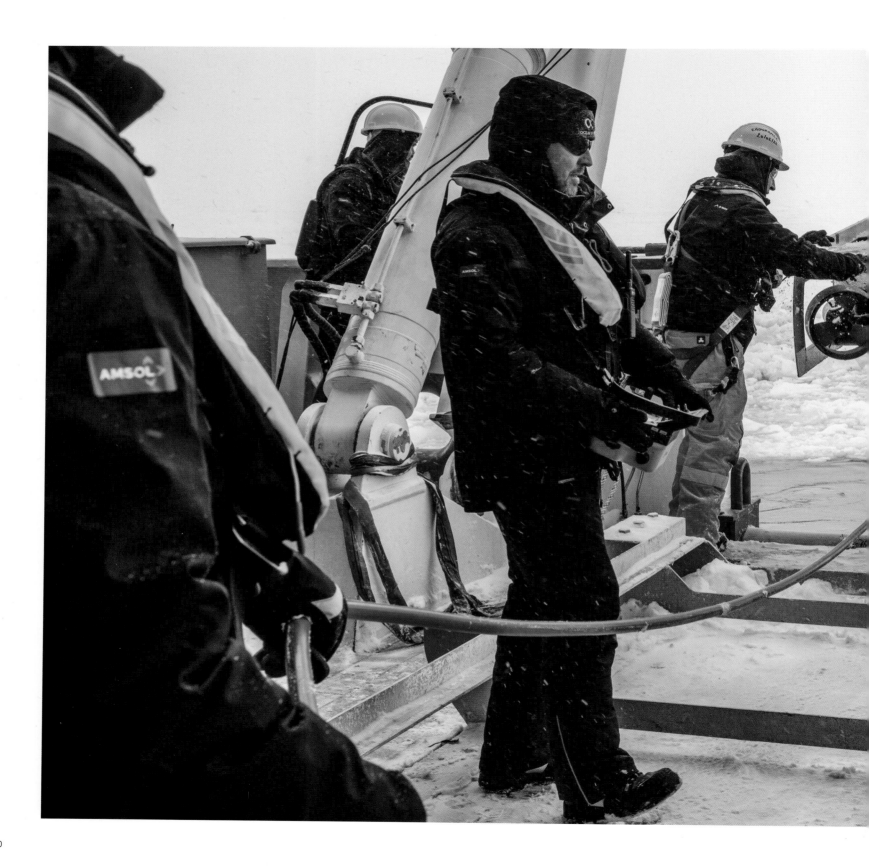

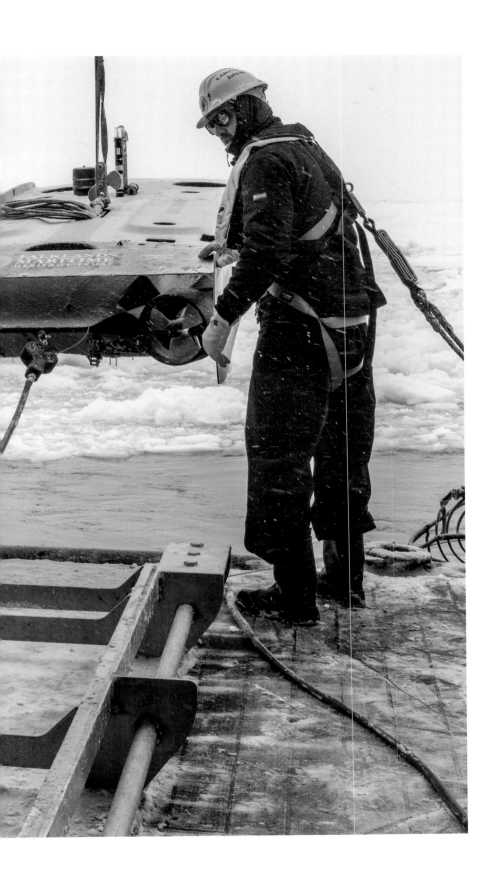

Working around the clock through wind, snow, and freezing temperatures, the subsea team, including Kerry Taylor (left, glasses), JC Caillens (orange pants), and Jeremie Morizet (far right), launches and recovers the Saab Sabertooth.

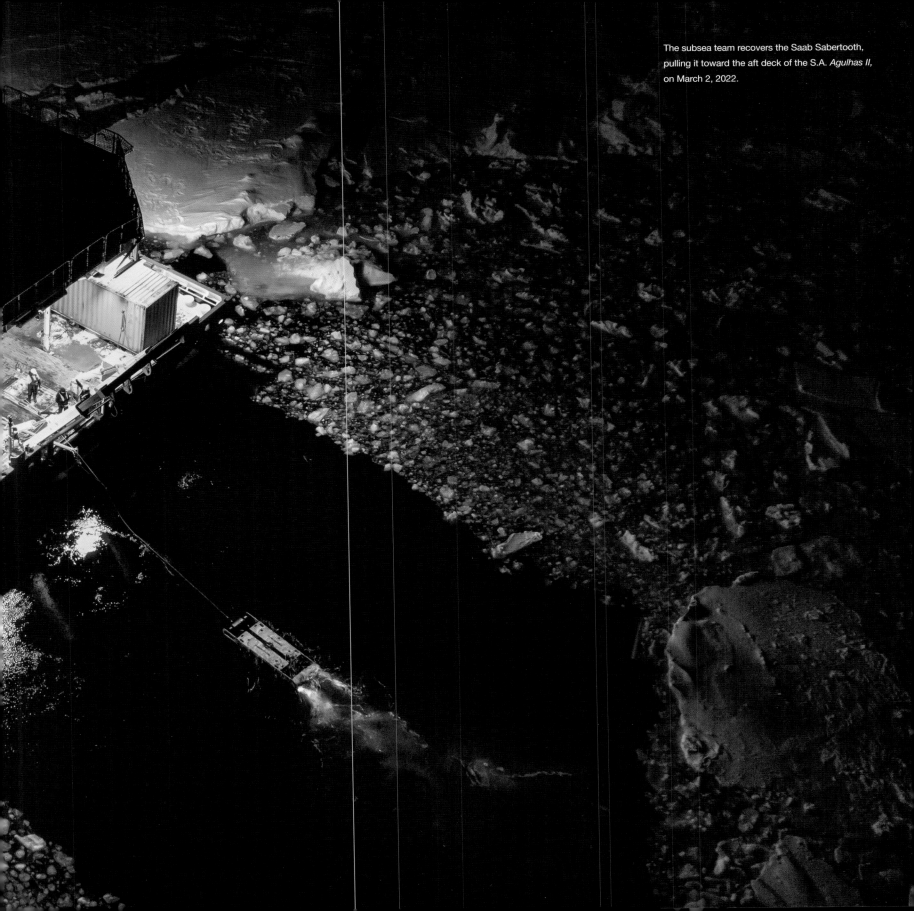

The subsea team recovers the Saab Sabertooth, pulling it toward the aft deck of the S.A. *Agulhas II,* on March 2, 2022.

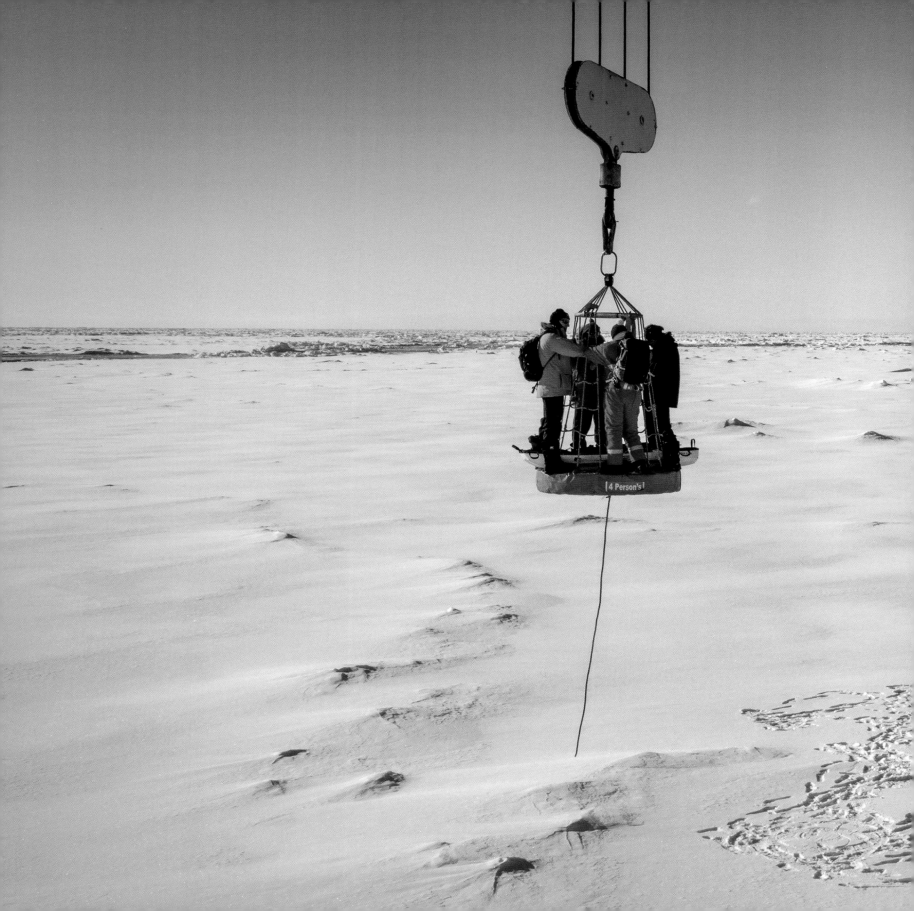

Endurance22 scientists hold tight to the rope basket as they are craned off the S.A. *Agulhas II* to carry out research on the sea ice.

Jakob Belter (left) and Thomas Busche, members of the
Endurance22 sea ice prediction team, clock in for their night
shift on the bridge of the S.A. *Agulhas II,* where they will
review satellite data to inform the search.

Nico Vincent, deputy expedition leader and manager of
subsea operations, exits the AUV operations container.

The Scientists

Scotsman Robert Clark, biologist aboard *Endurance,* worked in a laboratory equipped with a microscope and many glass bottles for collecting specimens such as plankton, fish, and other marine creatures. Shackleton described how Clark would celebrate his discoveries by "dancing about and shouting Scottish war-cries." Sadly, all of Clark's collections, observations, and notes were lost when *Endurance* sank.

Dr. Stefanie Arndt, a research scientist from the Alfred Wegener Institute in Germany, conducted sea ice research on board the S.A. *Agulhas II* during the Endurance22 expedition. One of her primary studies measured the salinity of sea ice samples from the Weddell Sea. Salinity is an indicator of sea ice age. Older multiyear ice is less saline and thicker, strong enough to survive the warmer summer months. Younger ice, meanwhile, is more saline, thinner, and at greater risk of melting away.

RIGHT: Dr. Stefanie Arndt examines samples of melted sea ice during Endurance22.

BELOW: Robert Selbie Clark, biologist on *Endurance,* studied penguins and the variety of marine life found at different ocean depths in the Weddell Sea.

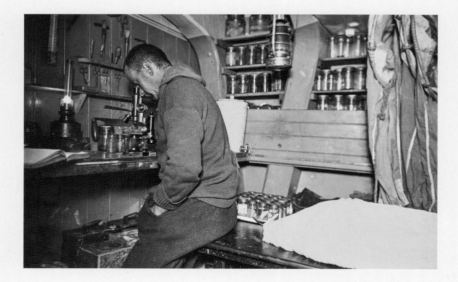

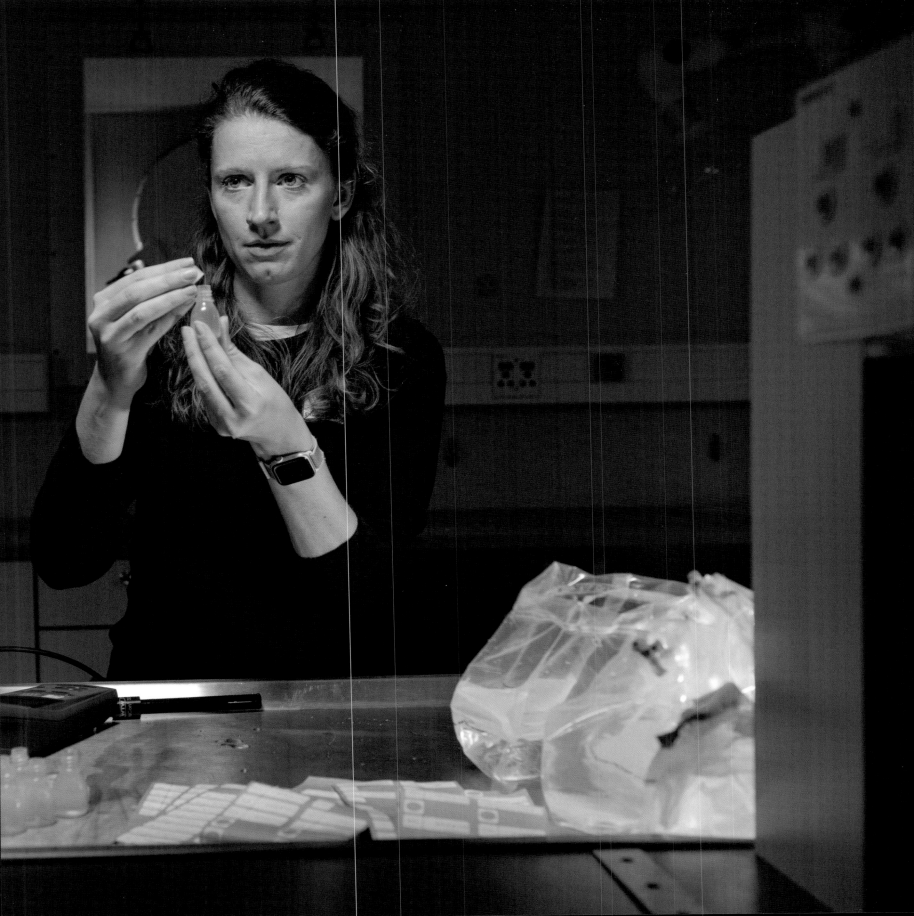

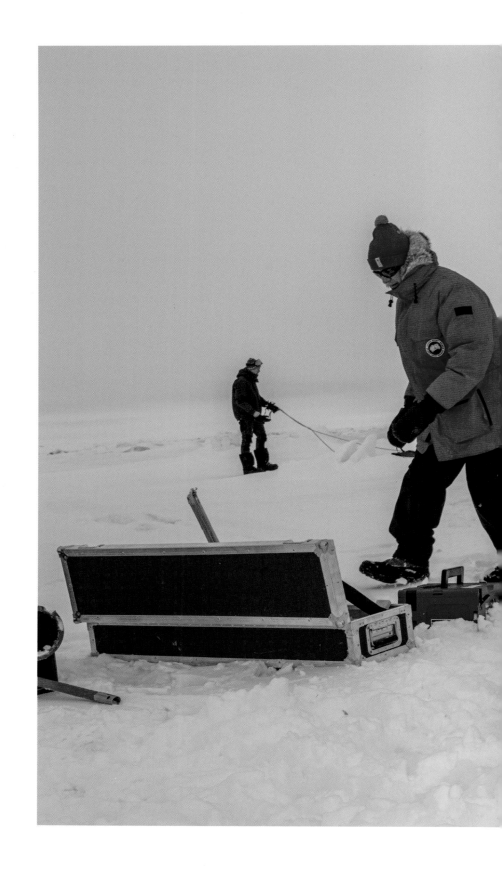

Sea ice samples hold critical information about changing environmental conditions in the Weddell Sea. Here, marine engineering scientists Jukka Tuhkuri (standing), from Aalto University, and James-John Matthee, from Stellenbosch University, collect an ice core.

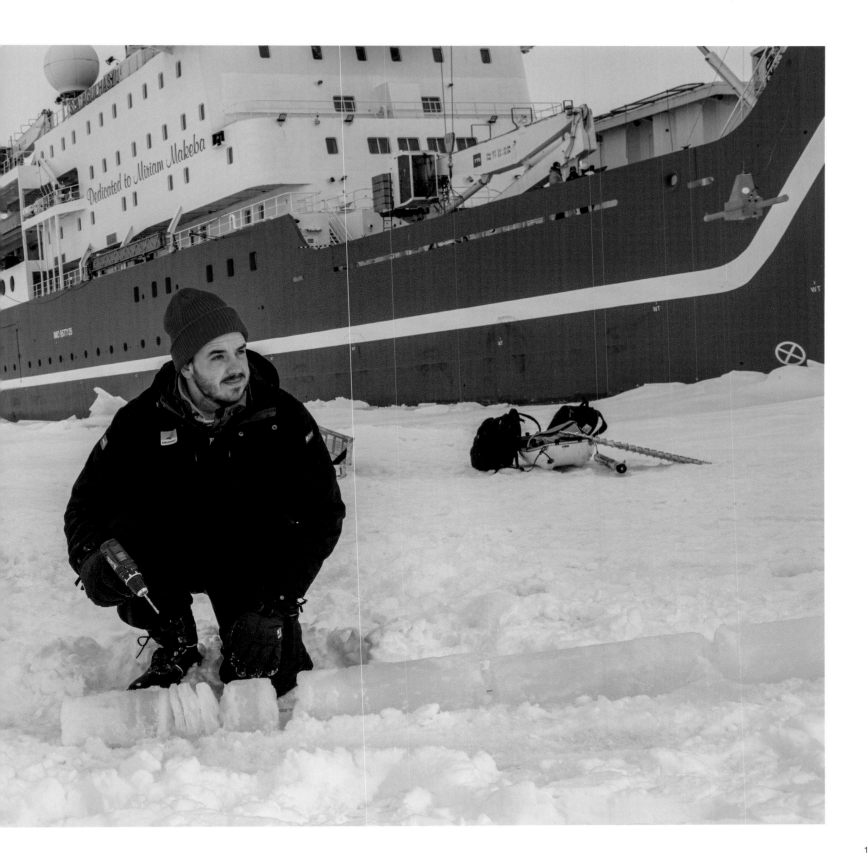

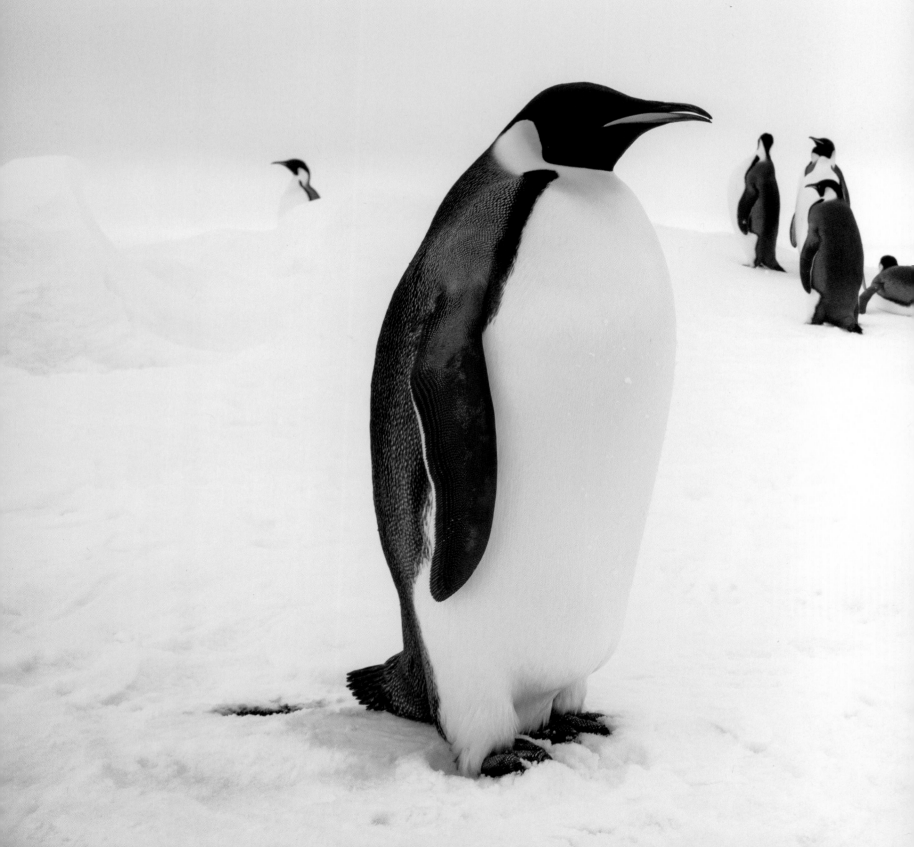

Emperor penguins wander over to look at their new visitors, the Endurance22 expedition team. Largest of all the penguin species and unique to Antarctica, these birds can stand 45 inches (1.1 m) tall and weigh as much as 88 pounds (40 kg). Muscular swimmers, they cannot fly.

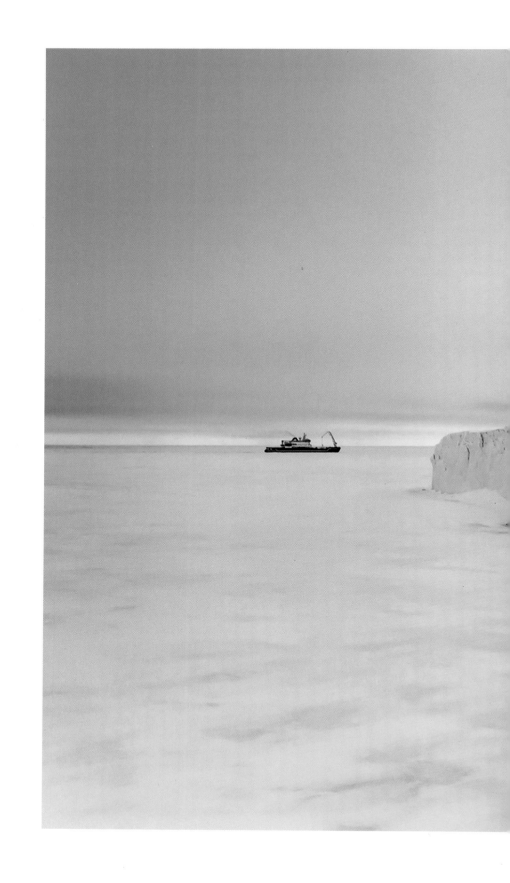

On March 5, 2022, the S.A. *Agulhas II* was locked into a large ice floe near an iceberg. That afternoon, Dr. John Shears and Mensun Bound took a hike to investigate the berg, completely unaware of the historic events unfolding on board the ship.

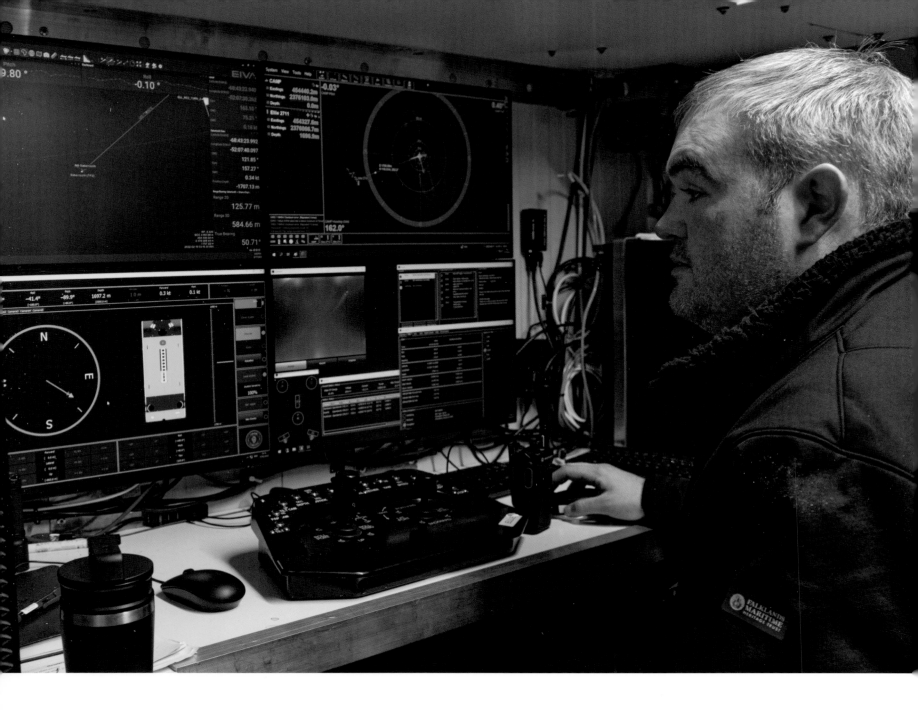

Working in the operations container, AUV pilot Robbie McGun-nigle watches the incoming sonar data from the Saab Saber-tooth. He was the first person in 107 years to see *Endurance*.

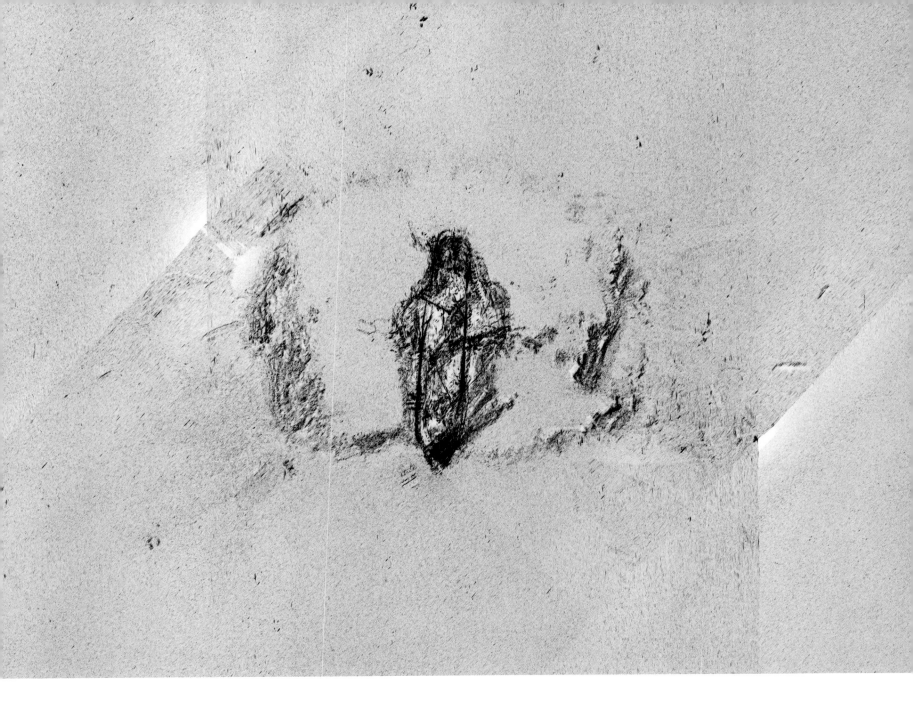

The post-processed sonar image of the wreck of *Endurance* shows the ship lying intact on the seabed. Around the wreck you can see an impact crater created when the ship hit the mud on the seafloor.

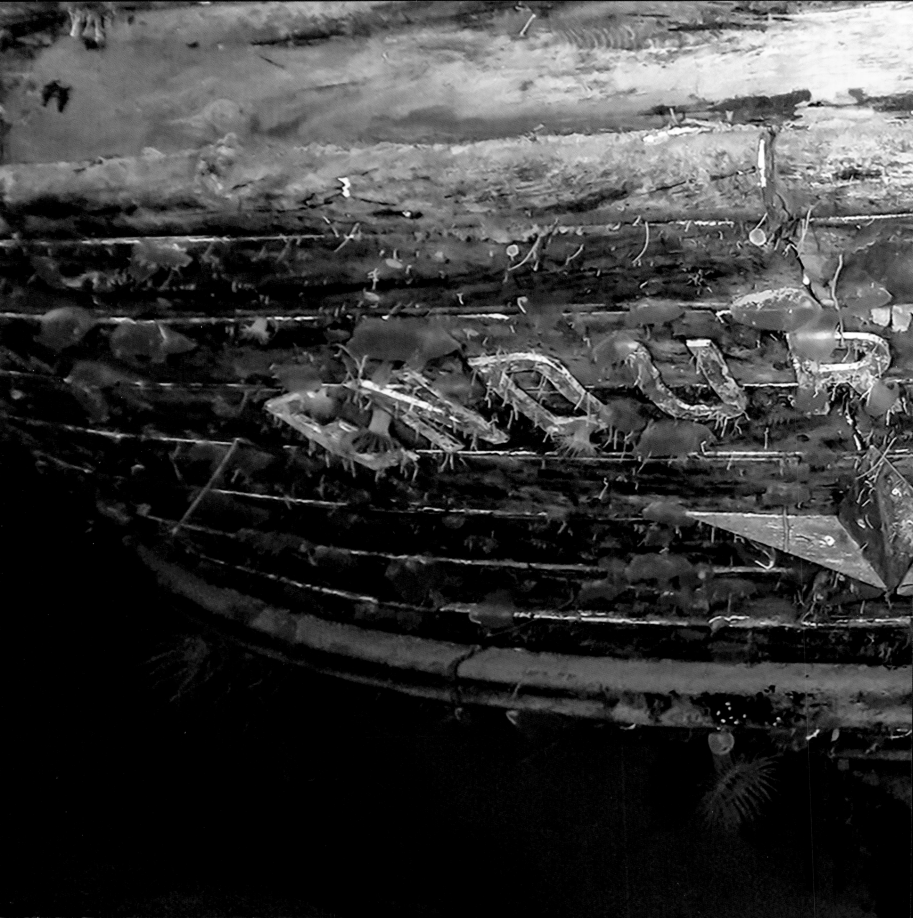

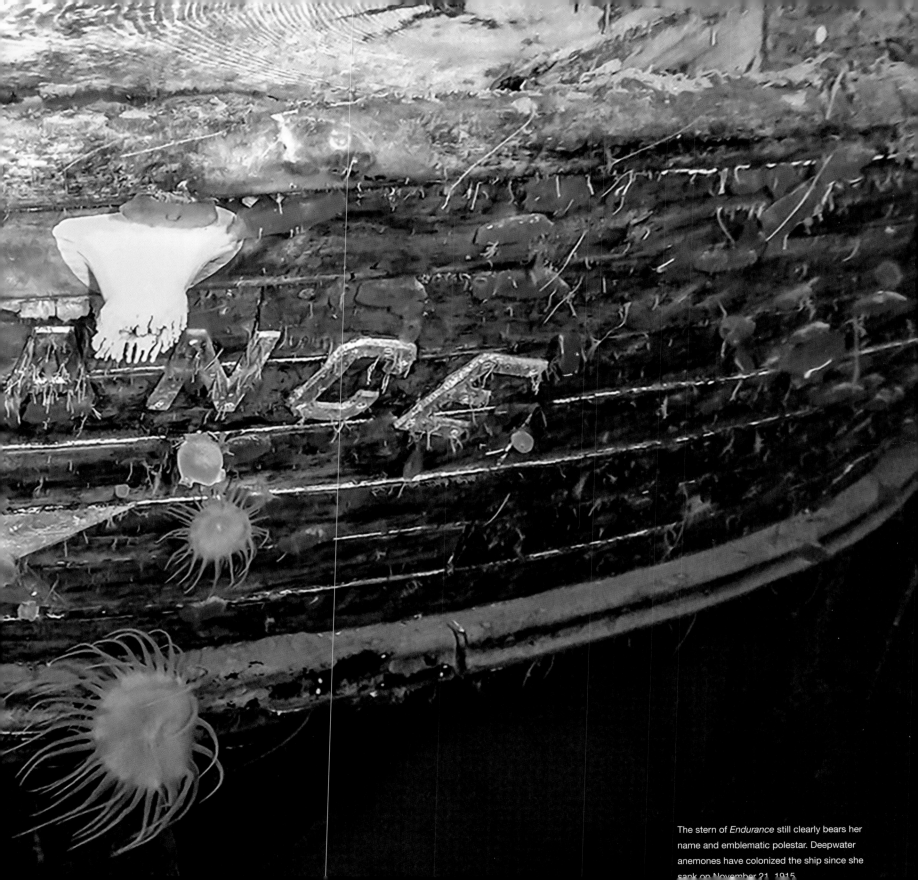

The stern of *Endurance* still clearly bears her name and emblematic polestar. Deepwater anemones have colonized the ship since she sank on November 21, 1915.

The *Endurance* Stern and Wheel

Despite a century of resting at the bottom of the ocean, *Endurance* is instantly recognizable in the underwater images captured by the Saab Sabertooth AUV. The stern and well deck are in remarkable condition. The taffrail, ship's wheel and steering gear, and a Kelvin sounding machine used to measure ocean depth are all visible. Behind the wheel is the open companionway and a glass porthole looking into Shackleton's cabin.

Endurance now has a motley crew. Since she sank, the wreck has become an artificial reef offering deep-sea life a secure home above the mud and ooze on the seafloor. The well deck has been colonized by a rich variety of sponges, sea squirts, anemones, hydroids, sea stars, and sea lilies, as well as what might be a new species of squat lobster. Scientists believe that most of these creatures subsist by filter feeding on "marine snow"—algae and krill feces carried along by the deep ocean currents.

RIGHT: The stern of *Endurance* remains remarkably intact. Her taffrail, ship's wheel, and aft well deck are all well preserved, and the round glass porthole into Shackleton's cabin is unbroken.

BELOW: *Endurance* rests in dry dock as she prepares for the Imperial Trans-Antarctic Expedition at London's Millwall Docks on July 1, 1914. Here, her hull is painted a regal white.

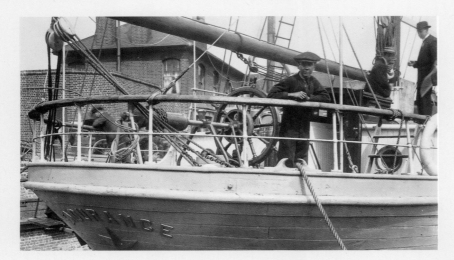

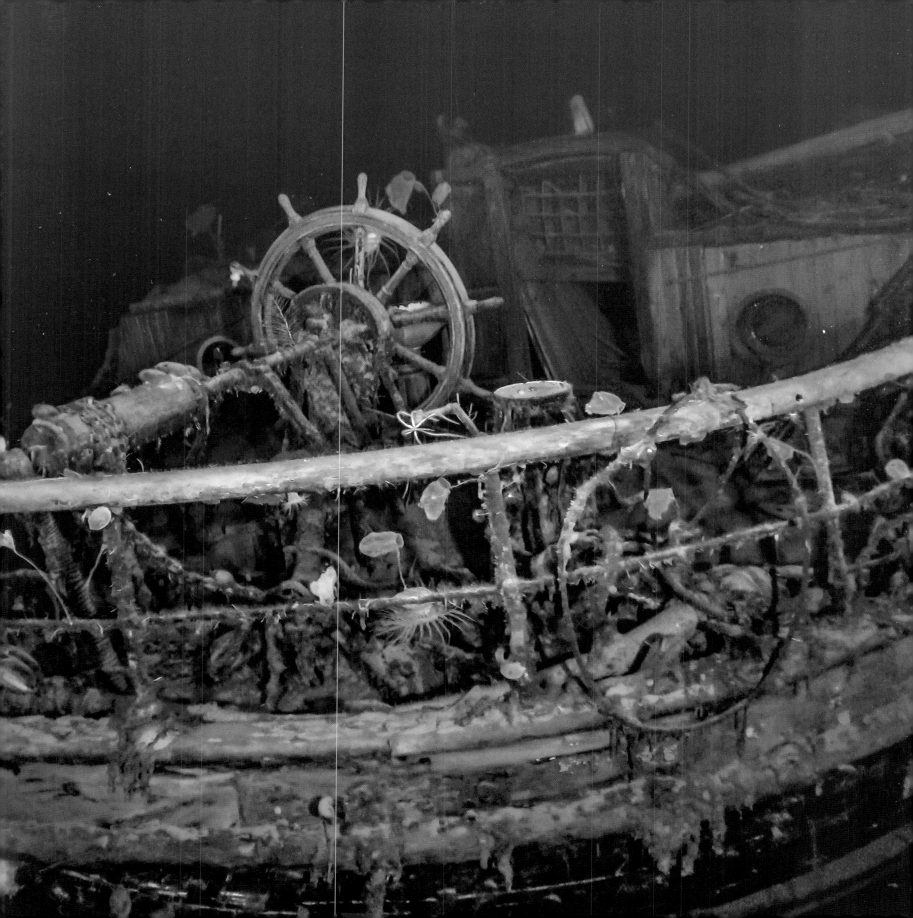

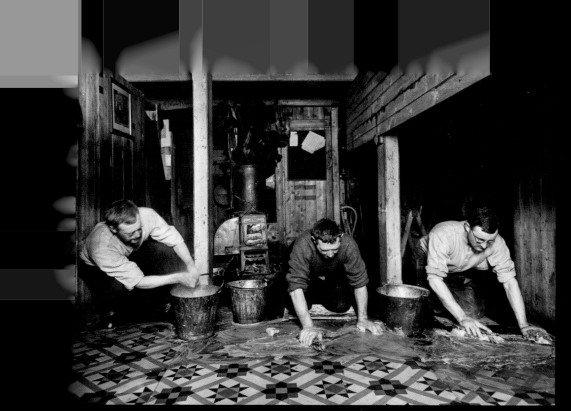

ABOVE: Members of Shackleton's crew—left to right, Dr. James Wordie (chief scientist), Alfred Cheetham (third officer), and Dr. Alexander Macklin (ship's surgeon)—scrub the linoleum on board *Endurance.* On the right, a high-resolution digital color photograph of the wreck taken by the Saab Sabertooth shows a piece of the linoleum in what remains of the ship's galley.

BELOW: On the left, a high-resolution digital photograph shows a seaman's leather boot next to a pile of rigging and wooden pulleys. On the right, a clue as to whose boot it might have been: a photograph of Frank Wild, Shackleton's trusty second-in-command, enjoying time on deck with some of the sledge dogs.

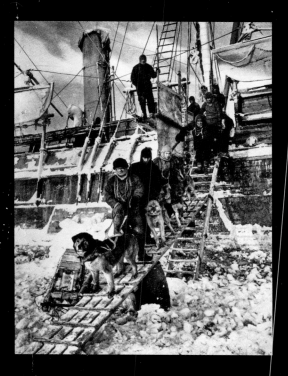

ABOVE: On the left, the crew of *Endurance* take the sledge dogs down the gangway for exercise on August 25, 1915. On the right, the wooden ladder they used now lies on the Weddell Sea floor near the wreck.

BELOW: On the left, Shackleton's crew celebrates Midwinter's Day on June 22, 1915, heralding the return of the sun. The men had a special dinner that day: roast pork, stewed apples, preserved peas, and plum pudding. On the right, some of the dinner plates now lie strewn on the deck of the wreck, along with lengths of rigging.

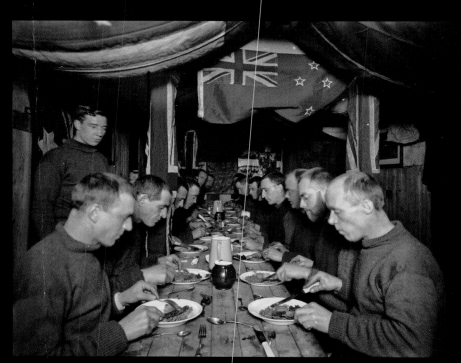

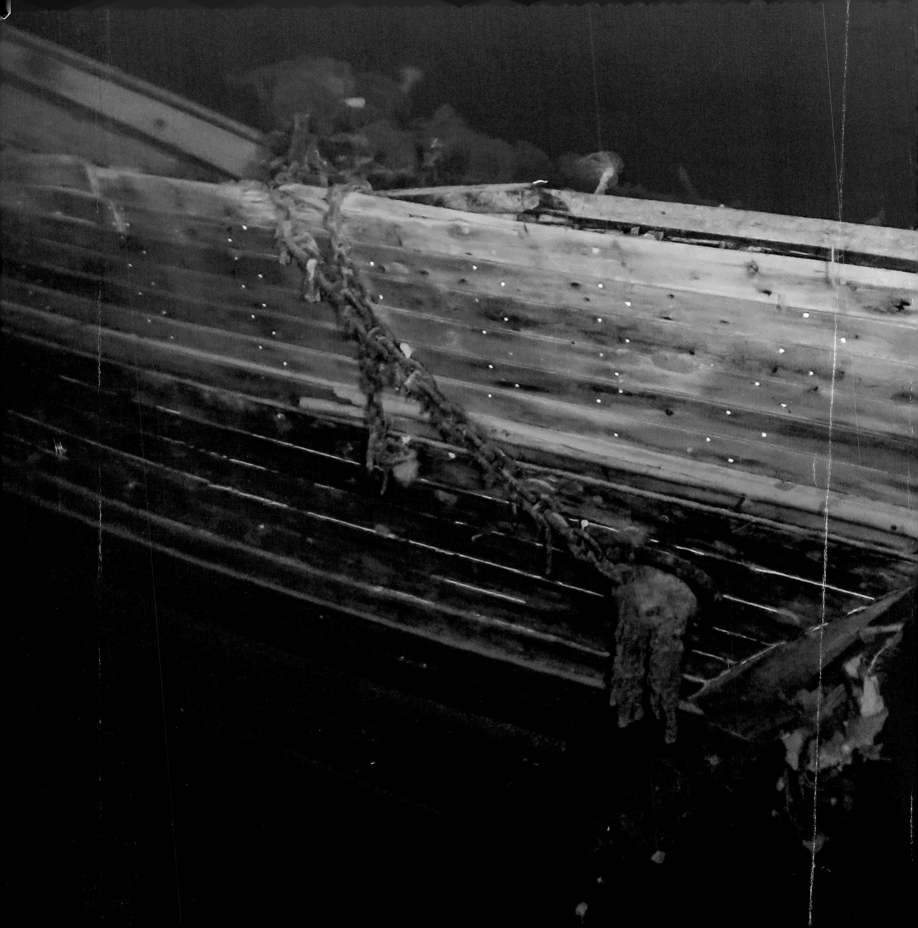

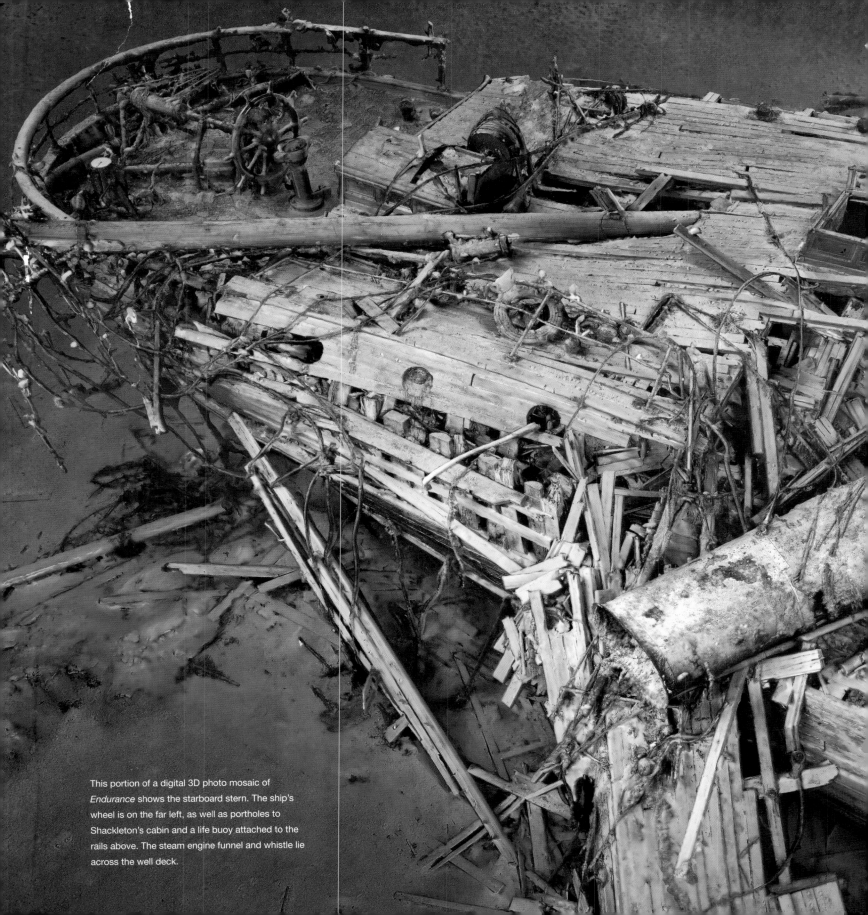

This portion of a digital 3D photo mosaic of *Endurance* shows the starboard stern. The ship's wheel is on the far left, as well as portholes to Shackleton's cabin and a life buoy attached to the rails above. The steam engine funnel and whistle lie across the well deck.

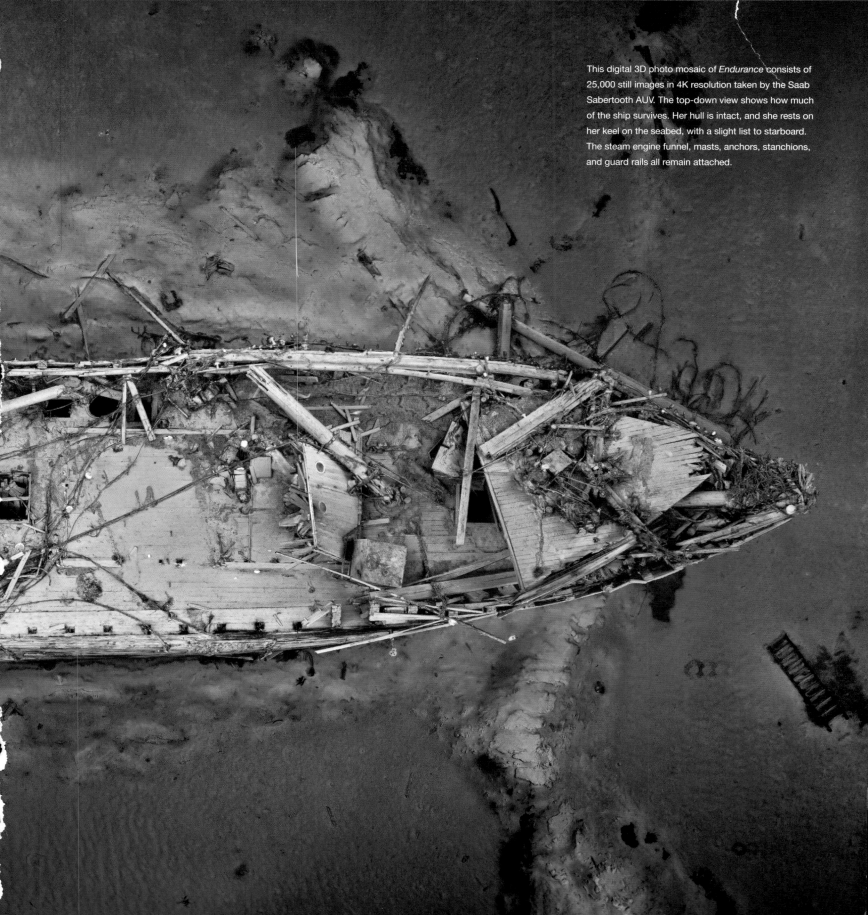

This digital 3D photo mosaic of *Endurance* consists of 25,000 still images in 4K resolution taken by the Saab Sabertooth AUV. The top-down view shows how much of the ship survives. Her hull is intact, and she rests on her keel on the seabed, with a slight list to starboard. The steam engine funnel, masts, anchors, stanchions, and guard rails all remain attached.

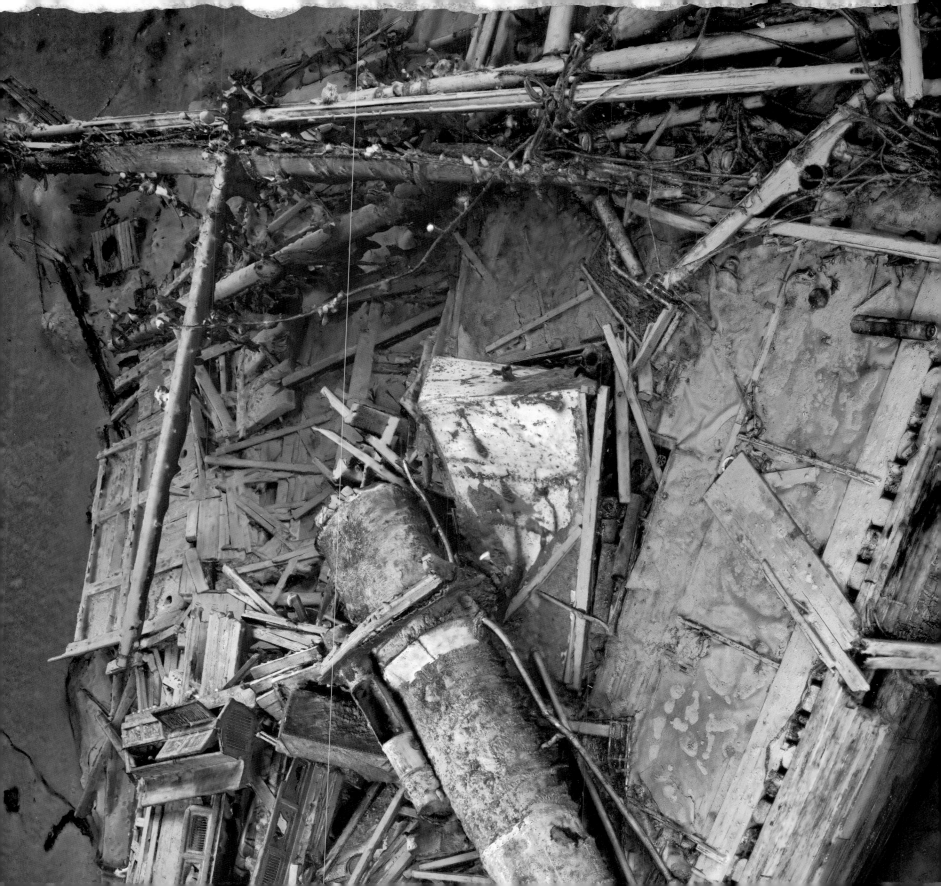

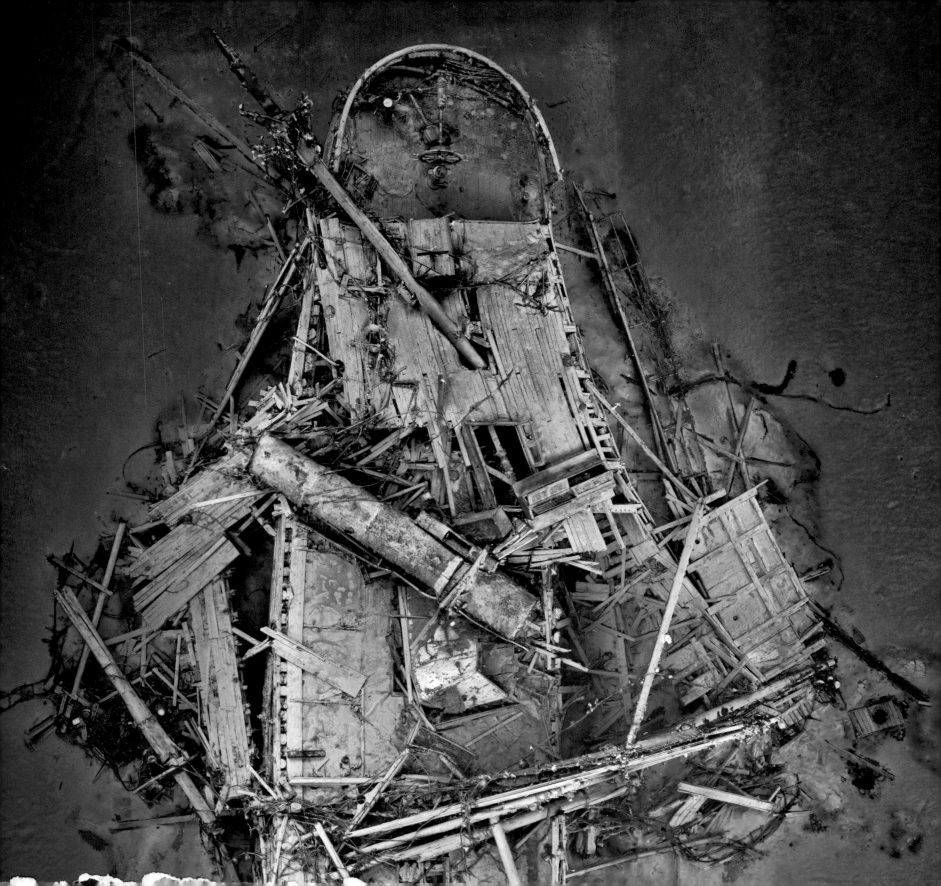

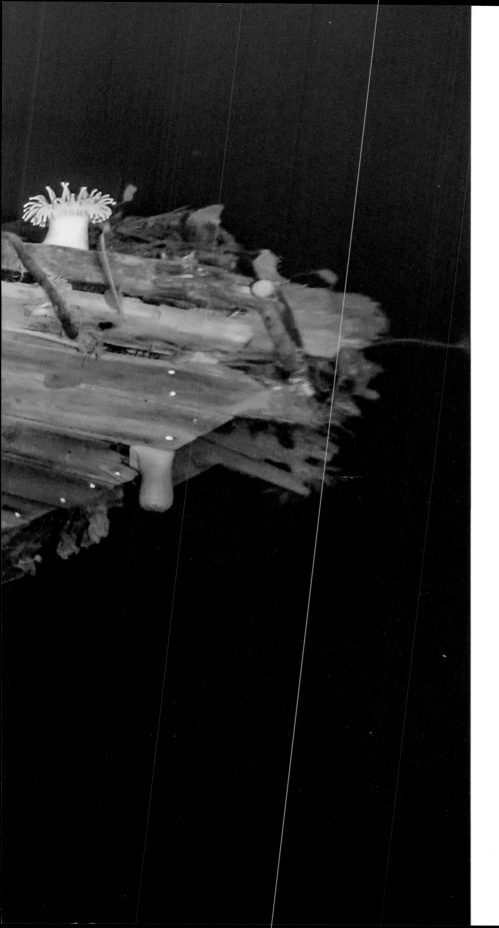

The starboard bow of *Endurance,* with an anchor chain still in place,
has become a home for a large cold-water anemone.

Endurance's mizzenmast has collapsed and lies on its side across the main deck. Its rigging lines are still attached and its wooden mast platform has been colonized by numerous anemones and glass sponges.

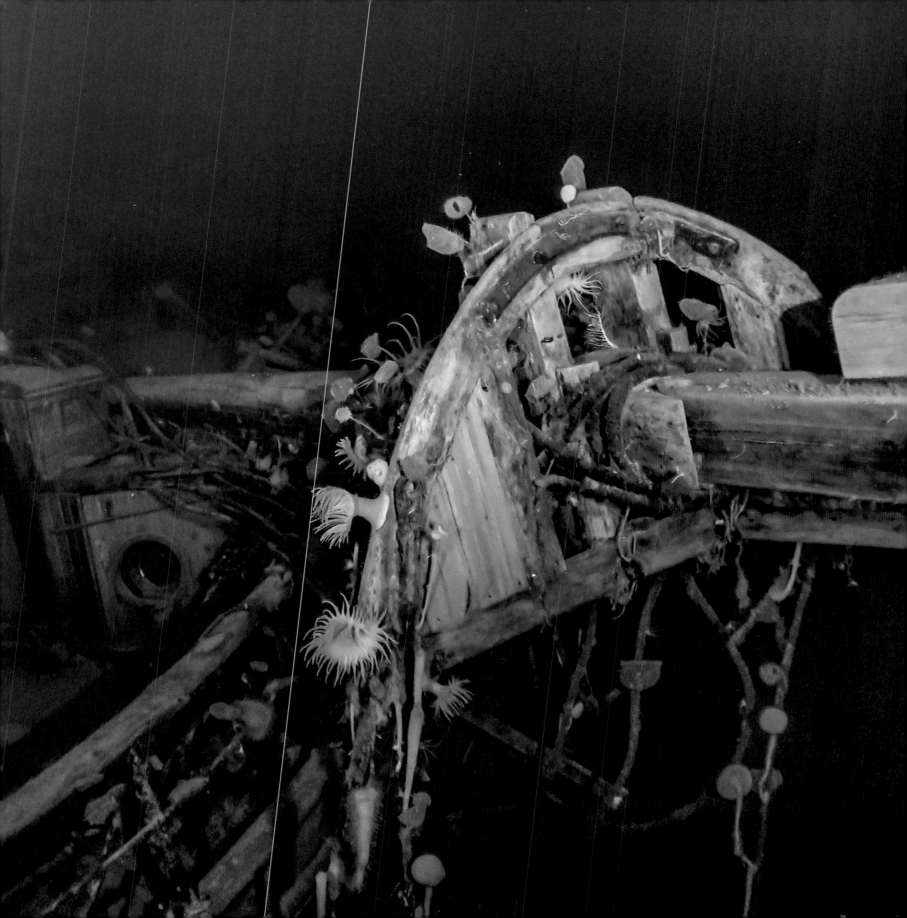

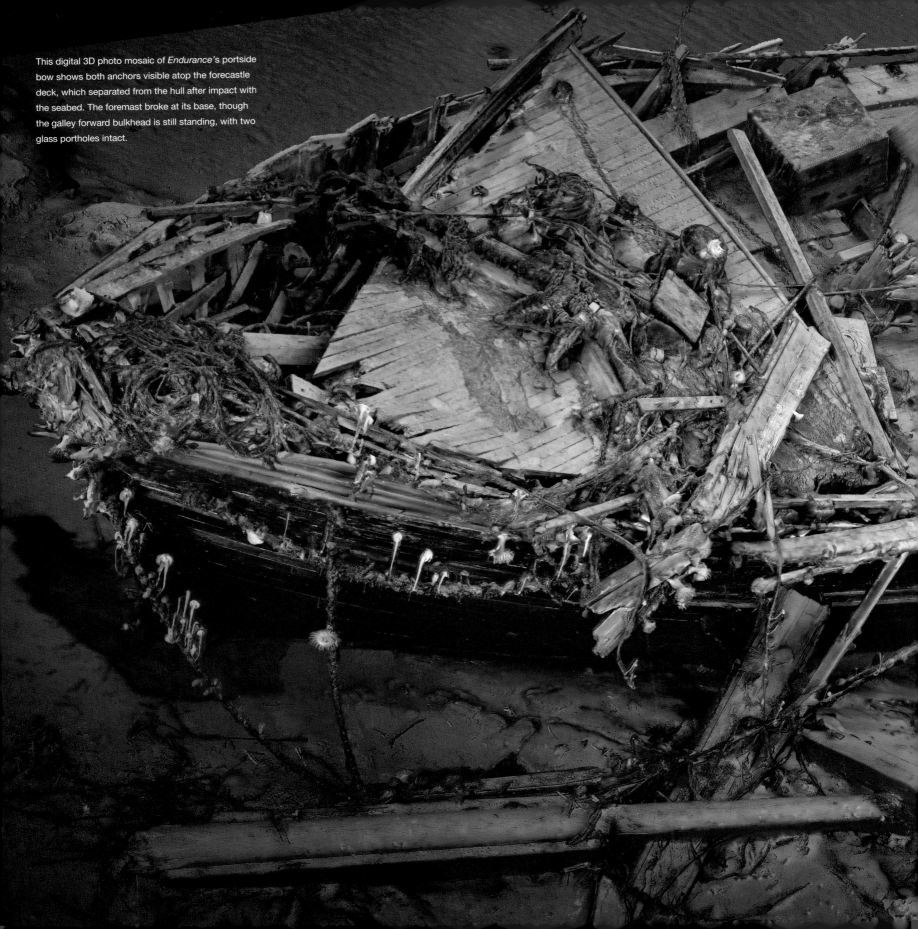

This digital 3D photo mosaic of *Endurance*'s portside bow shows both anchors visible atop the forecastle deck, which separated from the hull after impact with the seabed. The foremast broke at its base, though the galley forward bulkhead is still standing, with two glass portholes intact.

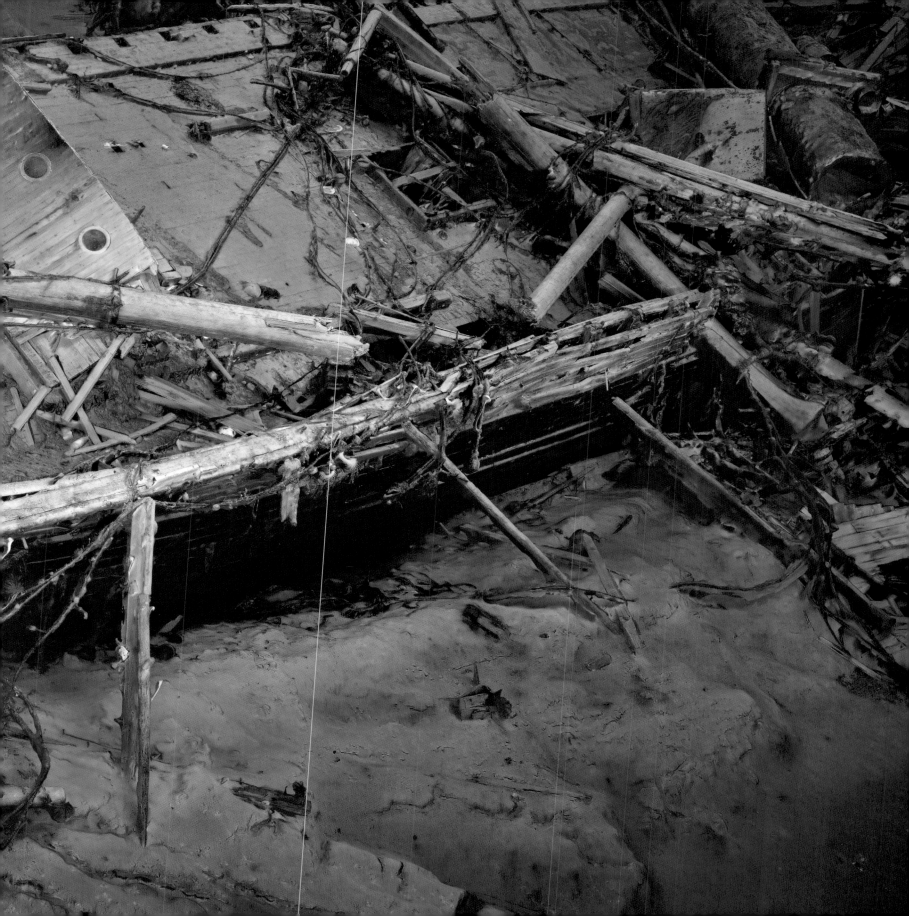

The incredible joy of the discovery: The faces of Mensun
Bound (left) and AUV supervisor Chad Bonin (middle) radiate
happiness and amazement, while Dr. John Shears (right) gives
Ellie the AUV a thank-you kiss.

Cheers all around: The entire crew celebrates their wonderful achievement. Here, Nico Vincent (left) and Chad Bonin congratulate each other with a hearty handshake.

Explorers From Across the World

MAEVA ONDE, SENIOR SURVEYOR, ENDURANCE22

I have been fascinated with Shackleton for 20 years. He was able to lead his men beyond what is humanly possible to endure, and *Endurance* represented an audacious shipwreck researching project that appeared unattainable, almost unreal. What could be more exciting?

When I interviewed to work at Deep Ocean Search in 2006, during what I call my "recklessness" years, the boss of the team asked me if I was "crazy enough" to join Nico Vincent's team. He had said it all! That was the beginning of my story as a deep-sea explorer.

Throughout this half of a lifetime I've now spent exploring the oceans, I've had to learn to coexist in close quarters with military service members and civilians, men and women, and people young and old. I've seen individuals who would not typically have crossed paths forge a true family through a multitude of shared moments. This incredible shared history—made of extraordinary events, intense moments of adversity, and exceptional discoveries—binds us all, gradually constructing this inseparable team spirit essential to our success.

On Endurance22, aboard the S.A. *Agulhas II,* more than a hundred individuals from all directions embarked on the same journey. The richness of this new adventure was founded on the concept of diversity. Scientists, media members, helicopter pilots, and Antarctic guides from such diverse backgrounds

converged with a common obsession. Uniting this heterogeneous group is a prerequisite to draw forth the finest qualities in each of us.

It required a certain tenacity and determination to endure the extreme working conditions on the S.A. *Agulhas II* deck. It became possible thanks to our unique group cohesion and the unwavering support we had for each other. It constituted the fundamental concept of team spirit which was decisive not only to our success, but to the survival of Shackleton's crew on the ice floe during the *Endurance* expedition as well.

On the day we discovered *Endurance*, everyone aboard was moved to see the wreckage materialize on our screens, but I especially remember those who stood beside me at that moment. For me, this story only holds worth when it's shared, and what makes it sublime is having experienced it with my maritime family. They are somewhat indescribable, the sentiments we harbor for one another, yet the feelings are undeniably present, imprinted within our very essence. And *Endurance* left an impression that is, naturally, beyond anything we've ever experienced before.

OPPOSITE: Maeva Onde, senior surveyor on the subsea team, reviews findings onscreen in the operations container as the Saab Sabertooth streams real-time data to the ship.

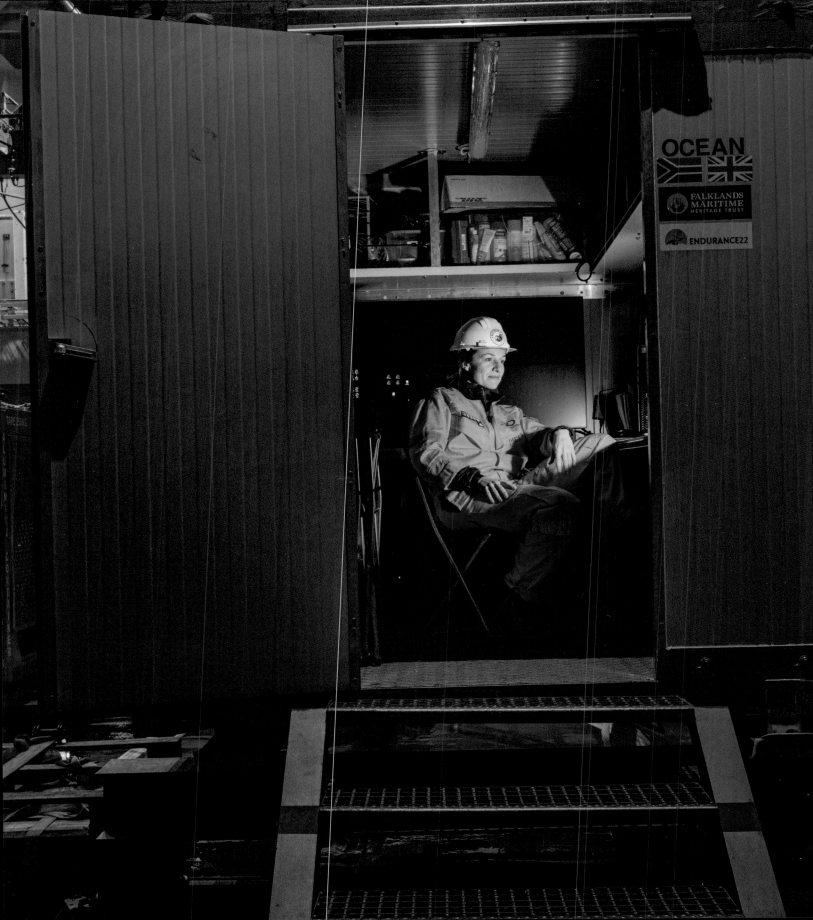

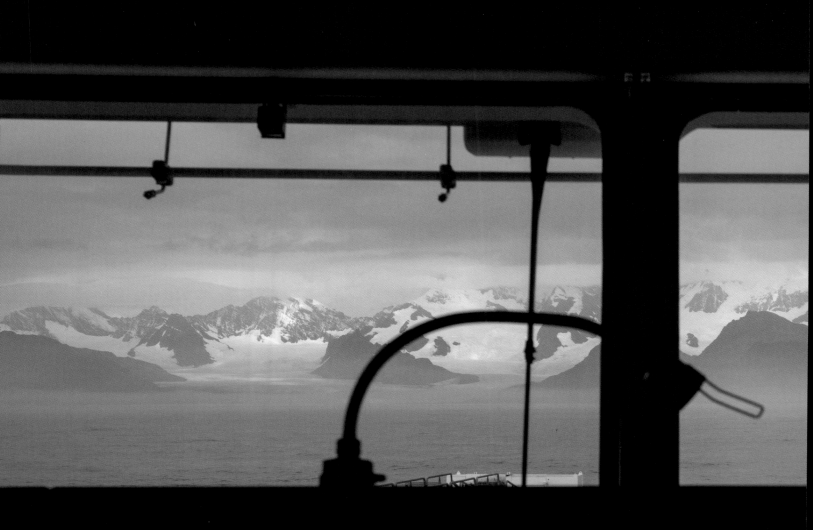

The Legacy

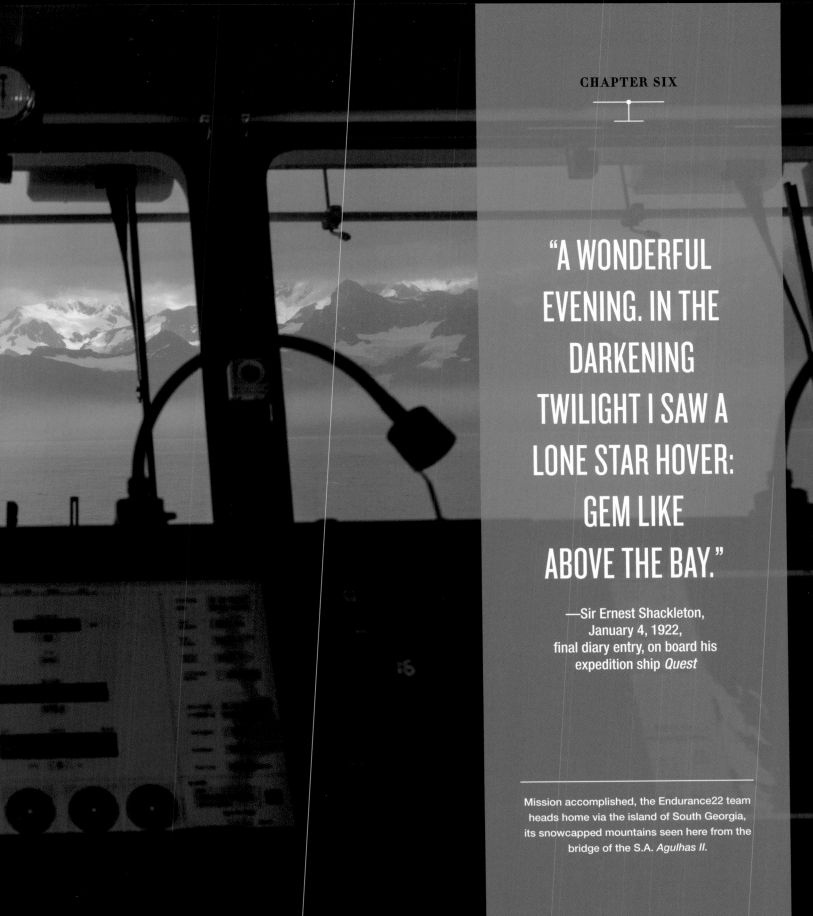

"A WONDERFUL EVENING. IN THE DARKENING TWILIGHT I SAW A LONE STAR HOVER: GEM LIKE ABOVE THE BAY."

—Sir Ernest Shackleton,
January 4, 1922,
final diary entry, on board his
expedition ship *Quest*

Mission accomplished, the Endurance22 team heads home via the island of South Georgia, its snowcapped mountains seen here from the bridge of the S.A. *Agulhas II*.

The Legacy

JOHN SHEARS

Our planned visit to South Georgia took on greater significance on the morning of March 6, 2022. I received a short message from Dave Murray at AMSOL containing some fascinating news. He had discovered Shackleton's burial on South Georgia had taken place on March 5, 1922—exactly one hundred years ago to the day that we had found his lost ship. I had absolutely no idea. Neither had anybody else on the expedition.

BREAKING NEWS

It was an easy journey out of the pack ice and away from the search area. By the early hours of March 9, we were back in open water and heading north toward South Georgia at 17 knots (19.5 mph/31.5 kph). At seven o'clock that morning, the Falklands Maritime Heritage Trust broke the news of our historic discovery to the world with a press release headlined "*Endurance* Is Found."

The incredible color photographs and film of *Endurance* resting on the seafloor made international front-page news and TV headlines and sparked a social media frenzy. Our discovery received features in *National Geographic, Le Monde* in France, and the *Times* in London. The *Times* reported, "The successful search for Ernest Shackleton's lost ship is a triumph of exploration." None of us expected our discovery to fascinate and amaze millions of people across the world, but over the next 24 hours, we gave more than 50 TV news interviews, and our story appeared in more than 1,500 newspaper and magazine articles. When Dan Snow tweeted about the discovery of the shipwreck from on board the S.A. *Agulhas II,* his message was viewed over 10 million times.

We were humbled that our story had resonated with so many people across the world. We received thousands of messages of congratulations, but I was especially moved and proud to receive a message from Sir Ranulph Fiennes, the world-famous British polar explorer who is the only man alive to have traveled around Earth's circumpolar surface. He commended our perseverance and determination and said of the team: "I do hope they fully realise the full significance of all their hard work and technical know-how."

Many journalists wanted to know if we had removed any artifacts from *Endurance* or if we were planning to raise the

Members of the Endurance22 team hitch a ride on one of the S.A. *Agulhas II*'s fast-response craft to visit Grytviken on South Georgia.

wreck from the seafloor. We explained that *Endurance,* along with all artifacts within her, on deck, or lying on the seabed nearby, were designated a permanent historic site and monument in 2019 under the international Antarctic Treaty, and thus totally protected. This designation means the site cannot be damaged, removed, or destroyed, and the wreck will remain undisturbed. We had taken only photographs, film, and a 3D laser scan of the ship. The complete digital 3D re-creation of *Endurance* will be made widely available for scientific research, museums, and exhibitions to bring this extraordinary ship to life for as many people as possible without causing her harm.

Following our discovery, the U.K. government started to increase the protection given to *Endurance.* On November 21, 2022, the U.K. Antarctic Heritage Trust announced that it had been commissioned by the Foreign, Commonwealth and Development Office to develop a conservation man-

agement plan for the wreck. This plan will identify the challenges and opportunities in conserving the ship and recommend measures and guidance to secure its protection. The Falklands Maritime Heritage Trust, together with Nico and me, are determined to make the plan a reality. When finished, the plan will be presented by the U.K. government at the annual Antarctic Treaty meeting for international adoption and implementation. This will make *Endurance* one of the best protected deepwater wrecks anywhere in the world.

FINDINGS IN THE ICE

Our scientific research in the ice of the Weddell Sea addressed important questions about the impact of global warming on the region. The low levels of sea ice we experienced in 2022 had helped our search for the wreck. The S.A. *Agulhas II* had only needed to sail about 10 nautical miles (11.5 mi/18.5) through thick pack ice to reach the search box in 2022, compared to about 90 nautical miles (105 mi/165 km) in 2019.

But was the reduced sea ice we sailed through in 2022 due to melting caused by global warming? Dr. Lasse Rabenstein, our chief scientist, had pointed out at the beginning of the expedition that sea ice conditions in the Weddell Sea could be highly variable and exceedingly unpredictable. At that

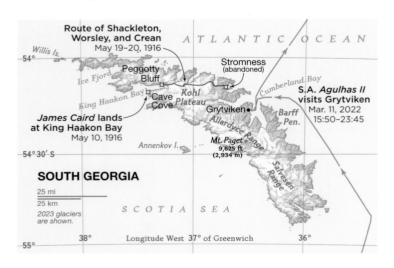

Map of South Georgia, a remote island about 1,200 miles (1,930 km) to the north of the Weddell Sea

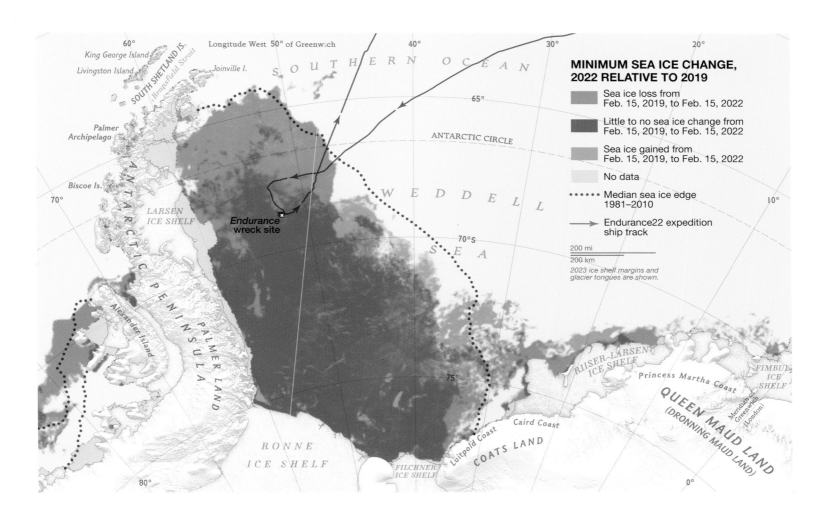

MINIMUM SEA ICE CHANGE,
2022 RELATIVE TO 2019

Sea ice loss from
Feb. 15, 2019, to Feb. 15, 2022

Little to no sea ice change from
Feb. 15, 2019, to Feb. 15, 2022

Sea ice gained from
Feb. 15, 2019, to Feb. 15, 2022

No data

Median sea ice edge
1981–2010

Endurance22 expedition
ship track

200 mi
200 km
2023 ice shelf margins and
glacier tongues are shown.

time, attributing this solely to global warming seemed premature, especially considering that there hadn't been any consistent decline in Antarctic sea ice extent over the previous decades, in stark contrast to the situation in the Arctic. It's possible that we had just been fortunate with our timing. However, in 2023, Lasse and other sea ice scientists were less certain about this perspective because of the latest results of satellite monitoring of sea ice around Antarctica.

A minimum record of sea ice extent around Antarctica was set on February 25, 2022, while we were in the Weddell Sea. On that day, satellites observed the ice covered 1.92 million square kilometers (741,300 mi²). However, this record was broken again on February 21, 2023, when the cover had reduced to 1.79 million square kilometers (691,100 mi²)—the lowest sea ice extent since satellite records began in 1979. Scientists are now warning that these record losses of sea ice around Antarctica, including in the

Map showing the change in sea ice extent for the Weddell Sea between February 2019 and February 2022

A New Antarctica

DR. LASSE RABENSTEIN, CHIEF SCIENTIST, ENDURANCE22

As the chief scientist of Endurance22, I had the privilege to follow in the footsteps of the Imperial Trans-Antarctic Expedition's pioneering researchers. Both missions aimed at exploration to improve our understanding of this remote continent, and under the Endurance22 banner, 15 diverse scientists from around the world joined forces. Our collective work has enriched our knowledge of Antarctic sea ice, aided long-term climate studies, and pioneered innovative techniques for navigation in ice-covered waters.

Despite the watchful eye of satellite technology and the Antarctic Treaty nations' steadfast commitment to continuous research, the Weddell Sea remains one of the least explored regions on our planet. Here, the persistence of sea ice in the summer and the presence of dense, multiyear ice in the region create logistical challenges unlike any other place in Antarctica. Endurance22 provided an opportunity to extend the sporadic data collection initiated by previous expeditions and enhance our understanding of the area's intricate interplay of ice, atmosphere, and ocean, a symphony that holds the key to a fundamental force driving our planet's ocean currents and exerting far-reaching influences on Earth's climate.

A pivotal question has weighed on my mind since we returned from the Weddell Sea: Did we navigate the same perilous sea ice conditions that Shackleton had experienced, or did global warming aid our quest for the wreck? To date, satellite data has not

unveiled a significant trend in the annual extents—maximum and minimum—of Antarctic sea ice. However, in 2023, we confronted a seventh consecutive year of below-average Antarctic sea ice extent, and scientists around the world see this as a possible profound shift in the continent's stability, a transition from a stable Antarctic sea ice cover to a vulnerable one prone to rapid, unpredictable fluctuations. In the extreme, such changes could raise the possibility of ice-free Antarctic summers, driven by the escalating heat in the global atmosphere. This development would have unforeseen consequences, including the potential for shifting ocean and weather patterns worldwide. Certainly, it would significantly impact Antarctic animals that rely on sea ice as their habitat.

Every scientist on the Endurance22 expedition shared an unwavering commitment to our primary mission: locating the wreck of *Endurance*. Because of the scientists' seamless collaboration with the crew and subsea team, our journey has illuminated the potential for synergy between expertise in sea ice research and underwater exploration. In the future, such collaboration will only shed more light on the still mysterious realm of the Weddell Sea and its sub-ice domain.

OPPOSITE: Dr. Lasse Rabenstein (left), chief scientist for Endurance22, together with his research colleagues Mira Suhrhoff and Jakob Belter, prepare to take measurements of sea ice and snow thickness on an ice floe in the Weddell Sea.

Weddell Sea, may be a sign of a fundamental change in the region. The cause may be unusually high summer air temperatures around the Antarctic Peninsula, in addition to subsurface warming of the Southern Ocean. If this is the case and rapid sea ice loss continues, it will have far-reaching impacts on Antarctic marine ecosystems and the global climate. Much is still unknown, and further monitoring and research is urgently required. The sea ice measurements collected on the Endurance22 expedition are a vital contribution to this effort and will help scientists to improve climate models of the region and predictions as to what will happen next.

Currently, *Endurance* is well protected because of its location on the seafloor. The deepwater conditions of the Weddell Sea are highly stable around the wreck, and the dense sea ice on the surface makes it difficult for ships to reach the site. However, these conditions may not last forever, so there is no room for complacency. Because of climate warming, it might be far easier for ships to get to the site in the future, and changes in ocean conditions may begin to affect the wreck. This is why the conservation management plan is critical to protect and safeguard the ship where she lies.

ENDURANCE'S NEW CREW

When deep-sea marine biologists began to look closely at the images of *Endurance,* they found that a wide variety of filter-feeding animals had colonized the wreck, including large sea anemones, sea lilies, sea squirts, glass sponges, and a huge six-armed sea star. The wreck was an oasis of life for deep-sea creatures. These creatures will colonize anything that stands proud on the ocean floor, which in the Weddell Sea usually means large boulders dropped by melting icebergs. Anything living even just a few inches above the seafloor can catch particles of food drifting by in the bottom currents. Of all the newcomers to *Endurance,* the biggest surprise was the discovery of a ghostly white crablike crustacean, called a squat lobster, climbing across the deck. The scientists were astonished by this first ever record of a squat lobster in the Weddell Sea. Some scientists thought the creature might be an entirely new species.

A most important finding by the biologists concerned a creature they didn't find on the wreck. Our subsea survey found no evidence of shipworms living on the *Endurance* wreck or in its timbers. Shipworms are marine bivalve mollusks. They bore into and eat wood, and as a result, destroy most wooden shipwrecks in warmer lower latitudes. But they haven't been found in the seas surrounding the Antarctic continent as the water is too cold for them to survive, and there is nothing for them to eat. There have been no trees growing in Antarctica for 30 million years, so there is no wood at all in the surrounding water. Plus, the Antarctic Circumpolar Current moves in a clockwise direction around the continent, acting as a natural oceanographic barrier that prevents wood—and any hitchhiking shipworms—from drifting south.

The complete absence of shipworms, combined with the cold temperatures, total darkness, low oxygen, lack of sedimentation, and the still waters at 10,000 feet (3,050 m) deep, together with the ship's strong construction, have all contributed to preserve *Endurance* in pristine condition. She rests on the seabed as if she had sunk just yesterday.

SHACKLETON'S GRAVE

We arrived at South Georgia during the early evening of March 11, 2022, our arrival delayed by nearly 12 hours due to rough weather and high winds.

South Georgia is one of the most spectacular and awe-inspiring places on Earth. The island is dominated by snow-capped mountains that rise straight out of the ocean. The majestic Allardyce mountain range forms the island's spine, with Mount Paget the highest peak at 9,629 feet (2,935 m). More than half the island is permanently covered by snow, ice, and glaciers. But despite the rugged terrain, the island is a haven for wildlife, including seals, penguins, and other seabirds, which can be found in the millions breeding there during the summer season. There are no trees on the island. In snow-free areas at the coast, the landscape is dominated by grassland, tussock grass, and peat bogs.

In 1904, the hunting of whales in the seas around South Georgia began and the first whaling station was opened at Grytviken. Whales were hunted for their oil, which was used in products such as margarine and soap. The industry expanded rapidly and several more stations were built, and

South Georgia became the center of whaling operations in the Southern Ocean. It is recorded that 175,250 whales were killed at South Georgia between 1904 and 1965. Grytviken was the last station to close, in 1966. It was left abandoned to decay and fall into ruins.

When we came into Cumberland Bay, we were greeted by drizzle and mist, and a minke whale surfacing right next to the ship. Before us lay King Edward Cove, and at its head the rusty red remains of Grytviken. About a mile away on the grassy hillside to the south, we could just make out the old whalers' cemetery where Shackleton is buried.

Shackleton died at South Georgia in the early hours of January 5, 1922, at the beginning of an expedition planning to circumnavigate Antarctica. By this time, the Boss was seriously ill. He suffered a massive heart attack and died in his cabin on board the ship *Quest,* which was anchored in King Edward Cove. He was only 47.

Shackleton's trusted deputy, Frank Wild, took over command of the *Quest* expedition and ordered Shackleton's body sent to Montevideo, Uruguay, to be returned to England. But when Shackleton's wife, Emily, learned of her husband's death, she asked for his body to be returned to South Georgia, to rest forever at the gateway to Antarctica.

On March 5, 1922, following a simple ceremony in the wooden church in Grytviken, Shackleton was buried in the whalers' cemetery. A hundred whalers and seamen, as well as the managers of all five whaling stations on South Georgia, attended the burial service. Shackleton's pallbearers

THE SMALL SQUARE CEMETERY CONTAINS 64 GRAVES, MOSTLY OF WHALERS, AND IS SURROUNDED BY A LOW WOODEN FENCE. SHACKLETON'S GRAVE IS THE LARGEST, AND AT ITS HEAD THERE IS A GRANITE MEMORIAL HEADSTONE.

were all whalers from the Shetland Islands in the far north of Scotland. They placed his body facing south toward Antarctica. The station doctor's wife, Mrs. Aaberg, the only woman on the island, picked a small bunch of flowers from the conservatory at her house and laid them on his coffin.

We started our own ceremony to honor Shackleton at 7:30 p.m. on March 11, 2022. The entire Endurance22 expedition team was present, along with many of the ship's crew and people working at the South Georgia Museum at Grytviken. The small square cemetery contains 64 graves, mostly of whalers, and is surrounded by a low wooden fence. Shackleton's grave is the largest, and at its head there is a granite memorial headstone, erected in 1928. The front bears a nine-pointed star, a symbol associated with the Shackleton family, and the reverse bears a quote from Shackleton's favorite poet, Robert Browning: "I hold that a man should strive to the uttermost for his life's set prize."

I stood quietly together with Nico at the graveside and we read the words on the headstone: "To the dear memory of Ernest Henry Shackleton, Explorer, Born 15th Feb. 1874, Entered Life Eternal 5th Jan. 1922."

Mensun started proceedings. He introduced Captain Knowledge, who spoke from his heart and said, as if speaking to Shackleton in person: "We've found your baby. We are here to present you with your baby." He then placed the photograph of the stern of *Endurance* on the grave below the headstone.

I spoke next from a short piece I had written that morning. On February 24, 2022, while our expedition had been

sailing in the desolate pack ice of the Weddell Sea, the largest military attack in Europe since World War II occurred when Russia invaded Ukraine. Already, there were thousands of deaths and casualties. The sobering reality of returning to a world torn by conflict was foremost on my mind as I read: "Today I've been reflecting on the history of Sir Ernest's life and the *Endurance,* and also about what it can tell us about our future. The *Endurance* departed England on 8 August, 1914, just as the First World War was declared. The expedition had no communication with the outside world, and it wasn't until Shackleton reached South Georgia and safety on 20 May, 1916, that he discovered millions of people had died. Sadly, history has repeated itself while we have been on our own Antarctic expedition. Once again war is raging in Europe, causing massive death and destruction, and the full extent of the horror will only become apparent to us when we return home to our families and loved ones. Here in this beautiful and tranquil location, it is hard to fathom why people are killing each other so far away. We offer our thoughts and prayers that peace will soon return to the world."

Others spoke, too: Mensun about Shackleton's legacy and read a few lines from Rudyard Kipling's poem "If—," a framed copy of which Shackleton had mounted on the bulkhead in his cabin on *Endurance.* Dan read Robert Browning's "Prospice," a symbolic poem for Ernest and Emily Shackleton. They often used the word "prospice" as a message of courage, hope, and love for each other throughout their lives.

With the ceremony finished, there was silence, and people started to drift out of the cemetery. I was the last to leave. It had been a moving and uplifting tribute. As I turned to go, I looked back at Shackleton's gray granite headstone and gave him a nod of thanks—one expedition leader to another—and carefully closed the cemetery's metal gate to stop the fur seals from getting in. I began to walk slowly back to the jetty and the tender waiting to take me back to the ship.

As I tramped through the wet tussock grass, I recalled a question a news reporter had asked me two days earlier: "What will you most remember about the Endurance22 expedition?" I had replied, "It was the people, all the team around me."

The team had become a big family, and their strength, determination, and friendship had sustained me throughout our incredible adventure. I smiled to myself, thinking the Boss would be amazed at our success and what we had achieved, perhaps slapping our backs and applauding our efforts in finding his ship against the odds.

The Endurance22 expedition was a bright shining star to the world, a glorious symbol of what can be achieved when people trust each other and work together to meet the greatest of challenges.

As the light began to fade and the drizzle turned to rain, all I could hear was the breeze and the occasional yelp of a fur seal pup. I stood up straight, looked ahead, and walked briskly down the hill. Time to go home.

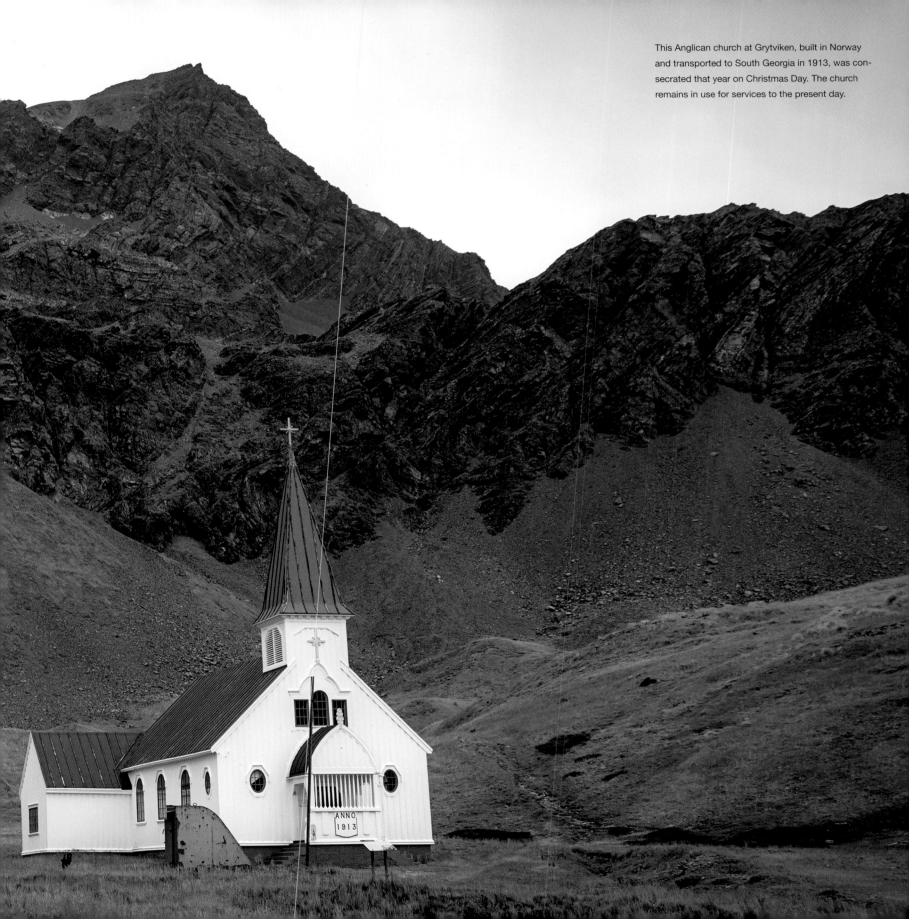

This Anglican church at Grytviken, built in Norway and transported to South Georgia in 1913, was consecrated that year on Christmas Day. The church remains in use for services to the present day.

Shackleton embarked on his final Antarctic expedition in
September 1921. He planned to circumnavigate Antarctica on
board his schooner-rigged steamship, *Quest,* but died of a
heart attack in his cabin while the ship was anchored in King
Edward Cove next to Grytviken whaling station. Here, in one of
the last known photographs of Shackleton, the Boss steadies
himself on *Quest's* rain-slicked deck.

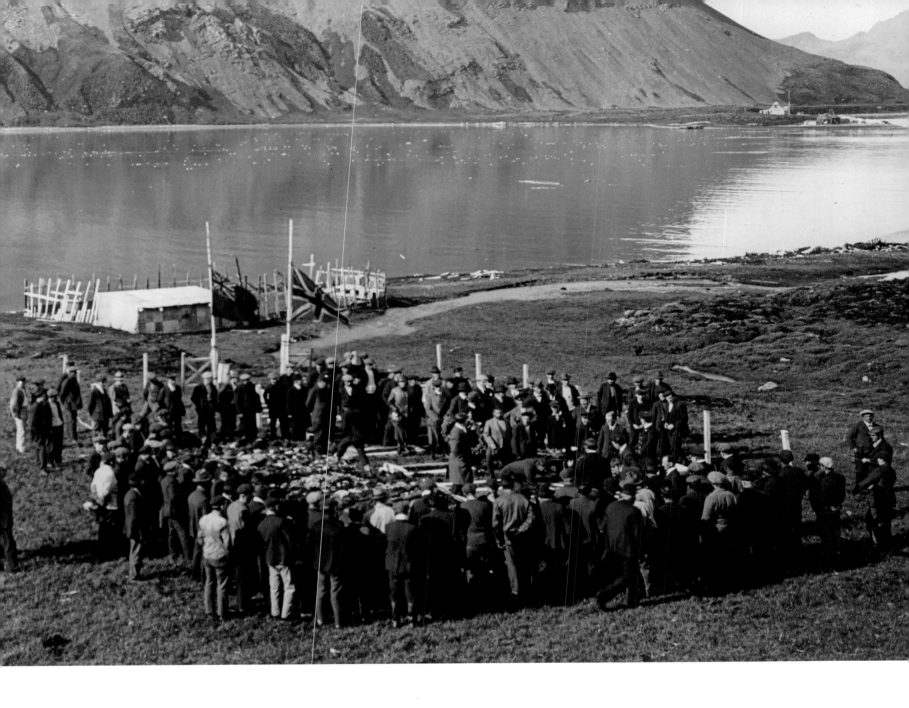

At the request of his wife, Emily, Shackleton was buried at Grytviken, South Georgia. The funeral, attended primarily by whalers and sailors, took place on March 5, 1922. *Endurance* was discovered by the Endurance22 expedition team 100 years later to the day.

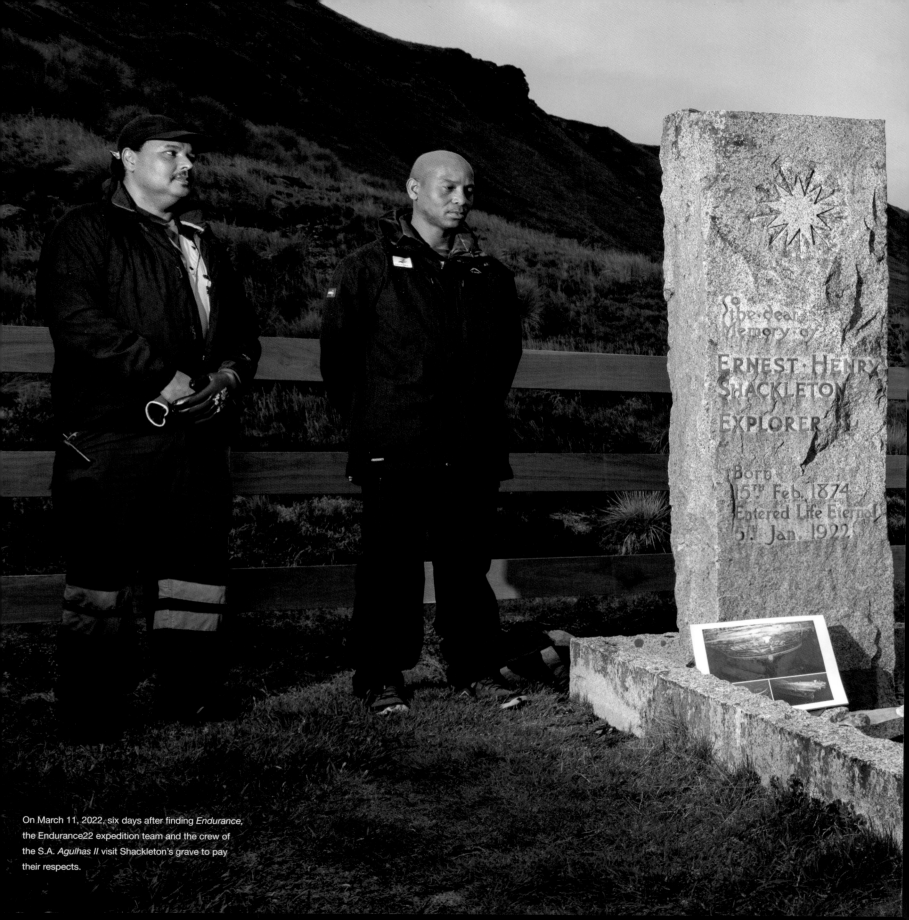

On March 11, 2022, six days after finding *Endurance,* the Endurance22 expedition team and the crew of the S.A. *Agulhas II* visit Shackleton's grave to pay their respects.

To
the dear
Memory of
ERNEST·HENRY
SHACKLETON
EXPLORER
Born
15TH Feb. 1874
Entered Life Eternal
5TH Jan. 1922

Fur seal pups play in the tussock grass at Grytviken, South Georgia. The Endurance22 vessel, the S.A. *Agulhas II,* is at anchor in the distance.

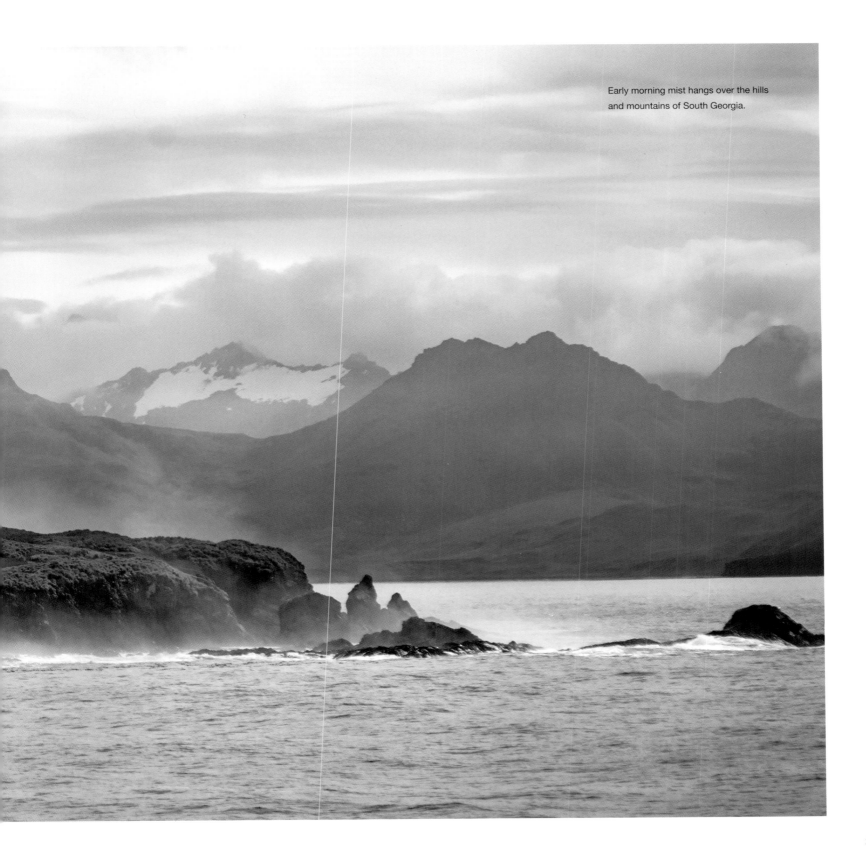

Early morning mist hangs over the hills and mountains of South Georgia.

The view of South Georgia through the stern hawser hole of the
S.A. *Agulhas II*

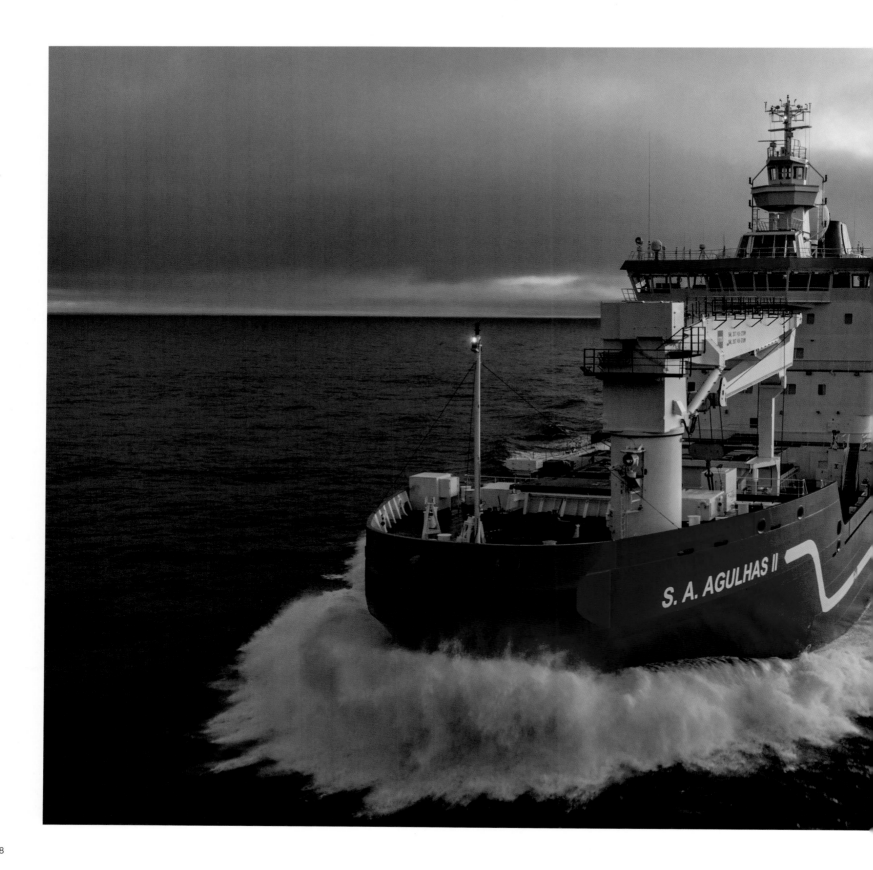

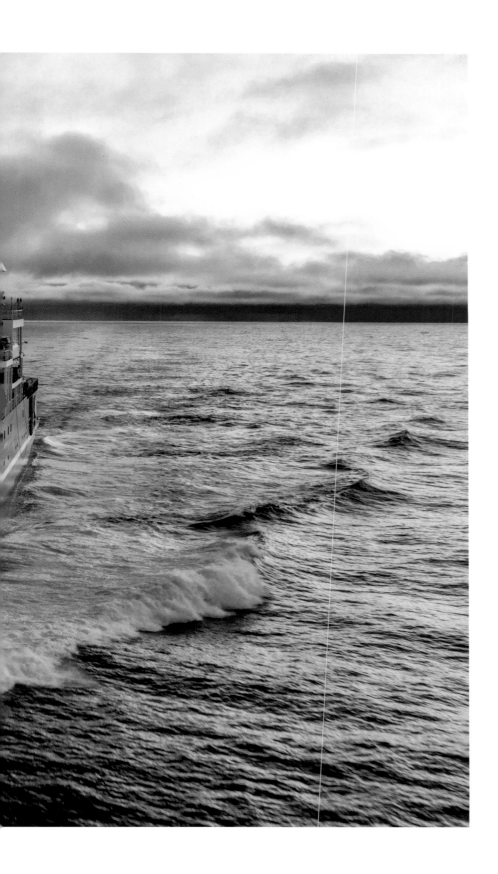

The S.A. *Agulhas II* sailing at full speed, 17 knots (19.5 mph/ 31.5 kph), across the Southern Ocean

Clear skies and a calm sea await the S.A. *Agulhas II*
as she makes the 3,000-mile (4,830 km) voyage
across the Southern Ocean back to Cape Town,
South Africa.

With *Endurance* found and the news broadcast around the world, it's time for a full team celebration. Everyone aboard the S.A. *Agulhas II* enjoys a *braai*—a traditional South African barbecue—on the helicopter deck.

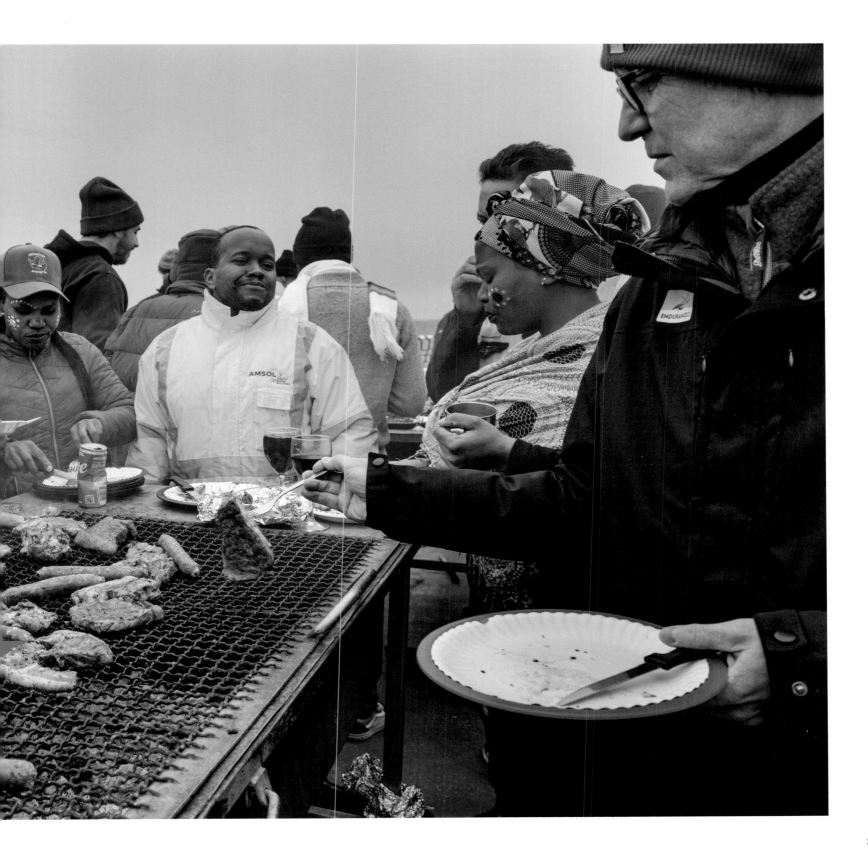

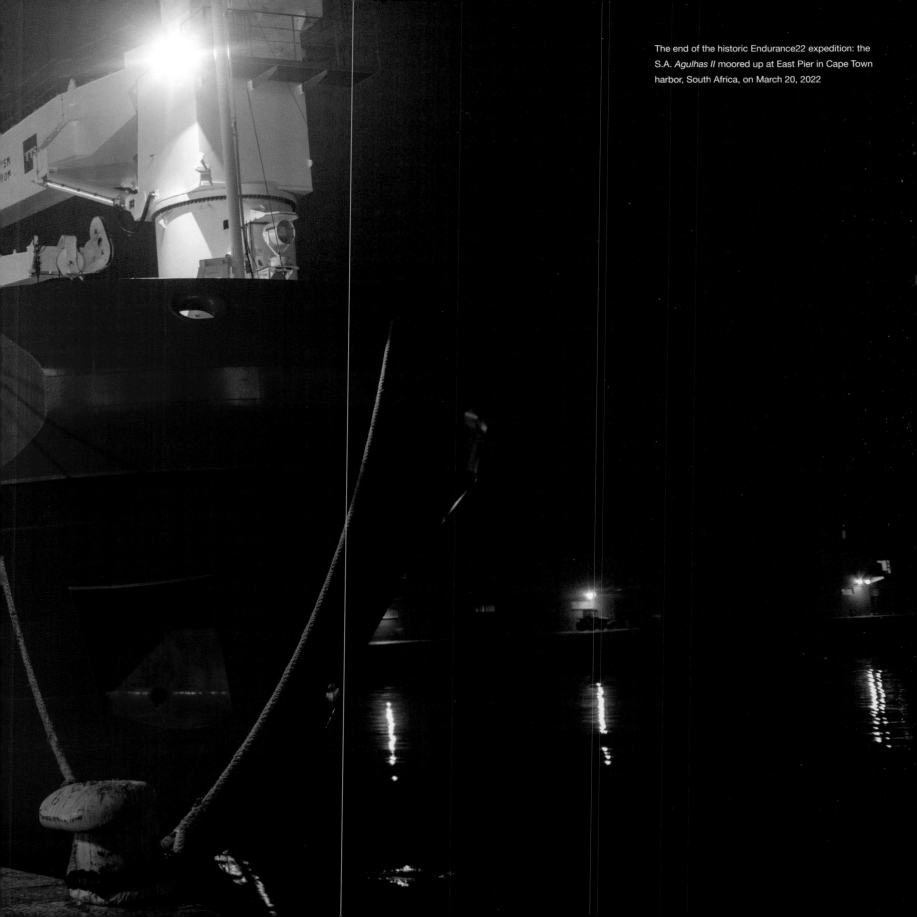

The end of the historic Endurance22 expedition: the S.A. *Agulhas II* moored up at East Pier in Cape Town harbor, South Africa, on March 20, 2022

Acknowledgments

Just as with the Endurance22 expedition itself, teamwork has been essential in the production of this National Geographic book about our quest and ultimate success in discovering *Endurance*.

My sincere thanks to our editors at National Geographic Books, Susan Tyler Hitchcock and Tyler Daswick, for their endless patience, excellent support, and good advice. Thank you to Lisa Thomas, editorial director at National Geographic Books, who saw the potential in my original idea and brought the book to publication. I'm grateful to Esther Horvath, the official photographer on Endurance22, for allowing her photographs of the expedition to be published for the first time in a book, and to Pierre Le Gall, marine surveyor at Deep Ocean Search, for his work processing the subsea imagery of *Endurance*. Thanks also to Anne Farrar, senior photo editor at *National Geographic* magazine, Jill Foley, and Adrian Coakley, director of photography at National Geographic Books, for editing the photographs and images, to Nicole M. Roberts, design manager at National Geographic Books, for her outstanding and persistent design work, and to Greg Ugiansky, senior cartographer at National Geographic Books, for preparing the maps and diagrams.

I would like to thank the members of the Endurance22 expedition who have contributed valuable text to the book: Tim Jacob, Natalie Hewit, Captain Freddie Ligthelm, Maeva Onde, Dr. Marc de Vos, and Dr. Lasse Rabenstein.

My sincere gratitude to Her Royal Highness, the Princess Royal, for providing the foreword. Thank you to Alison Neil, the chief executive of the South Georgia Heritage Trust, for her help arranging this.

I am grateful to the Falklands Maritime Heritage Trust for giving permission for the publication of the book and for allowing the spectacular subsea imagery of *Endurance* to be included. Thank you to the chairman of the trust, Donald Lamont, for his introduction. I particularly want to thank Anthony Clake, who made the expeditions of 2019 and 2022 possible.

My special thanks go to my co-author, and great friend, Nico Vincent. He and I have worked closely together for more than a year to write our account of Endurance22, overcoming challenges and setbacks, and we have persevered to bring this book to a global audience.

Finally, thank you to my daughters, Olivia and Isobel, for their encouragement, and to Liz, my wife, for her constant support, good advice, and wise words. I couldn't have written the book without her.

—J. S.

How can I thank all those who have enabled me to achieve this unimaginable feat without forgetting someone? A task that only the Boss can overcome.

From my childhood village in the French Alps, from which I fled the cold, here I am today, an integral part of polar history. My parents are still laughing about it. I'd like to thank them for allowing me this career over the world's oceans.

My son "endured" the three years of my life that were necessary to make this project a success. There are no words to thank him for his patience.

In rescuing his crew from the most horrific conditions, Shackleton and his famous leadership demonstrated that the role of each individual is the strength of the group.

That group is them, the Endurance22 subsea team, men and women who have given their all to discover *Endurance*. This story is theirs. This success is theirs. What a sense of pride to be at their head, what an honor to be at their side. This team exists thanks to one man, John Kingsford.

I owe special thanks to my co-author, Dr. John Shears, who for this book quietly supported me in adjusting my "Frenchglish" of Marseille to a proper Cambridge University formulation. This shows he is not only an excellent team leader ... but also a good friend.

However, my thankfulness goes to Anthony Clake, benefactor of this entire expedition, who placed his trust in me. He gave me free hands to make this project a success. I am eternally grateful to him and dedicate our success to him.

I'd like to end with a personal message to my late beloved wife: "Hey SweetHeart, please do me a favor, from where you are, give thanks and hugs to the Boss for me. He deserves it."

—N. V.

Sources and Further Reading

SOURCES

de Vos, Marc, et al. "Understanding the Drift of Shackleton's *Endurance* During Its Last Days Before It Sank in November 1915, Using Meteorological Reanalysis Data." *History of Geo- and Space Sciences* 14 (2023), 1–13.

Dowdeswell, Julian, et al. "Delicate Seafloor Landforms Reveal Past Antarctic Grounding-line Retreat of Kilometres per Year." *Science* (May 2020), 1020–24.

Fretwell, Peter T., Aude Boutet, and Norman Ratcliffe. "Record Low 2022 Antarctic Sea Ice Led to Catastrophic Breeding Failure of Emperor Penguins." *Communications Earth & Environment* 4 (2023), article 273.

Hitchcox, Thomas, and James Forbes. "Laser-to-Vehicle Extrinsic Calibration in Low-Observability Scenarios for Subsea Mapping." *IEEE Robotics and Automation Letters* 9, no. 4 (2024), 3522–29.

Hurley, Frank. *Argonauts of the South*. G.P. Putnam's Sons, 1925.

Lansing, Alfred. *Endurance: Shackleton's Incredible Voyage*. McGraw-Hill, 1959.

Shackleton, Ernest. "Endurance Diary." Unpublished manuscript, 1915. SPRI MS 1537/3/7.

———. *South: The Story of Shackleton's Last Expedition 1914–1917*. Heinemann, 1919.

Worsley, Frank. "Endurance Diary." Unpublished manuscript, 1915. SPRI MS 296.

———. *Endurance: An Epic of Polar Adventure*. Philip Allan, 1931.

FURTHER READING

Alexander, Caroline. *The Endurance*. Bloomsbury, 1999.

Bound, Mensun. *The Ship Beneath the Ice: The Discovery of Shackleton's* Endurance. Macmillan, 2022.

Dowdeswell, Julian, and Michael Hambrey. *The Continent of Antarctica*. Papadakis, 2018.

Fiennes, Ranulph. *Shackleton: The Biography*. Michael Joseph, 2021.

Fisher, Margery, and James Fisher. *Shackleton*. James Barrie, 1957.

Heacox, Kim. *Ernest H. Shackleton: The Antarctic Challenge*. National Geographic, 1999.

Huntford, Roland. *Shackleton*. Hodder and Stoughton, 1985.

Hussey, Leonard. *South With Shackleton*. Sampson Low, 1949.

Mill, Hugh Robert. *The Life of Sir Ernest Shackleton*. Heinemann, 1923.

Rex, Tamiko, ed. *South With Endurance: Shackleton's Antarctic Expedition 1914–1917 (The Photographs of Frank Hurley)*. Bloomsbury, 2001.

Tyler-Lewis, Kelly. *The Lost Men*. Bloomsbury, 2006.

Wild, Frank. *Shackleton's Last Voyage: The Story of the Quest*. Cassell, 1923.

Worsley, Frank. *Shackleton's Boat Journey*. Hodder and Stoughton, 1940.

Timeline of Events

▸ **DECEMBER 17, 1912:** The ship is launched from Framnæs Mekaniske, a shipyard in Sandefjord, Norway. Named *Polaris* after the North Star, the ship was designed by Ole Aanderud Larsen and built under the supervision of Christian Jacobsen for a consortium led by the Belgian polar explorer Adrien de Gerlache and Norwegian shipowner Lars Christensen.

▸ **AUGUST 1, 1914:** Sir Ernest Shackleton buys the ship in March 1914 for use by the Imperial Trans-Antarctic Expedition and renames her *Endurance*. Following a refit and repairs, *Endurance* departs Millwall Docks, London, England.

▸ **AUGUST 8, 1914:** *Endurance* departs from Plymouth, England, for Buenos Aires, Argentina, under the command of Captain Frank Worsley.

▸ **OCTOBER 9, 1914:** *Endurance* arrives in Buenos Aires, where Shackleton, Frank Wild, and Frank Hurley join the ship.

▸ **OCTOBER 26, 1914:** *Endurance* departs Buenos Aires.

▸ **NOVEMBER 5, 1914:** *Endurance* arrives at Grytviken whaling station, King Edward Cove, on the island of South Georgia.

▸ **DECEMBER 5, 1914:** *Endurance* departs South Georgia for the Weddell Sea, Antarctica.

▸ **DECEMBER 7, 1914:** *Endurance* first encounters the pack ice.

▸ **JANUARY 18, 1915:** *Endurance* becomes beset and, immobilized, begins drifting in the pack ice.

▸ **OCTOBER 27, 1915:** With *Endurance* crushed in the ice and badly damaged, Shackleton orders the crew to abandon ship.

▸ **NOVEMBER 21, 1915:** *Endurance* sinks. Worsley records an estimated sinking position of the ship as 68° 39' 30" S and 52° 26' 30" W.

▸ **JUNE 2, 1916:** *Endurance* is declared a total loss by Lloyd's of London. The entry in the Loss Book recorded (incorrectly): "Endurance | British—crushed by ice in Weddell Sea and afterwards foundered November 20 1915."

▸ **JANUARY 5, 1922:** Sir Ernest Shackleton dies in his cabin on board the expedition ship *Quest* while it is anchored off Grytviken whaling station on South Georgia.

▸ **MARCH 5, 1922:** Sir Ernest Shackleton's body is buried in the cemetery at Grytviken whaling station.

APRIL 10, 2018: The Flotilla Foundation announces that the Weddell Sea Expedition will take place in early 2019, its objectives to survey the Larsen C Ice Shelf, document the marine life of the western Weddell Sea ecosystem, and attempt to locate the wreck of *Endurance.*

FEBRUARY 10, 2019: The Weddell Sea Expedition 2019, led by Dr. John Shears on board the South African icebreaker S.A. *Agulhas II,* reaches the sinking location of *Endurance.* An autonomous underwater vehicle (AUV), a Kongsberg Hugin 6000, is deployed to search for the wreck. When communications with the AUV fail, however, it is lost under the sea ice with no data retrieved. The AUV is never recovered.

OCTOBER 9, 2019: The wreck of *Endurance* is listed as Historic Site and Monument No. 93 under the Antarctic Treaty. The designation protects the wreck, including all debris which may be lying on the seabed within a 492-foot (150 m) radius, particularly all fixtures and fittings associated with the ship, including the ship's bell, and all personal possessions left on the ship at the time of sinking.

JULY 5, 2021: The Falklands Maritime Heritage Trust (FMHT) announces the Endurance22 expedition to locate, survey, and film the wreck of *Endurance.* The trust names Dr. John Shears as the expedition leader, Nico Vincent as the deputy expedition leader and subsea manager, and trustee Mensun Bound as director of exploration. The expedition will use the S.A. *Agulhas II* and depart Cape Town, South Africa, in early February 2022.

SEPTEMBER 1, 2021: The subsea team begins two and a half months of training and trials with the Saab Sabertooth AUVs in Sweden and France in preparation for the Endurance22 expedition.

FEBRUARY 16, 2022: On board the S.A. *Agulhas II,* the Endurance22 expedition reaches the sinking location of *Endurance* and, for the first time, deploys a Sabertooth AUV to search for the wreck.

MARCH 5, 2022: The Endurance22 subsea team, led by Nico Vincent, discovers the wreck of *Endurance* using the Sabertooth AUV. The ship is in excellent condition, intact and upright on the seabed at a depth of 9,869 feet (3,008 m). Her position is recorded as 68° 44' 21" S, 52° 19' 47" W—5.7 miles (9.1 km) south and 6.2 miles (10 km) east of the estimated position given by Worsley in 1915.

OCTOBER 31, 2022: The listing of the wreck of *Endurance* as a historic site and monument is updated by the Antarctic Treaty nations, now citing its exact position and increasing the area protected to a circle with a 1,640-foot (500 m) radius.

NOVEMBER 21, 2022: The United Kingdom Antarctic Heritage Trust announces that it has been commissioned by the U.K. government to produce a conservation management plan for the wreck of *Endurance.*

With the S.A. *Agulhas II* locked into an ice floe, the Saab Sabertooth AUV is deployed into a pool of open water at the stern.

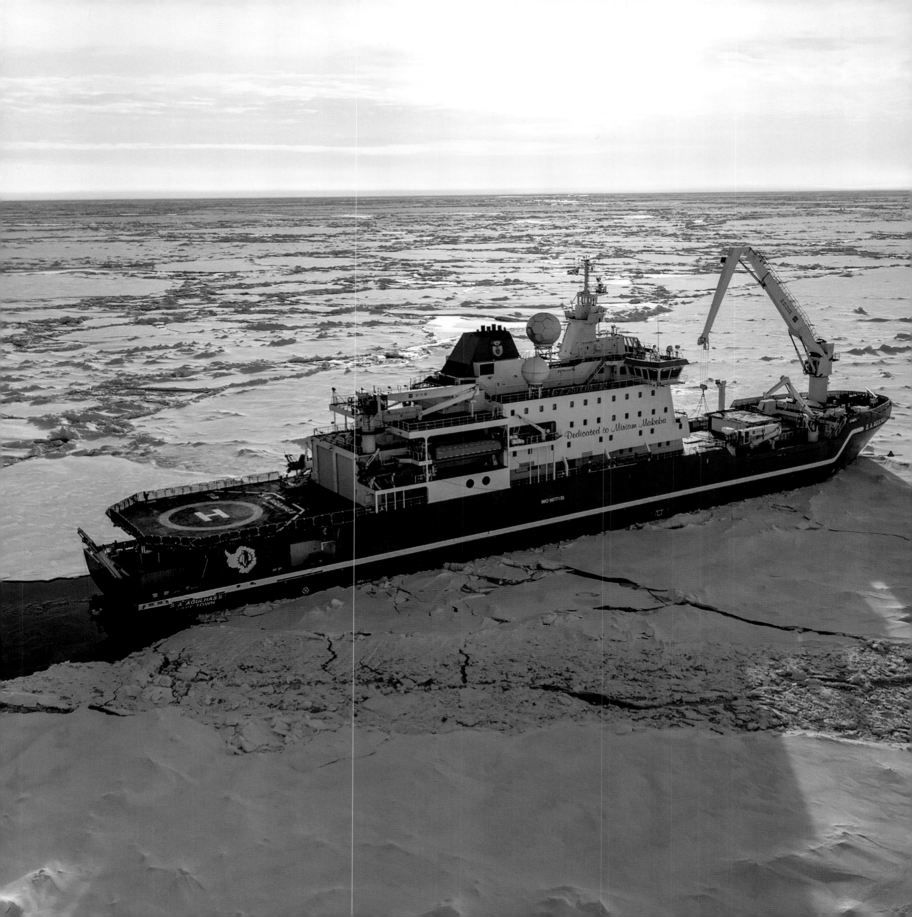

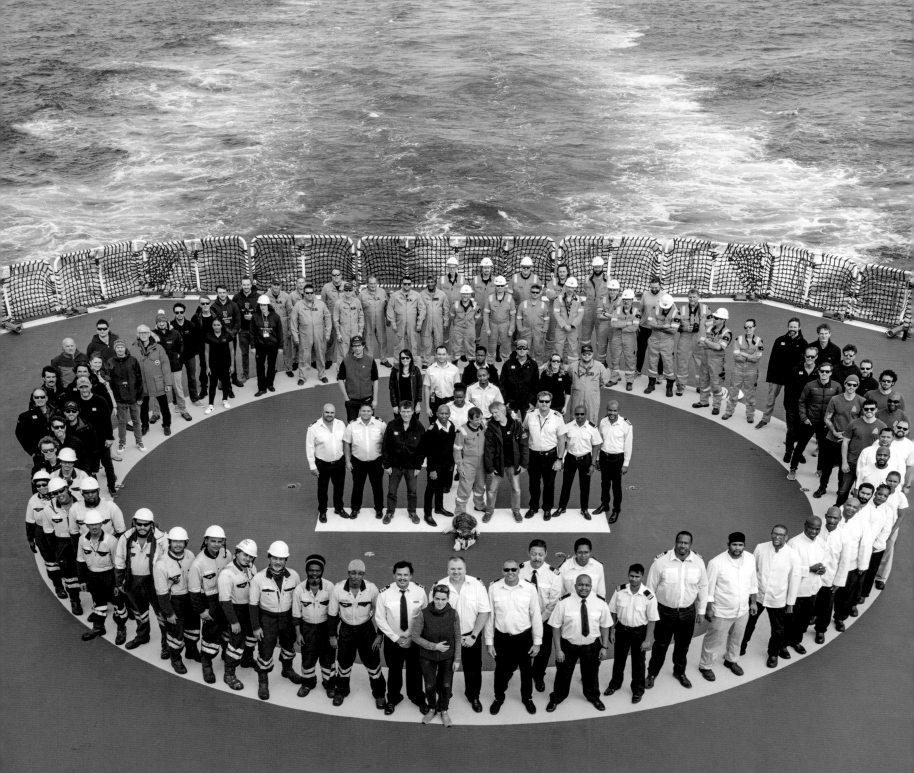

Members of the Endurance22 Expedition

SENIOR EXPEDITION TEAM

▸ Dr. John Shears (U.K., Shears Polar Ltd.)
 Expedition leader

▸ Nico Vincent (France, Deep Ocean Search)
 Deputy leader and subsea manager

▸ Dr. Lasse Rabenstein (Germany, Drift+Noise Polar Services)
 Chief scientist

▸ Mensun Bound (U.K., Falklands Maritime Heritage Trust)
 Director of exploration

▸ JC Caillens (France, Deep Ocean Search)
 Subsea offshore manager

▸ Carl Elkington (South Africa, White Desert)
 Ice camp manager

▸ Michiel Swanepoel (South Africa, Ultimate HELI)
 Helicopter operations manager

▸ Natalie Hewit (U.K., Little Dot Studios)
 Film director

▸ Captain Knowledge Bengu (South Africa, AMSOL)
 Master of the S.A. *Agulhas II*

▸ Captain Freddie Ligthelm (South Africa, Ship2Shore)
 Ice pilot

▸ Dr. Lucy Coulter (U.K., University Hospitals Dorset NHS Foundation Trust)
 Expedition doctor

EXPEDITION TEAM

▸ John Albertson (U.S.A., SEARCH, Inc.)
 Marine archaeologist

▸ Thomas Andreasson (Sweden, Saab)
 Saab AUV engineer

▸ Dr. Stefanie Arndt (Germany, Alfred Wegener Institute)
 Senior sea ice field scientist

▸ Wayne Auton (U.K., White Desert)
 Field guide and paramedic

▸ Scott Barnes (South Africa, Ultimate HELI)
 Helicopter pilot

▸ Frédéric Bassemayousse (France, Deep Ocean Search)
 Ice-drilling supervisor

▸ Professor Anriëtte Bekker (South Africa, Stellenbosch University)
 Senior ship engineering scientist

▸ Jakob Belter (Germany, Alfred Wegener Institute)
 Senior sea ice field scientist

▸ Buzz Bezuidenhout (South Africa, Ultimate HELI)
 Helicopter pilot

- Nick Birtwistle (U.K., Little Dot Studios)
 Producer

- James Blake (U.K., Little Dot Studios)
 Aerial cameraman

- Chad Bonin (U.S.A., Ocean Infinity)
 AUV supervisor

- Seb Bougant (France, Deep Ocean Search)
 Logistics manager

- Kevin Brashar (U.S.A., ROTAK)
 Helicopter pilot

- Grant Brokensha (South Africa, White Desert)
 Field guide

- Jodi Brophy (South Africa, Ultimate HELI)
 Helicopter engineer

- Nicholas Burden (South Africa, White Desert)
 Camp leader

- Chad Burtt (South Africa, White Desert)
 Field guide

- Thomas Busche (Germany, German Aerospace Center)
 Senior remote sensing manager

- Saunders Carmichael-Brown (U.K., Little Dot Studios)
 Presenter

- Darius Carstens (South Africa, Ultimate HELI)
 Helicopter avionics engineer

- Grant Clark (South Africa, White Desert)
 Field guide

- Dr. Marc de Vos (South Africa, South African Weather Service)
 Senior meteorologist/oceanographer

- Emmanuel Guy (France, White Desert)
 Ice camp first aider

- Chad Halstead (U.S.A., ROTAK)
 Helicopter pilot

- Esther Horvath (Hungary)
 Expedition photographer

- Timothy Hughes (U.S.A., ROTAK)
 Helicopter engineer

- Tim Jacob (U.S.A., Reach the World)
 Education outreach coordinator

- Zakaria Johnson (South Africa, Ultimate HELI)
 Helicopter ground team

- Dr. Christian Katlein (Germany, Alfred Wegener Institute)
 Sea ice scientist

- Joe Leek (U.K., Ocean Infinity)
 AUV pilot and technician

- Pierre Le Gall (France, Deep Ocean Search)
 Data processor

- Lars Lundberg (Sweden, Saab)
 Saab AUV engineer

- François Macé (France, Deep Ocean Search)
 Senior surveyor

- James-John Matthee (South Africa, Stellenbosch University)
 Mechanical engineering scientist

- Robbie McGunnigle (U.K., Ocean Infinity)
 AUV pilot and technician

- Gregoire Morizet (France, Deep Ocean Search)
 Senior surveyor

- Jeremie Morizet (France, Deep Ocean Search)
 Subsea survey engineer

- Paul Morris (U.K., Little Dot Studios)
 Producer

- Dmitrii Murashkin (Russia, German Aerospace Center)
 Remote sensing sea ice specialist

- Maeva Onde (France, Deep Ocean Search)
 Senior surveyor

- Michael Patz (U.S.A., ROTAK)
 Helicopter engineer

- Carla-Louise Ramjukadh (South Africa, South African Weather Service)
 Meteorologist/oceanographer

- Beat Rinderknecht (Switzerland, Drift+Noise Polar Services)
 Science technician

- Tom Ross (South Africa, White Desert)
 Field guide

- Clément Schapman (France, Deep Ocean Search)
 Senior surveyor

- Dan Snow (U.K., History Hit)
 History broadcaster

- Fred Soul (France, Deep Ocean Search)
 Senior surveyor

- Ben Steyn (South Africa, Stellenbosch University)
 Ship engineering student

- Alexandra Stocker (Switzerland, Drift+Noise Polar Services)
 Sea ice scientist

- Mira Suhrhoff (Germany, Drift+Noise Polar Services)
 Sea ice science student

- Charles Tait (South Africa, Ultimate HELI)
 Chief helicopter pilot

- Kerry Taylor (U.K., Ocean Infinity)
 AUV supervisor

- Eduan Teich (South Africa, Ultimate HELI)
 Helicopter engineer

- Professor Jukka Tuhkuri (Finland, Aalto University)
 Senior ship engineering scientist

- Waldo Venter (South Africa, Ultimate HELI)
 Helicopter pilot

- Warren Vogt (South Africa, Ultimate HELI)
 Helicopter engineer

Illustrations and Maps Credits

ILLUSTRATIONS

Many thanks to Professor James Forbes and Dr. Thomas Hitchcox at McGill University and to Voyis Imaging Inc. for their help in making the digital subsea imagery of *Endurance* a reality. These stunning images were produced with the magical talents of Pierre Le Gall of Deep Ocean Search Ltd.

Cover, Falklands Maritime Heritage Trust and National Geographic; back cover, Frank Hurley © RGS-IBG; gatefold, Falklands Maritime Heritage Trust and National Geographic; 2–3, James Blake; 4, Mitchell Library, State Library of New South Wales; 14–5, Mitchell Library, State Library of New South Wales; 16, courtesy The National Library of Scotland; 20–1, Frank Hurley/Scott Polar Research Institute, University of Cambridge/Getty Images; 22–3, Mitchell Library, State Library of New South Wales; 23, Nick Birtwistle; 24–5, Frank Hurley/Royal Geographical Society/Alamy Stock Photo; 26–7, Frank Hurley/Royal Geographical Society via Getty Images; 28–9, Esther Horvath; 30–1, image © 2024 Planet Labs PBC; 32, Esther Horvath/Falklands Maritime Heritage Trust; 33–5, Nick Birtwistle; 36–7, Frank Hurley/Royal Geographical Society via Getty Images; 38, Frank Hurley/Scott Polar Research Institute, University of Cambridge/Getty Images; 46–7, © National Maritime Museum, Greenwich, London/Bridgeman Images; 48–9, Print Collector/Getty Images; 50–1, Private Collection/Photo © Christie's Images/Bridgeman Images; 52–3, Frank Hurley/Royal Geographical Society via Getty Images; 54, Frank Hurley/Royal Geographical Society/Alamy Stock Photo; 55, Niday Picture Library/Alamy Stock Photo; 56–7, Frank Hurley/Royal Geographical Society/Alamy Stock Photo; 58–9, Frank Hurley/Scott Polar Research Institute, University of Cambridge/Getty Images; 60–1, Frank Hurley/Album/Alamy Stock Photo; 62–3, Frank Hurley/Scott Polar Research Institute, University of Cambridge/Getty Images; 63, Esther Horvath; 64–5, Frank Hurley/Scott Polar Research Institute, University of Cambridge/Getty Images; 66–7, Frank Hurley/Royal Geographical Society/Alamy Stock Photo; 68–9, Frank Hurley/Royal Geographical Society via Getty Images; 70, Esther Horvath/Falklands Maritime Heritage Trust; 71, Esther Horvath; 72–3, Frank Hurley/Royal Geographical Society via Getty Images; 74–6, © 2019, A&E Television Networks, LLC. All rights reserved. Used with permission. Photo: Tamara Stubbs; 88–9, J Trincali; 90–101, © 2019, A&E Television Networks, LLC. All rights reserved. Used with permission. Photo: Tamara Stubbs; 102–3, Frank Hurley/Scott Polar Research Institute, University of Cambridge/Getty Images; 103, Esther Horvath; 104–5, Pierre Le Gall; 106, Esther Horvath/Falklands Maritime Heritage Trust; 107, Esther Horvath; 108–9, © 2019, A&E Television Networks, LLC. All rights reserved. Used with permission. Photo: Tamara Stubbs; 110–2, Esther Horvath; 122–3, Nico Vincent; 124–5, JC Caillens; 126–7, Kevin Brashar; 128–9, Clément Schapman; 130–1, Esther Horvath; 132–3, Nick Birtwistle; 134–5, Esther Horvath; 136–7, Pierre Le Gall; 138–9, Nico Vincent; 140, Esther Horvath; 140–1, Frank Hurley/Scott Polar Research Institute,

University of Cambridge/Getty Images; 142–3, Esther Horvath; 144, Esther Horvath/Falklands Maritime Heritage Trust; 145, Esther Horvath; 146–7, Nick Birtwistle; 148–9, Esther Horvath; 150, Nick Birtwistle; 153, Copyright Saab AB; 164–5, James Blake; 166–171, Esther Horvath; 172–3, James Blake; 174–5, Nick Birtwistle; 176, Lasse Rabenstein; 177, Esther Horvath; 178, Frank Hurley/Scott Polar Research Institute, University of Cambridge/Getty Images; 178–183, Esther Horvath; 184–5, James Blake; 186, Esther Horvath; 187, Falklands Maritime Heritage Trust; 188–9, Falklands Maritime Heritage Trust and National Geographic; 190, Hulton Archive/Getty Images; 190–1, Falklands Maritime Heritage Trust and National Geographic; 192 (UP LE), Frank Hurley/Royal Geographical Society/Alamy Stock Photo; 192 (UP RT) and (LO LE), Falklands Maritime Heritage Trust and National Geographic; 192 (LO RT), Frank Hurley/Royal Geographical Society via Getty Images; 193 (UP LE), Niday Picture Library/Alamy Stock Photo; 193 (UP RT) and (LO RT), Falklands Maritime Heritage Trust and National Geographic; 193 (LO LE), Frank Hurley/Royal Geographical Society via Getty Images; 194–7, Falklands Maritime Heritage Trust and National Geographic; 198–9, Falklands Maritime Heritage Trust and National Geographic; 200–5, Esther Horvath; 206, Beat Rinderknecht; 210, Esther Horvath/Falklands Maritime Heritage Trust; 211, Esther Horvath; 216–7, Nick Birtwistle; 218, Scott Polar Research Institute, University of Cambridge; 219, © Thomas Binnie, Jr., courtesy South Georgia Museum; 220–3, Esther Horvath; 224–5, Nick Birtwistle; 226–7, Pierre Le Gall; 228–9, James Blake; 230–1, Clément Schapman; 232–5, Esther Horvath; 241, James Blake; 242, Esther Horvath; 255 (UP LE) and (UP RT), Esther Horvath/Falklands Maritime Heritage Trust; 255 (LO), James-John Matthee.

MAPS

Special thanks to Dr. Lasse Rabenstein at Drift+Noise Polar Services and Dr. Frazer Christie at the Scott Polar Research Institute.

British Antarctic Survey Geodata Portal. *bas.ac.uk/data/our-data.*

General Bathymetric Chart of the Oceans (GEBCO).

Polar Geospatial Center, University of Minnesota. Reference Elevation Model of Antarctica. Howat, I., Morin, P., Porter C., and Noh, M.-J. 2018. "The Reference Elevation Model of Antarctica," Harvard Dataverse, V1. *data.pgc.umn.edu/elev/dem/setsm/REMA.*

Rignot, E., J. Mouginot, and B. Scheuchl. 2017. MEaSUREs InSAR-Based Antarctica Ice Velocity Map, Version 2. Boulder, CO: NASA National Snow and Ice Data Center Distributed Active Archive Center. *dx.doi.org/10.5067/D7GK8F5J8M8R* (Oct. 2018).

Scientific Committee on Antarctic Research. SCAR Composite Gazetteer of Antarctica. *data.aad.gov.au/aadc/gaz/scar.*

Spreen, G., L. Kaleschke, and G. Heygster. 2008. "Sea Ice Remote Sensing Using AMSR-E 89-GHz Channels." *Journal of Geophysical Research: Oceans* 113, no. C2. Institute of Environmental Physics, University of Bremen, Germany. Sea Ice Concentration › AMSR-E/AMSR2.

Index

FALKLANDS MARITIME HERITAGE TRUST

Over the centuries, the seas in the South Atlantic around the Falkland Islands have seen triumph and tragedy as ships—whether naval or merchant vessels—and those on board have faced the challenges of nature and humankind. For some, the Falkland Islands were a safe haven. For many, the surrounding seas became their graveyard. The Falklands Maritime Heritage Trust was established in 2014 with the aim of bringing these stories to a global audience.

The first major project that the trust undertook was a search for the German naval vessels sunk early in the First World War in the Battle of the Falklands. Mensun Bound, a trustee, Falkland Islander, and marine archaeologist, led an expedition in 2019 that located and filmed the wreck of the S.M.S. *Scharnhorst*, one of the six German ships sunk in that battle. We tell that story on the Trust's website *(www.fmht.co.uk)* and also invite our audience to explore other notable wrecks in the waters around the Falkland Islands, the island of South Georgia, and Antarctica.

Strangely enough, as the Royal Navy and the Kaiser's ships were exchanging fire in the Battle of the Falklands on December 8, 1914, Sir Ernest Shackleton and his men had entered the ice of the Weddell Sea on board *Endurance,* with a wholly peaceful purpose. Their story of triumph over disaster is a tale that truly deserves to be described as epic. The Trust was privileged to have the opportunity to organize the Endurance22 expedition *(www.endurance22.org),* which in 2022 was crowned with success in the face of so many difficulties. We are grateful to National Geographic Books for producing this beautiful book, with its faithful account of our expedition and its context.

Donald Lamont
Chairman, Falklands Maritime Heritage Trust

About the Authors

DR. JOHN SHEARS is a polar geographer and expedition leader with more than 30 years of experience in both Antarctica and the Arctic. A long-standing fellow and chartered geographer of the Royal Geographical Society, he is also a leading expert on the Antarctic Treaty system, serving as senior policy adviser on treaty matters to the British government for more than 20 years. In 2019, Dr. Shears was awarded the Polar Medal by Her Majesty Queen Elizabeth II in recognition of his "outstanding achievement and service to the United Kingdom in the field of polar research." Currently a visiting professor in the School of Geography and Environmental Science at the University of Southampton, he lives near Cambridge, U.K., and manages his polar consultancy business, Shears Polar Ltd.

NICO VINCENT is a subsea engineer, surveyor, and underwater vehicle manager with more than 30 years of experience on deep-sea projects, including the discovery and survey of many significant shipwrecks. He and his team hold four world records, including the recovery of the world's deepest cargo of silver coins on behalf of the U.K. government; they supported the location of the fighter plane of Antoine de Saint-Exupéry; and, working with explorer Victor Vescovo, discovered the world's deepest wreck: the U.S.S. *Samuel B. Roberts,* a World War II destroyer escort found 22,621 feet (6,895 m) deep in the Philippine Sea. They have also helped investigate significant air accidents, including Air France AF447 in 2009, Malaysia Airlines Flight MH370 in 2014, and EgyptAir Flight MS804 in 2022. Vincent is now operations manager of Deep Ocean Search Ltd. and lives in Marseilles, France.

In Memoriam

JAMES-JOHN MATTHEE
March 17, 1995–August 30, 2023
Mechanical engineering scientist, Stellenbosch University,
 South Africa
Member of the Weddell Sea Expedition 2019 and the
 Endurance22 expedition

Since 1888, the National Geographic Society has funded more than 14,000 research, conservation, education, and storytelling projects around the world. National Geographic Partners distributes a portion of the funds it receives from your purchase to National Geographic Society to support programs including the conservation of animals and their habitats.

National Geographic Partners, LLC
1145 17th Street NW
Washington, DC 20036-4688 USA

Get closer to National Geographic Explorers and photographers, and connect with our global community. Join us today at nationalgeographic.org/joinus

For rights or permissions inquiries, please contact National Geographic Books
Subsidiary Rights: bookrights@natgeo.com

For complete illustrations credits, see pages 246–7.

ISBN: 978-1-4262-2383-9

Printed in Malaysia

24/IVM/1